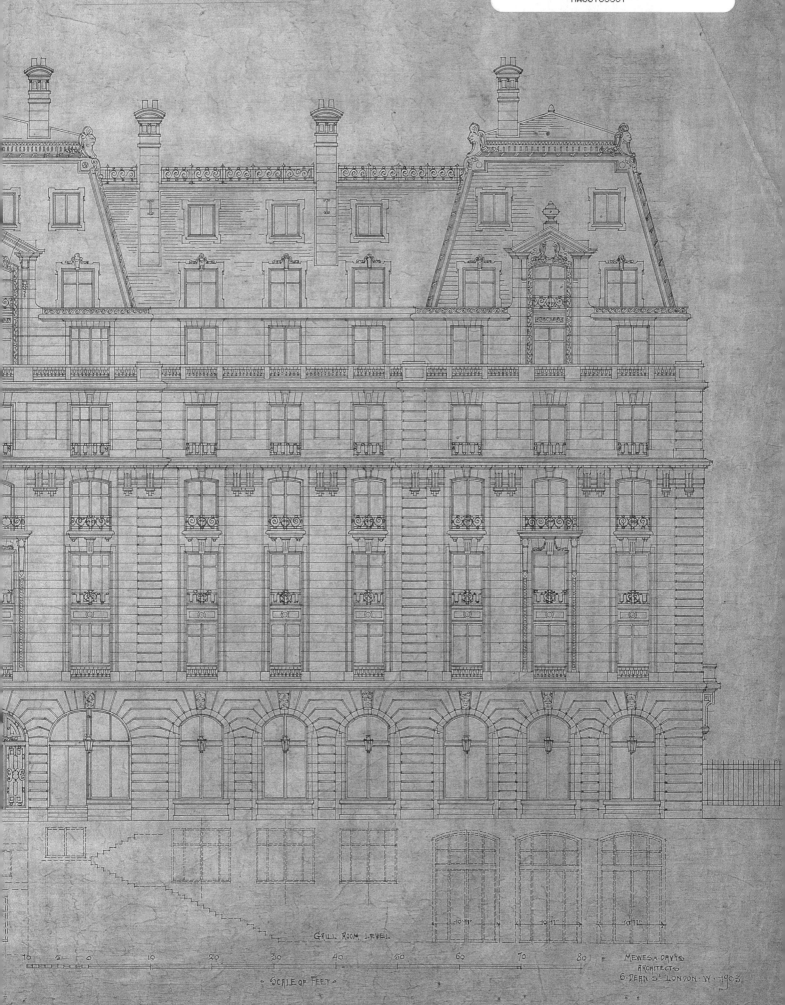

GRILL ROOM LEVEL

GRILL ROOM LEVEL

10 5 0 10 20 30 40 50 60 70 80

· SCALE OF FEET ·

MEWES & DAVIS
ARCHITECTS
6 · DEAN S? LONDON · W · 1903.

THE RITZ HOTEL

LONDON

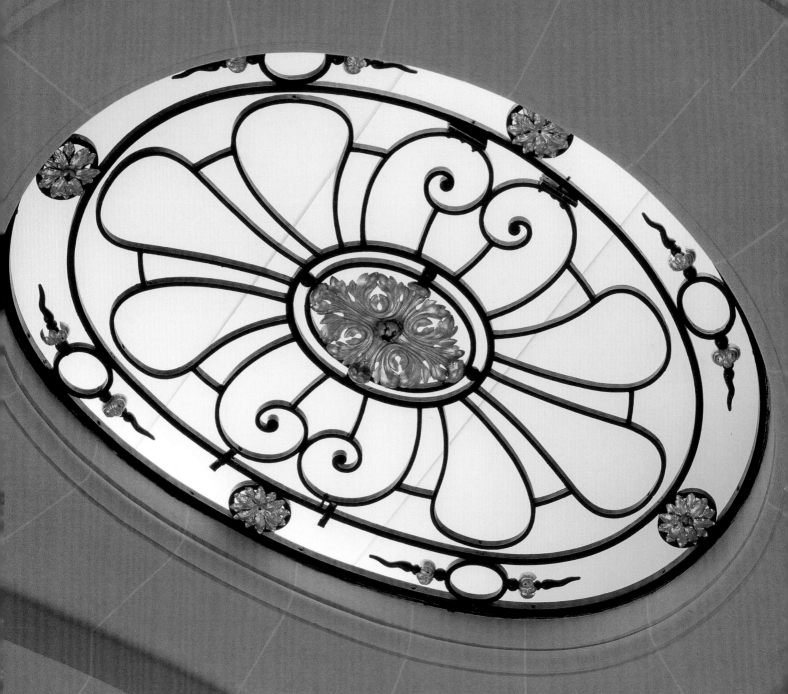

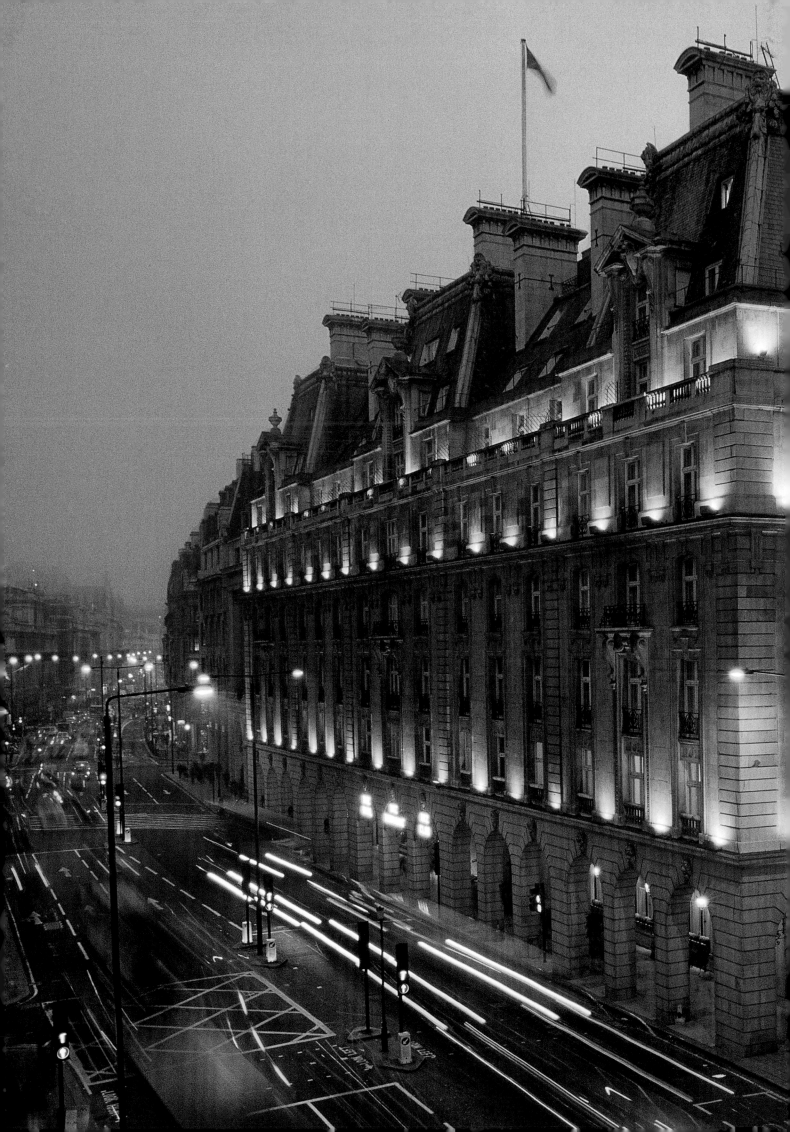

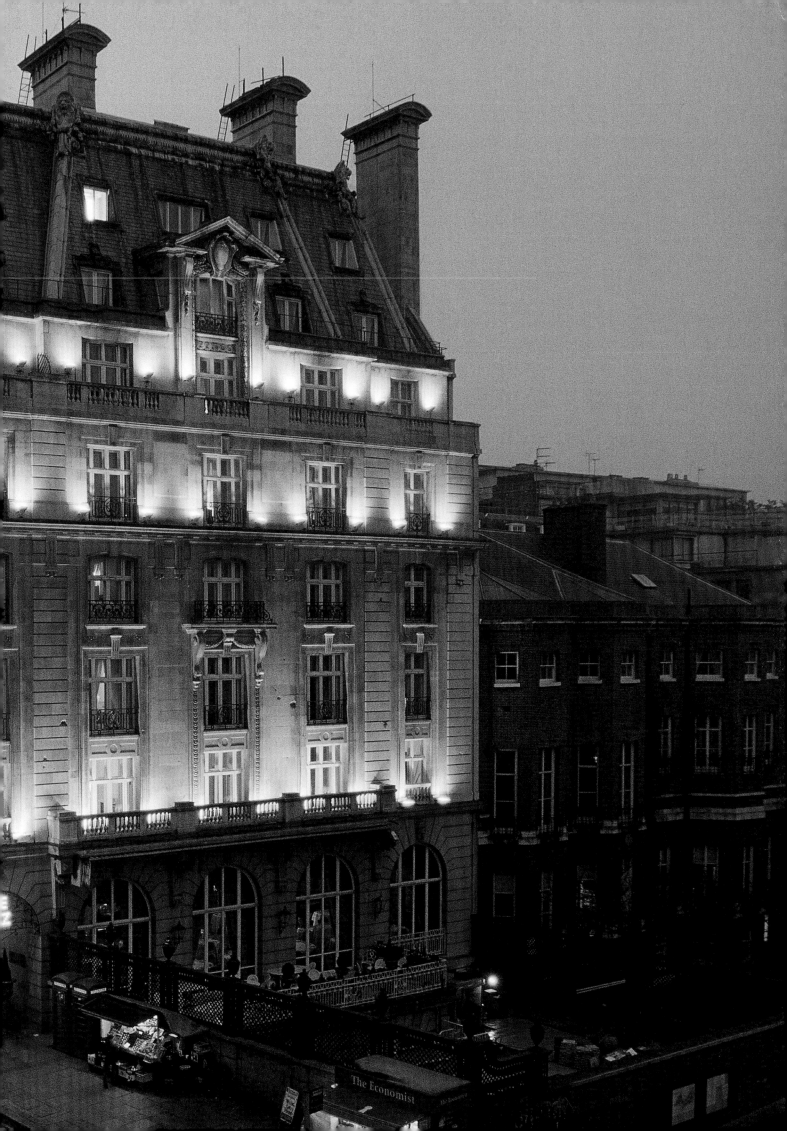

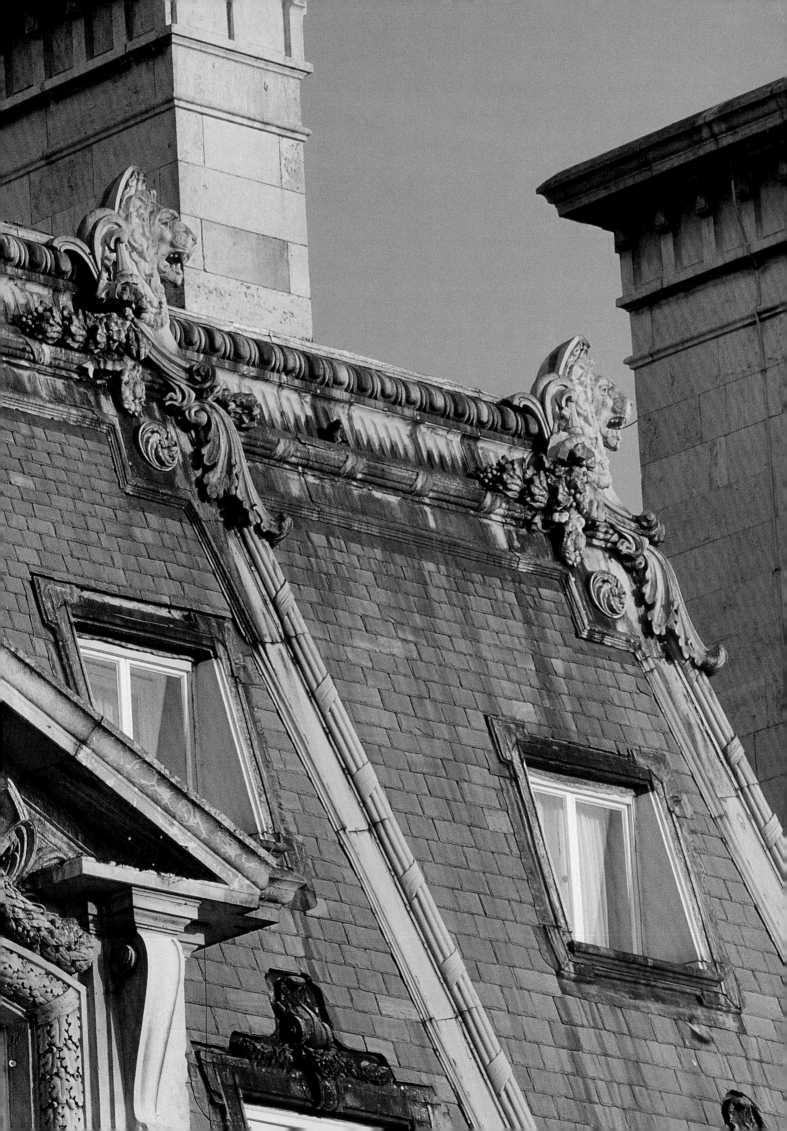

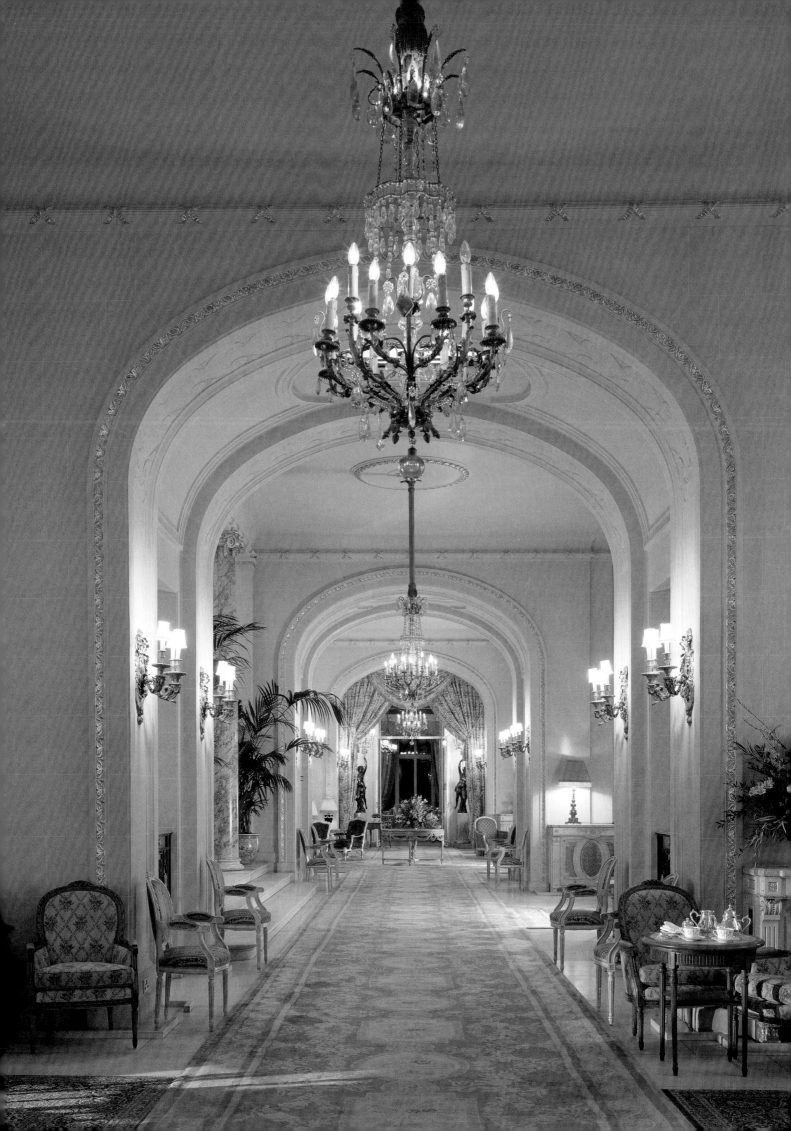

THE RITZ HOTEL
LONDON

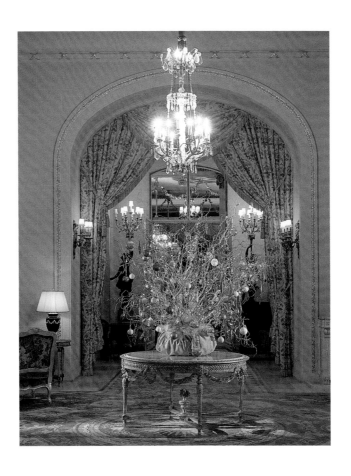

Marcus Binney

Special photography by James Mortimer

Thames & Hudson

Endpapers: architects' drawing of the Piccadilly elevation, 1905 (from the archives of Mewès & Davis Architects Ltd).
Page 1: Ceiling light in one of the bays of the Grand Gallery.
Pages 2-5: The Ritz at night, seen from the north-west, and a detail of the roof showing copper lion's heads.
Page 6: Part of the Grand Gallery looking west.
Page 7 (title page): Christmas decorations in the Grand Gallery.
Page 9: The entrance vestibule with the hall porter's desk.
Pages 10-11: The double doors leading from the vestibule to the Grand Gallery, and one of the ornate ground-floor clocks.
Page 12: Christmas tree in the entrance vestibule.

Sources of illustrations

The photographs specially taken for this book by James Mortimer have been supplemented with illustrations from the Ritz Hotel's own archive. Other items were kindly supplied by the following: Mme Robert Bourgès-Maunoury p. 23; By permission of the British Library p.17; The Bylander Waddell Partnership Ltd pp. 72–5; Illustrated London News Picture Library pp. 36, 116; London Metropolitan Archives pp. 24, 25, 28, 106–7; Mewès & Davis Architects Ltd, Plymouth pp. 26–7, 29, endpapers; Musée Bouilhet-Christofle, Saint-Denis pp. 108, 111 (sketches), 112; National Monuments Record pp. 88, 89 below, 90; Roger-Viollet, Paris pp. 46 above, 47; Mrs Ann Davis Thomas p. 22; V&A Picture Library, London pp. 40 above, 41, 46 below

Any copy of this book issued by the publisher as a paperback is sold subject to the condition that it shall not by way of trade or otherwise be lent, resold, hired out or otherwise circulated without the publisher's prior consent in any form of binding or cover other than that in which it is published and without a similar condition including these words being imposed on a subsequent purchaser.

© 1999 The Ritz Hotel (London) Ltd

First published in the United Kingdom in 1999 by The Ritz Hotel (London) Ltd, in association with Thames & Hudson Ltd, 181A High Holborn, London WC1V 7QX

First published in the United States of America in 1999 by Thames & Hudson Inc., 500 Fifth Avenue, New York, New York 10110

Library of Congress Catalog Card Number 99-70942

ISBN 0-500-01934-7

All Rights Reserved. No part of this publication may be reproduced or transmitted in any form or by any means, electronic or mechanical, including photocopy, recording or any other information storage and retrieval system, without prior permission in writing from the publisher.

Printed in Singapore

Acknowledgments

The idea for this book came from the Barclay family, who acquired The Ritz in 1995. At The Ritz itself my first thanks are to Giles Shepard the Managing Director, Luc Delafosse the General Manager, and to Michael Seal and other members of the management and staff. Abundant help was provided by Pat Hardy and Janine Wilson, who have built up an impressive collection of photographs and archival material. Invaluable practical assistance has been provided by Jay Hargreaves and Kim Tipper, while Francesca Evers patiently directed my incessant telephone enquiries to the right quarter.

In the course of my research, Timothy Shaw gave me crucial insights into the history and management of grand hotels. To Ann Davis Thomas I am grateful for a wealth of material about her late father's architectural practice. M. Pierre Escoffier kindly provided me with many interesting insights about restaurants and catering in grand hotels.

Companies House, Susan Scott at the Savoy archives, the Greater London Record Office, Royal Doulton, Westminster City Archives and the Institution of Structural Engineers, as well as Christofle & Cie in France, have all been valuable sources. Special thanks are due to Peter Cowling for allowing me access to the Mewès & Davis archive in Plymouth and to Alan Knight of the Bylander Waddell Partnership for information on the Ritz's steel-frame construction.

In Paris, Vincent Bouvet has been a crucial source of information about the architect Charles Mewès and grand hotels. Other important insights on furnishing and decor have come from John Hardy and Hugh Roberts. Philippe Belloir has provided information on aspects of the recent programme of redecoration. For tips and pointers of many kinds I am grateful to Sophie Andreae, Nick Bridges, Richard Garnier, John and Eileen Harris, Martin Meade, Ken Pollington, Alex Starkey, Derek Taylor, Paul Velluet and David Watkin.

In America, Christopher Monkhouse, an authority on the history of grand hotels, first fired me with an enthusiasm for the subject, while Calder Loth has provided numerous leads. Thanks also to Shelby Taylor of the Ritz-Carlton Hotel Company, Marie-Josée Allaire of the Ritz-Carlton, Montreal, and Caron LeBrun of the Ritz-Carlton, Boston.

With his splendid photographs James Mortimer has made an invaluable contribution to the book; my thanks are also due to his patient assistant Michael Maynard and to Alexandra Sullner for her supervision of interior styling.

At Thames & Hudson I am indebted to Stanley Baron, who initially took up the idea for this book, and to Jamie Camplin and Mark Trowbridge for co-ordinating editorial aspects in bringing the project to a successful conclusion.　　　　　M. B.

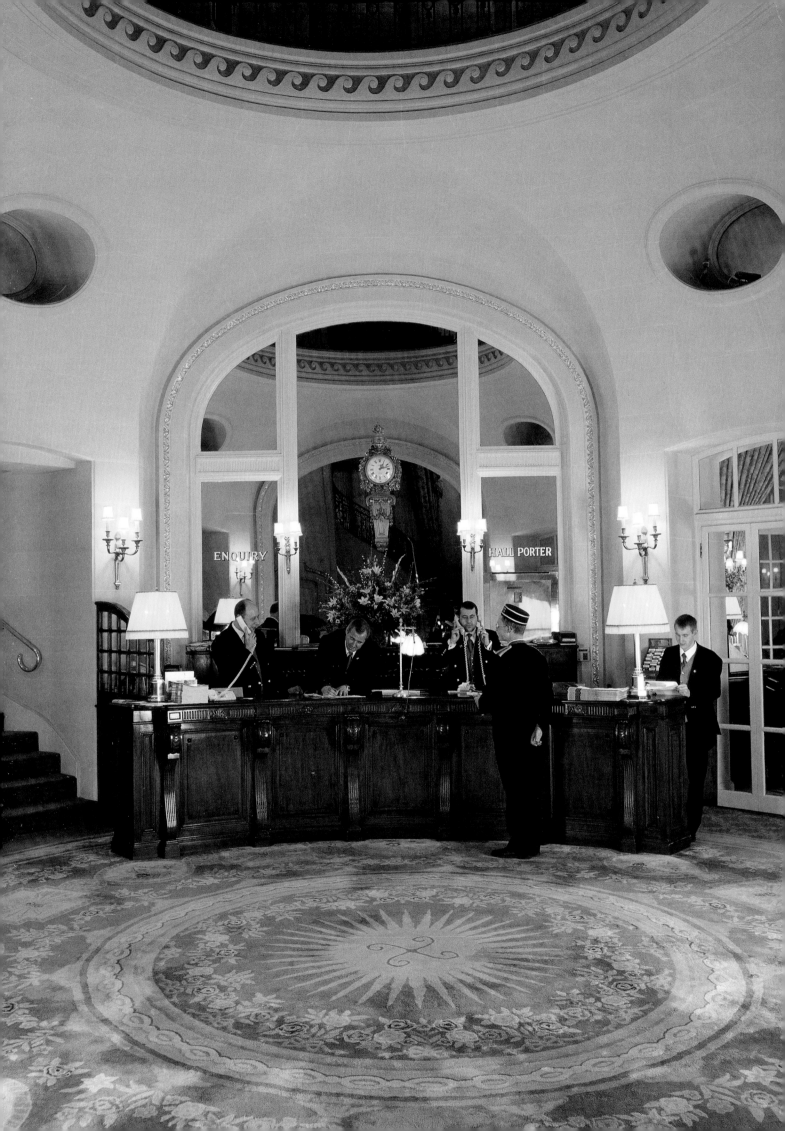

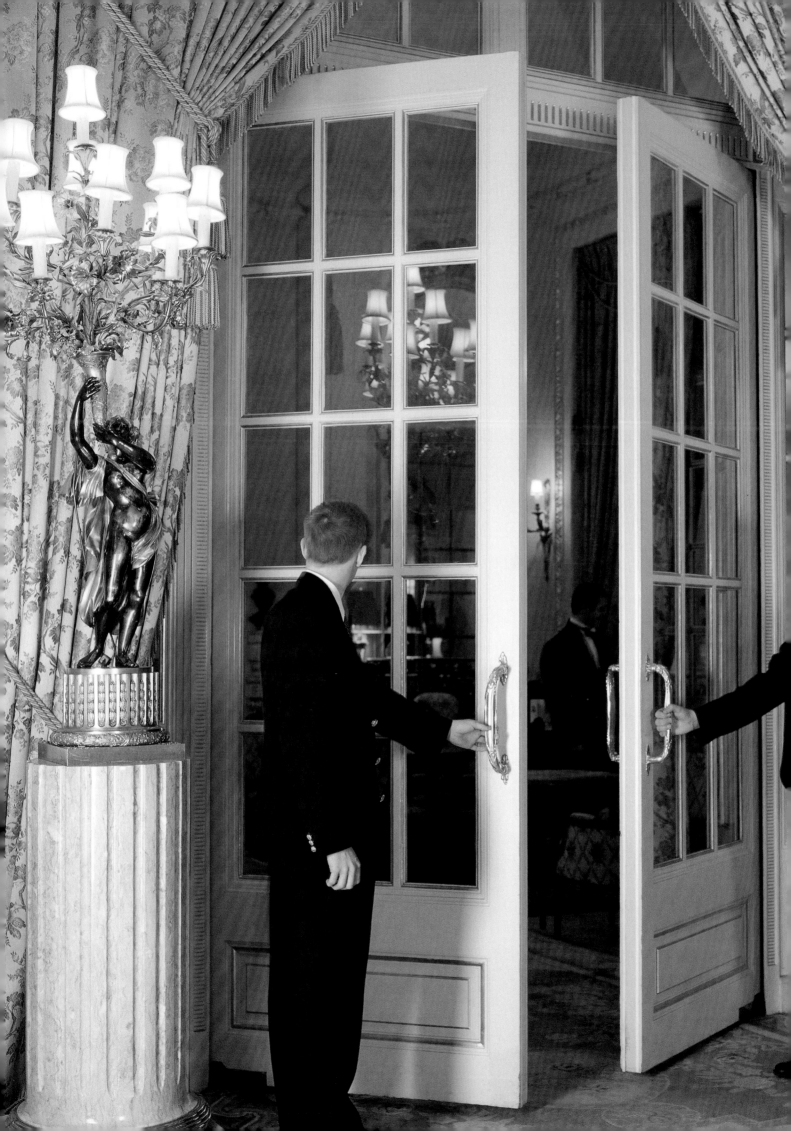

Contents

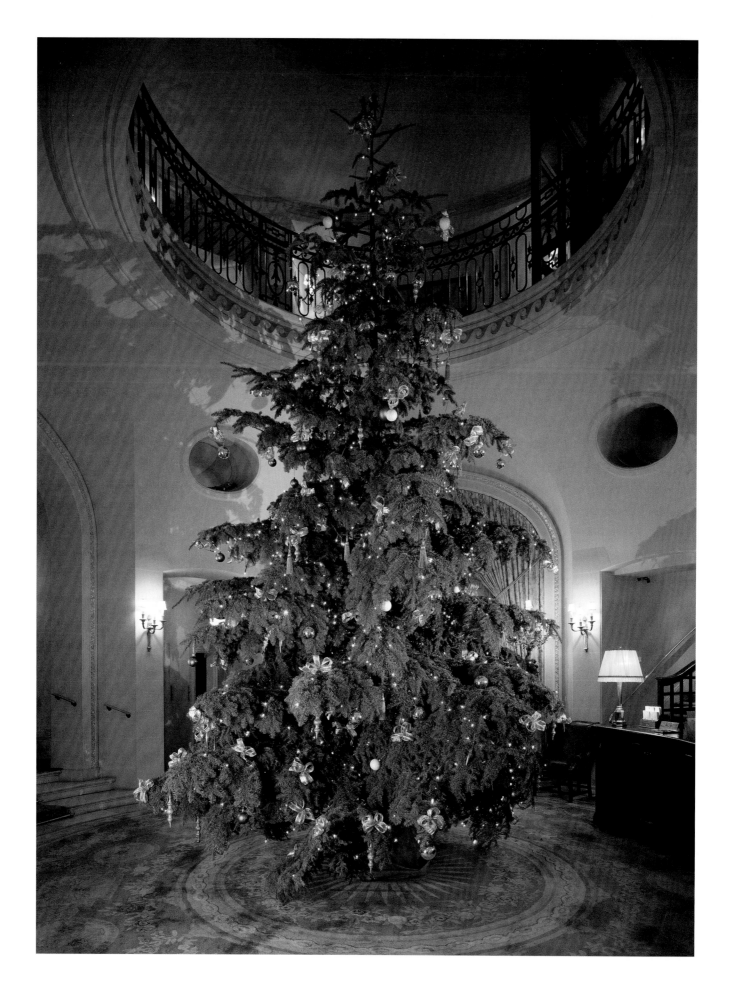

FOREWORD

When Mr David Barclay and Mr Frederick Barclay acquired The Ritz in October 1995, the hotel was down at heel and its staff demoralized since prospects for the future were unclear. Although the Ritz name still reigned supreme, the product was sadly neglected and a shadow of its former glory. I was fortunate enough to be asked to join The Ritz in December of that year, and since that time the Barclay family has lavished an enormous amount of time, money and love on the hotel in order to restore it to its original Edwardian splendour and to rebuild the clientele.

Now that ownership of the hotel is once again in private hands, both the clients and the staff of The Ritz know that the hotel's future is assured and that it will continue to be loved as it was by those who were in control at the time of its opening in 1906. No expense has been spared to retain and preserve the beauty of the building, the richness of the fabrics, and the highest standards of service to the clients whilst at the same time incorporating all those important modern comforts that today's discerning traveller demands.

Maintaining traditional qualities of service and style, combined with the elegant spaces of Mewès and Davis's remarkable building, remains the aim of The Ritz, and I as Managing Director, together with Mr Luc Delafosse, the General Manager, and all the staff, am excited and proud to be a part of the hotel's renaissance.

Giles Shepard

PREFACE

Not surprisingly, I accepted an invitation to write a new book on the Ritz with alacrity. There were just two small problems. First, there is an excellent book written by Hugh Montgomery-Massingberd and David Watkin in 1980, at the time Trafalgar House owned the hotel, and second, at some point before the present owners acquired the hotel, the entire archive had left the building and, despite repeated efforts, has not been traced.

The purpose of the present book is to explore new angles and record aspects of the hotel's history and the very extensive programme of refurbishment now nearing completion. The exquisite pale marbles of the Restaurant have been painstakingly cleaned, magnificent new carpets woven, new fabrics introduced. In the process it has become clear just what a remarkable survival the London Ritz is. All the main ground-floor rooms, the circular vestibule and the handsome stone staircase, the Grand Gallery, the Palm Court (originally known as the Winter Garden), the Restaurant and the gorgeous Marie Antoinette Room, remain almost entirely as the architects designed them, complete with original chandeliers and wall-sconces. Upstairs, though the original bathrooms were stripped out in the 1980s, a remarkable amount also remains – Louis Seize panelling and marble fireplaces, most of the original gilt-bronze light fittings, and even a number of Ritz clocks and copper coal-skuttles.

With the help of Christofle in Paris and their excellent archives, as well as Royal Doulton, much valuable material has come to light about the silverware and china supplied to the Ritz, and an exciting number of original items have been found to remain in the hotel. Remarkably, the practice of Mewès & Davis (the architects of the hotel) continues in Plymouth and retains a substantial collection of original drawings for the Ritz, while Bylander Waddell, the structural engineers who designed the pioneering steel frame of the Ritz, continue to work from offices in Harrow and retain the original drawings for the steelwork, as well as lantern slides showing progress on construction during 1905.

Arthur Davis's daughter, Ann Davis Thomas, who lives in the United States, has gathered together much interesting material on her father, while at the Ritz itself a considerable archive collection of photographs of the hotel, as well as items such as correspondence, brochures, handsomely produced menus and press cuttings, has been assembled.

A wealth of interesting and lively material, describing the hotel and all its novel features when it opened, has come from contemporary publications – newspapers, magazines and the technical press. It has been no less exciting to find material on Ritz's other hotels, as well as the Ritz-Carltons in America that bear the names of his two great London hotels.

From all this it emerges that the upstairs-downstairs life of a great hotel is as interesting as that of many great aristocratic houses. Few buildings are as rewarding to study as those that continue, little altered, to flourish in the role for which they were designed. This is all the more remarkable at the Ritz, as the building has been in intensive daily use since the day it opened.

Among the major hotels of the world, the London Ritz stands out as a masterpiece, and no one recognizes that more than those who work in it.

April 1999 M.B.

CESAR RITZ AND HIS HOTELS

César Ritz was the greatest hotelier in history. Palatial hotels were established by him, or following his strict stipulations, in London and Paris, Budapest, Madrid and Rome, in Boston, Montreal and New York. A whole series of major hotels – in Baden-Baden, Cannes, Frankfurt, Lucerne, Monte Carlo and Salsomaggiore – owed their success to his ideas, enterprise and energy, as did the mighty Savoy in London. Ritz-Carlton restaurants were installed on the liners of the Hamburg-Amerika line, the *Amerika,* the *Kaiserin Auguste Victoria* and the *Imperator.*

From humble and wholly impecunious beginnings in Switzerland, Ritz rose to become, in the words of King Edward VII, 'hotelier to Kings and King of hoteliers'. Yet in many ways Ritz is an enigma. For years the best and indeed the only source of biographical details was a delightful book written by his wife, Marie-Louise, whom he married in 1888. She was seventeen years his junior and took over much of Ritz's role after his sudden collapse at the age of 52, while at the height of his success.

Marie-Louise's book, published in 1938, is written with charm and skill. For its date, it is exceptionally chatty, full of precise information about places, people and events, spiced with amusing gossip and conversation, and altogether a very perceptive chronicle of her husband's meteoric rise and achievements, while also explaining the calamity of his illness.

The most engaging description of Ritz is given in a delightful book, *Dinners and Diners,* written by Lt.-Col. Nathaniel Newnham-Davis. The

author was an early example of the modern food columnist, and his book is a reprint of his articles in the *Pall Mall Gazette*. He was a remarkable character, a man who moved freely in high society; when he died, his funeral was held with full military honours at St Martin's-in-the-Fields.

Recalling Ritz's time at the Carlton Hotel, he describes him as 'very slim, very quiet with nervous hands clasped tightly together, he would move through the big restaurant seeing everything … bowing to some of the diners, standing by a table to speak to others, possessing a marvellous knowledge of faces and of what the interests were of all the important people of his clientèle.' According to Newnham-Davis, Ritz 'had an enormous facility for quick work, no detail was too small for him, and when he had made up his mind that a thing should be done he took unlimited trouble to have it carried out.'

César Ritz was born on 22 February 1850 in the Swiss village of Niederwald at the foot of the Rhône Glacier on the road to Saint-Gotthard. He was the thirteenth and youngest child of Johann Josef Anton Ritz, the mayor of the village. His family were peasant farmers, but as Pierre Andrieu put it, 'these *montagnards* were nobles' – with a family crest on the great stone stove in the room where Ritz was born, a crest that was later to emblazon the silver, china, letterheads and literature of the Ritz Hotel in Paris. Like a boy in the *Iliad*, the young Ritz stood guard over his father's goat herds.

At the age of fifteen, Ritz was sent as apprentice wine-waiter to the Hôtel des Trois Couronnes et Poste at Brig. At the end of the year the owner, M. Escher, told him, 'You'll never make anything of yourself in the hotel business. It takes a special knack, a special flair, and it's only right I should tell you the truth: you haven't got it!' Ritz was undeterred and set off to Paris in 1867, the year of the Exposition Universelle. He began at the Hôtel de la Fidelité, polishing shoes, scrubbing floors, rushing up and down stairs with suitcases and trays. Next he served as a waiter in a *prix fixe* restaurant, breaking records for swiftness (and at breaking crockery too), arriving in 1869 at the fashionable Restaurant Voisin, at the corner of the rue Cambon and the rue du Faubourg Saint-Honoré, where the proprietor M. Bellenger would teach his staff to baste a duck, decant a Burgundy and carve a roast. Here Ritz also learned the art of aiming to please the customers, making a mental note of their special likes, and anticipating their every wish.

In 1873, the restless Ritz set out for Vienna, where another great International Exhibition was opening, and found work at once in the restaurant Les Trois Frères Provençaux, near the Imperial Pavilion. When the Pavilion was too crowded with royal visitors, the restaurant would help them out, and here Ritz was able to observe emperors, kings and princes first-hand, among them his future patron the Prince of Wales (later King Edward VII). Ritz made a mental note that the Prince liked his beef well done and was particularly fond of a well-roasted chicken.

At Christmas Ritz was at the Grand Hotel in Nice, not as a waiter, or even *maître d'hôtel*, but as restaurant manager. Now his life was to assume the seasonal pattern which would carry him to future success – of winters spent on the French Riviera and summers in the Swiss mountains, the life of an age which had yet to discover either ski-ing or sunbathing.

In 1875, Ritz took a job as *maître d'hôtel* at the Grand Hotel in Locarno, on the shores of Lake Maggiore, and that winter he went on to become manager of the Hôtel de Nice in San Remo, where the Tsarina, in poor health, came to stay. Here, finally in charge, Ritz triumphantly doubled the receipts in a season.

His subsequent rise to international fame and fortune was enhanced by close collaboration with the great chef Auguste Escoffier, beginning in 1884 at the Grand Hotel, Monte Carlo. In his memoirs Escoffier recalls that 'the ideas and thoughts that we both believed in helped us to work together in total harmony ... until his death ... we were inseparable friends.'

César Ritz died on 26 October 1918. A month later, the *Financial Times* printed a report of the AGM of the Carlton Hotel Company in which the chairman, William Harris, paid a warm tribute to Ritz, the company's first managing director, saying that 'from humble beginnings he raised himself by his own ability to be the most eminent hotel keeper in the world, and he may be said to have revolutionised hotel and restaurant life in London.'

Portrait of César Ritz with dedication to his friend and collaborator, the renowned chef Auguste Escoffier.

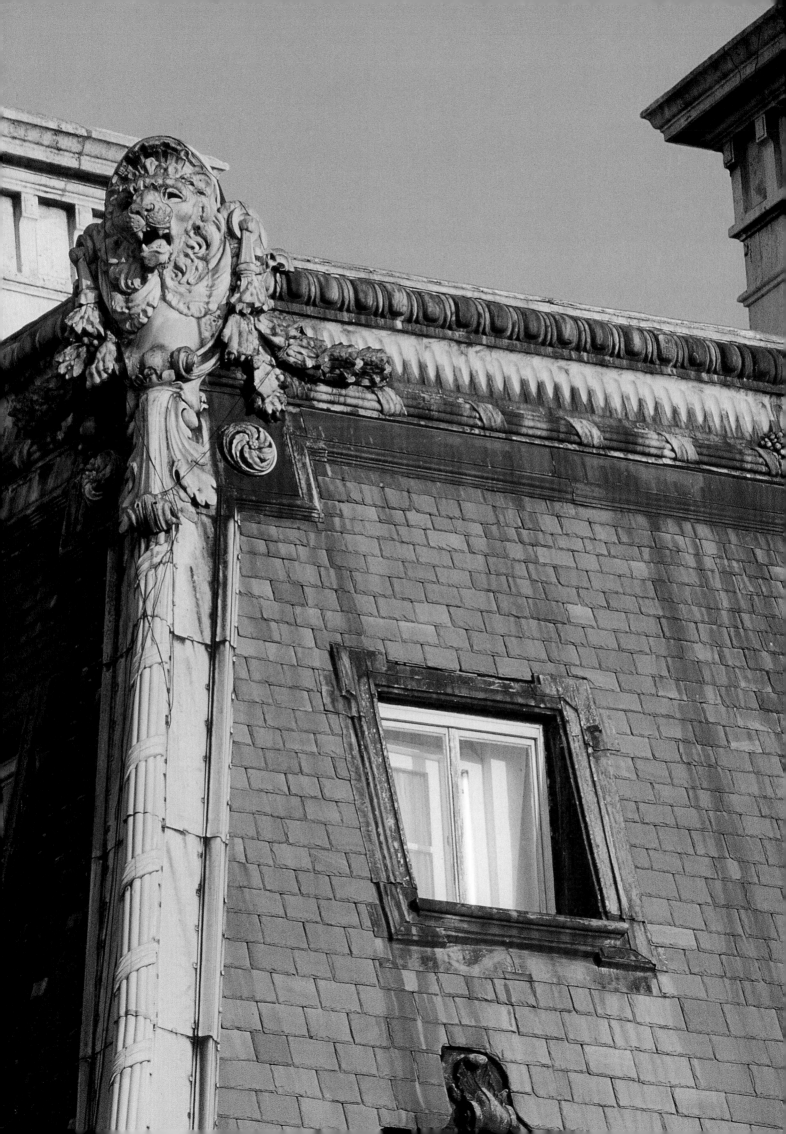

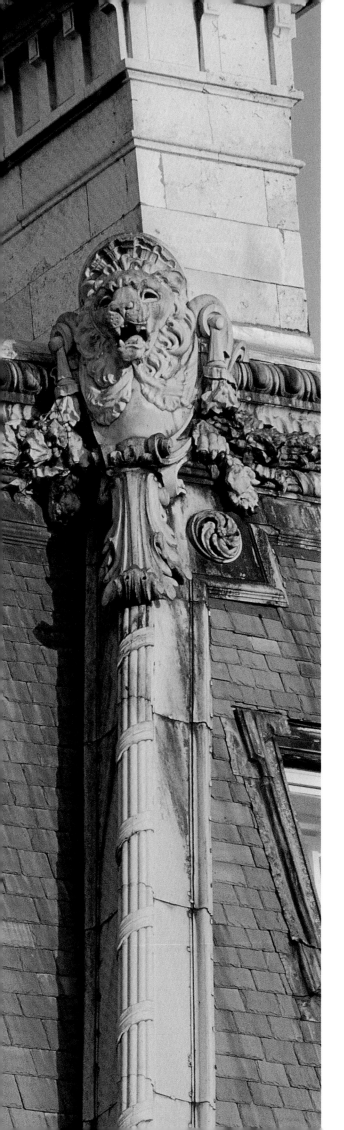

THE BUILDING OF THE RITZ

A grand hotel needs an imposing fashionable location where it can command the attention of every passer-by. The Savoy and the Cecil both stood on the Strand, with a spectacular view over the Thames to the south. The Imperial and the Russell both overlooked the spacious garden in the centre of Russell Square. Later Grosvenor House and the Dorchester were both to be built on Park Lane, looking out over Hyde Park. Other grand hotels built around the turn of the nineteenth century, the Carlton, the Piccadilly and the Waldorf, were all built on major thoroughfares.

In earlier centuries the prime positions along great streets had largely been taken by grand aristocratic mansions – Grosvenor House, Dorchester House and Londonderry House along Park Lane, Marlborough House, Clarence House and Lancaster House overlooking the Mall. Devonshire House, overlooking Green Park, stood almost opposite what is now the Ritz. Further along Piccadilly stood Burlington House, taken over for the Royal Academy in 1854, and Melbourne House of 1776 now fronting the apartments known as Albany.

Piccadilly became a fashionable shopping street towards the end of the eighteenth century. By 1788 the famous house of Fortnum and Mason's was supplying delicacies such as poultry and game in aspic, decorated lobsters and prawns, potted meats, hardboiled eggs in forcemeat (Scotch eggs), savoury patties and fresh and dried fruits. John Hatchard wrote in his diary on 30 June 1797, 'This day, by the grace of God, the good will of my friends and £5 in my pocket, I have opened my bookshop in Picadilly.'

The Ritz Hotel stands on the site of one of the most famous coaching inns in England, 'The Old White Horse Cellar', then No. 155. According to *A Picture of London*, printed in 1805, 'This house is well known to the public on account of the great number of stage coaches which regularly call there. In a pleasant coffee room passengers can wait for any of the stages and travellers in general are well accommodated with beds.' Later came the Bath Hotel and next to it the Walsingham, which opened in 1887. A sketch plan of the site in 1886 shows the Bath Hotel on the Arlington Street corner, with a coachbuilders shop (partly rebuilt in 1862) next door on Piccadilly, followed by a coal merchant's shop, stationers' shop and the Cockburn wine shop 'in old buildings'. The survival of such establishments in a street that by now included numerous aristocratic mansions and fashionable shops was due to one thing only – the narrow and awkward strip of land on which the properties stood, tapering to just 18 ft at the Green Park end. Rebuilding became a viable proposition only after the acquisition of a 66-ft strip of freehold land, backing on to Wimborne House. The old buildings were demolished in 1886 and Walsingham House was built by Lord Walsingham at enormous cost (£300,000 it was said). This was a red-brick block of chambers and hotel with twin entrances, each with its own glass shelter. Eight storeys high, it was a massive gabled and turreted composition, in the manner of the contemporary Hyde Park Hotel. The firm that was to build the London Ritz was a separate company from the Ritz Hotel Syndicate which had been responsible for the Paris hotel. It went under the unexpected name of the Blackpool Building & Vendor Co. Ltd, and in 1902 purchased the adjoining sites of the Walsingham House Hotel and the Bath Hotel.

PREVIOUS PAGE

Detail of the mansard roof, set back from the façade, showing the architects' window lights and decorative copper lion's heads.

The former Walsingham House (which opened as a hotel in 1887), demolished to make way for the construction of the Ritz.

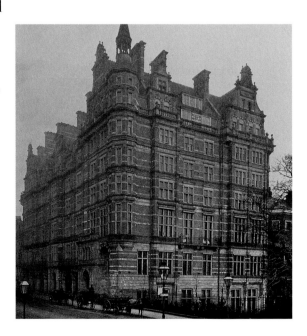

Mewès and Davis

The choice of architect for the London Ritz fell naturally on the Frenchman Charles Mewès (1860–1914). Mewès had worked brilliantly with César Ritz on his Paris hotel, and the result had been acclaimed a triumph on the basis of which Mewès's career had taken off. Mewès had been placed fourth in the prestigious competition for the Grand Palais and Petit Palais, erected on the Right Bank of the Seine for the 1900 Paris International Exhibition. To prepare the drawings he had taken on one of the brightest pupils at the Ecole des Beaux-Arts, Arthur Joseph Davis (1878–1951).

According to a Memoir in the *RIBA Journal*, Mewès was 'essentially a big man, both mentally and physically. He was a magnetic personality with a compelling influence tempered by a humorous and tolerant outlook on life'. He was also retiring, and his limited command of English led him to leave the talking to Davis when in England. As well as spending time quietly in the house in Inverness Terrace which he shared with Davis, he would assiduously visit museums and buildings of interest. He was also a great book lover and would spend hours at the shops of Maggs and Quaritch hunting for rare books for his library. He had inherited a small moated castle in Alsace where he would spend an annual holiday shooting, sketching and exploring the country around. Eventually, the heavy workload and constant travel took its toll on Mewès and he died after a major operation when he was only 54.

Davis was born in London but his father took the family to Brussels when he was a boy. From the age of ten he had shown an interest in architecture. In 1894 he entered the atelier of Godefroy, then passed into the Ecole in 1896 (fourth on the list in the competitive examination) as a pupil of Pascal, and completed the course in the unusually short time of three and a half years. He received numerous mentions and three medals – though as a foreigner he was precluded from competing for the school's major prizes such as the Prix de Rome.

Mewès had taken on a partner in Germany, A. Bischoff, to design hotels and other buildings in Cologne and Hamburg. For the Hamburg-Amerika line Mewès worked on ocean liners, including the *Imperator*, the

Vaterland and the *Bismarck*. He
set up the partnership in London
with Davis in 1900, when Davis
was just 22. Their first major
commission was to be the
remodelling of Luton Hoo in
Bedfordshire for Sir Julius
Wernher, Bt. Before that they
had taken over work at the new
Carlton Hotel, designed by
Henry Florence, which was then
nearing completion. Constance
Beerbohm provides a vivid
description of the Carlton in an
article entitled 'Where Society
Dines' in *The Woman at Home*
in 1905. 'The restaurant has an
atmosphere of gaiety which
infects the stranger on entering.
The style of decoration is the
Louis Seize, it is the most
charming of styles and best
calculated to harmonise with gala

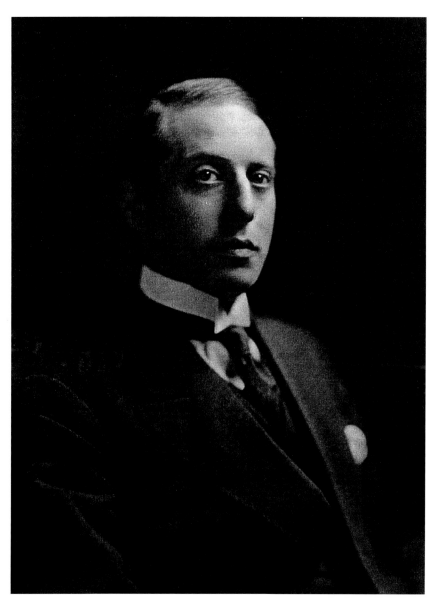

Arthur Davis (1878–1951),
joint architect of the Ritz
with Charles Mewès.

attire. The Palm Court, a big airy room, is all cream colour and pink
marble; the carpet is of a deep rose; the silken draperies are of faintest
coral.' (Intriguingly, this is very like the colour scheme adopted for
carpets and curtains in the recent redecoration of the Ritz Restaurant.)

The Carlton and the Ritz were just the first in a run of remarkably
handsome and accomplished buildings by Mewès & Davis, which include,
most notably, the RAC Club in Pall Mall and the *Morning Post* in the
Aldwych (the last recently transformed into a hotel). Following Mewès's
death in 1914, Davis turned from French to Italianate, beginning with the
magnificent Cunard Building on the Pierhead at Liverpool (1914–16),
positively Florentine in its monumentality, and continuing with a series
of the best buildings of the 1920s and 1930s to be found in the City of
London. These include the palatial Hudson's Bay Company Building in

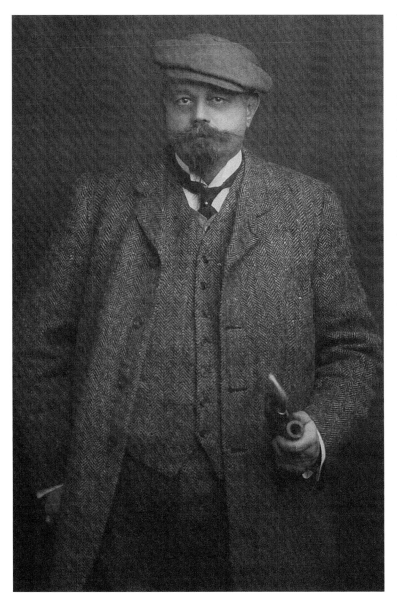

Charles Mewès (1860–1914), whose partnership with Arthur Davis began in 1900.

Bishopsgate and the exquisitely refined Westminster Bank in Threadneedle Street. In 1925, he also remodelled the restaurant of the Hyde Park Hotel. During the recession of the 1930s, he received more liner commissions, this time from Cunard, for interior work on the *Queen Mary*, the *Franconia* and *Laconia II*.

The historian Alastair Service gives a charming thumbnail sketch of Davis, provided by Mrs Margaret Lewis, who knew the architect well from about 1910. 'Davis was rather short, good-looking, something of a dandy and fastidiously neat. A traditional *bon viveur*, he liked conversation, parties and the company of elegant women. He was an expert on good food and wine. He could be devastatingly charming but his wit was stinging rather than humorous.' According to his daughter, Davis's circle of friends included the architects Albert Richardson, Edwin Lutyens and Oliver Hill; his closest friend was Herbert Austen Hall. Golf and watercolour painting were his chief recreations.

The roles of Mewès and Davis were often inseparable, but Davis, as the partner in London, clearly had a major role in developing building plans. The owners of the Carlton had warmly thanked Davis for his work in a letter of 10 July 1899, terminating his services at the end of the month on completion of the assignment, conveying 'the high appreciation which the Board feel in regard to the manner in which he has carried out his duties.' A letter just eight days later from the Carlton secretary tells Davis that the Board wishes to retain his services for a further three months and thereafter from 'month to month in order that you may supervise the completion of the works'.

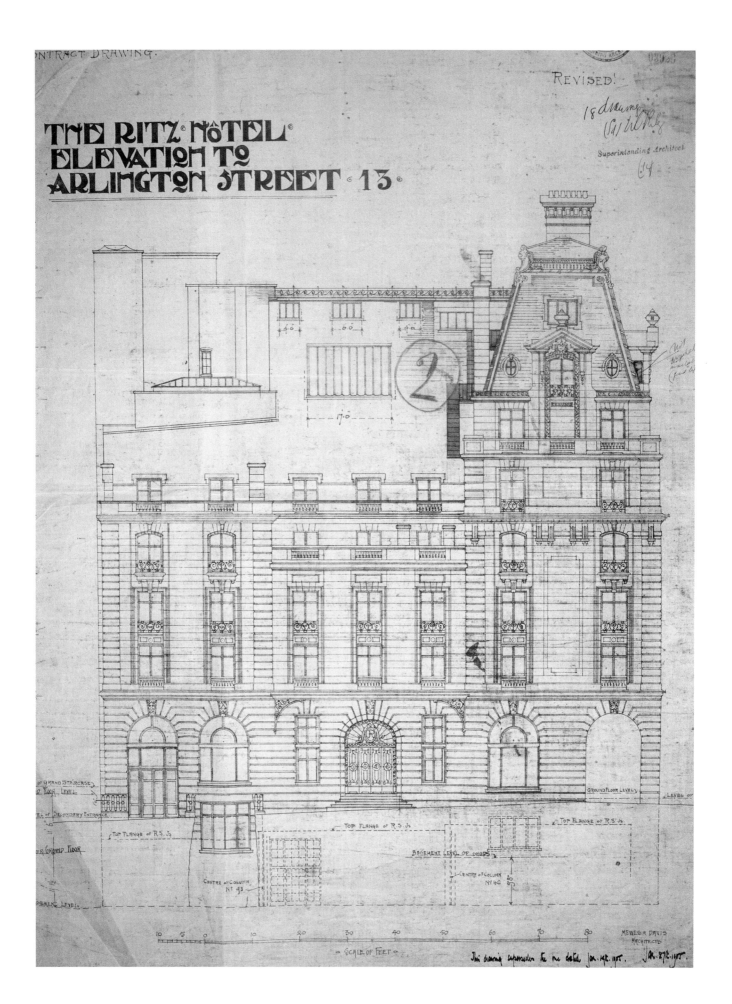

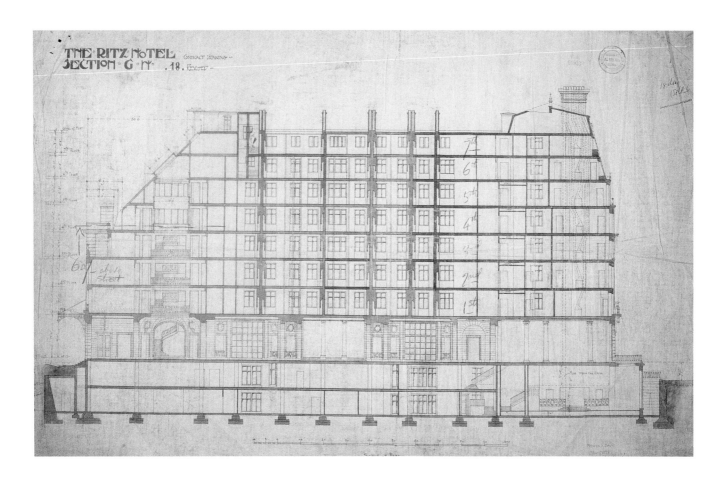

THE RITZ HOTEL *Contract Drawing* SECTION · G · Nº · 18 · *Revised* ·

Architects' drawings of
the east elevation (left)
and an east-west section,
showing the two basement
levels and the double-
height ground-floor public
areas, with six floors of
guest bedrooms and suites
above and staff
accommodation on the
seventh.

OVERLEAF

Preliminary ground-floor
plan (March 1904)
showing the principal
public spaces and the
Piccadilly arcade,
preserved in the archives
of Mewès & Davis
Architects Ltd, Plymouth.

The minutes of a meeting of the Managers of the Blackpool Building
& Vendor Company held at the company offices on 28 January 1903
report 'a discussion with Mr Mewès and Mr Davis', noting the fee agreed
was '5% of the estimated building costs of the new building with a further
2.5% on a 10% excess on the estimate to cover contingencies'. An initial
sum of £1,200 was to be paid as soon as the plans and working drawings
were complete.

Davis was extraordinarily painstaking in his preparation of designs.
A set of floor-plans and sections for the Ritz by Mewès & Davis survive in
the London Metropolitan Archives. Another much larger set of drawings
survive with the Mewès & Davis practice which today is based in
Plymouth. They evidently went to work quickly, for each of the floor-
plans in the main set in London is stamped 1903 – though some are also
inscribed with later dates (for example 'January 14, 1905'), presumably
those of submission for building regulation approval.

Curiously, only one plan is missing from the London set, that of the
all-important ground floor, the decoration of which was also supervised
by the architects. In the Plymouth office, however, there is a matching

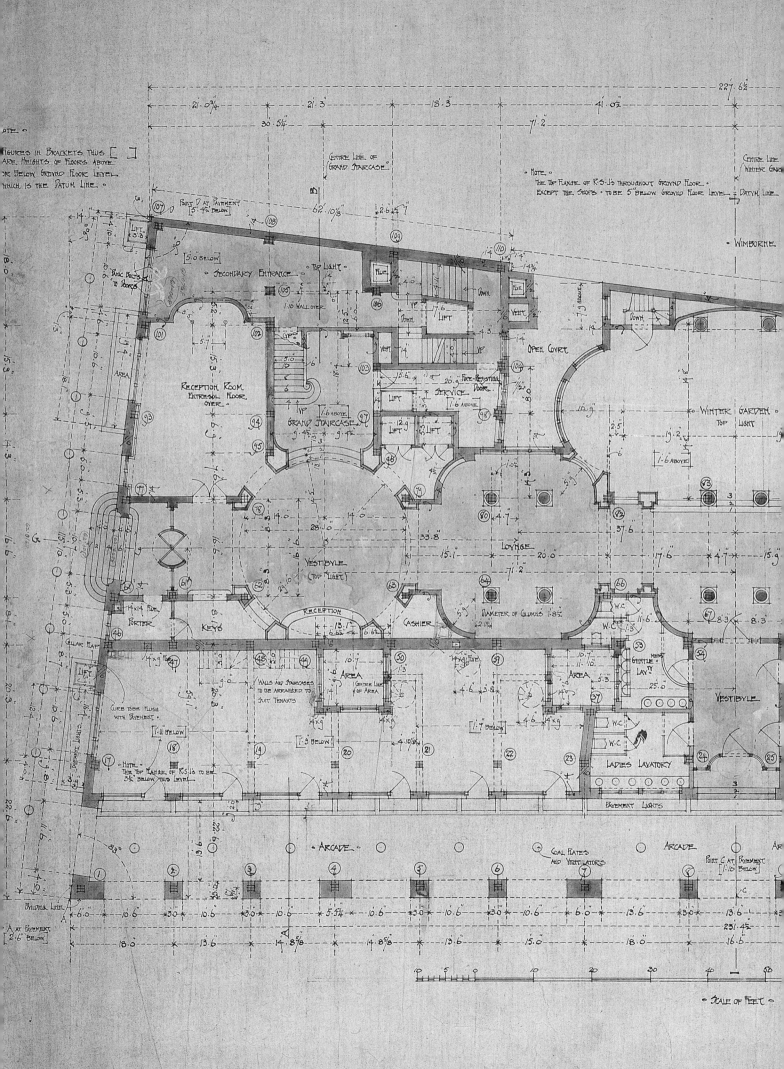

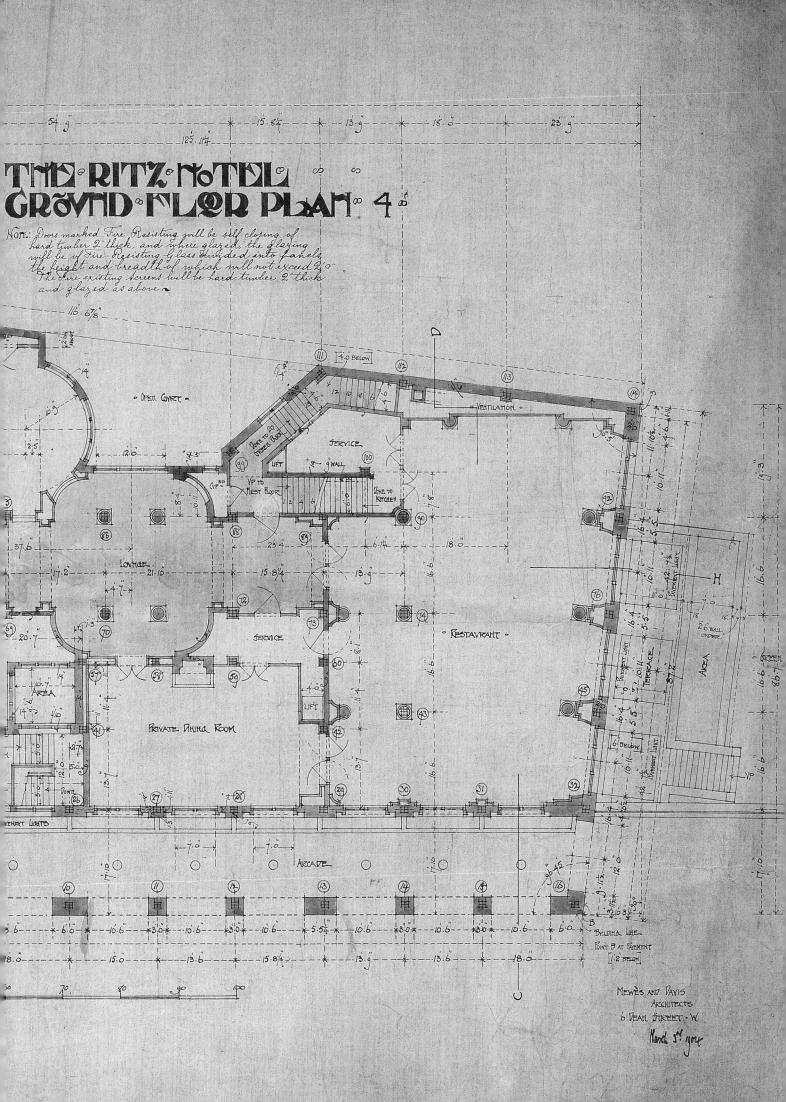

THE RITZ HOTEL
GROUND FLOOR PLAN 4

NOTE: Doors marked Fire-Resisting will be self closing of
hard timber 2" thick, and where glazed, the glazing
will be of Fire-Resisting Glass divided into panels,
the height and breadth of which will not exceed 2'0"
The fire existing screens will be hard timber 2" thick
and glazed as above.

OPEN COURT

SERVICE

LOUNGE

SERVICE

RESTAURANT

PRIVATE DINING ROOM

AREA

ARCADE

VENTILATION

AREA

TERRACE

BUILDING LINE
Point B at Pavement
[1.2 Below]

MEWÈS AND DAVIS
ARCHITECTS
6 DEAN STREET · W.

March 5th 1904

drawing from the same set, coloured in
the same way, which shows that the
layout of the main rooms went through an
important evolution. This plan shows the
Grand Gallery, the Winter Garden (now
the Palm Court) and the Restaurant in
the same configuration as they are today –
the one difference being that there are
groups of columns along the gallery
(presumably matching those at the
entrance to the Winter Garden), as well
as a colonnade on one side of the dining
room. The need for the columns may
not have been simply architectural, but
structural as well. The surviving plan
is dated 'March 3, 1904' and at this time
it appears that Mewès and Davis had
not yet envisaged the great circle of
chandeliers which is the delight of the

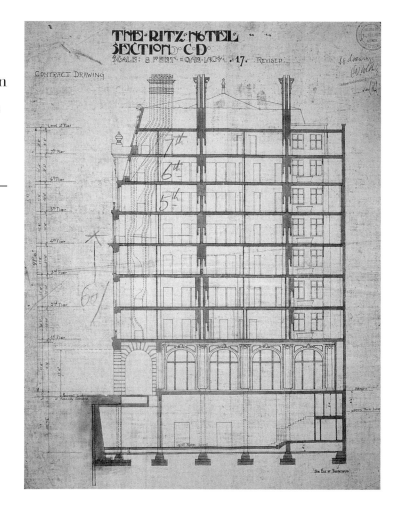

A north-south section
showing the Piccadilly
arcade with bedrooms
above and the system of
chimney flues rising to a
massive stack at roof level.

dining room today. The drawing does, however, show the arcade which
takes its inspiration, as was noted from the start, from the rue de Rivoli
in Paris. This was yet further evidence of the pro-French mood created
by the Entente Cordiale, for the arcades along the Quadrant in Regent
Street, intended to serve as a covered walk for the nobility and gentry on
rainy days, had been removed half a century before because they had
instead become 'a haunt for vice and immorality'.

The main purpose of the Ritz arcade was to win much needed extra
space for the bedrooms above. On another site the architects might have
introduced more modelling into the huge frontage – perhaps setting the
centre and the corner pavilions boldly forward, but here this was
impossible without losing valuable floor space on upper floors. Instead,
variety had to be created largely in the roofs, with projecting dormers and
ranks of soaring chimneys to break the skyline. The finest ornamental
details of all, the large green copper lions at the corners of the pavilion
roofs – the emblem of the hotel from the start – are set at the very top of
the building.

Detail of a preliminary
architects' design for the
south elevation of the
Winter Garden (now the
Palm Court), showing a
variant of the trelliswork
as finally executed; and
(below) an early sketch by
Davis for the south end of
the Restaurant, showing
the classical urns that he
originally intended for the
niches flanking the central
sculpture. Both from the
archives of Mewès & Davis
Architects Ltd, Plymouth.

By 1900 the use of Portland stone had become almost *de rigueur*
for major buildings in London. The Crown Commissioners, tired of the
problems caused by peeling stucco in Regent Street, demanded Portland
stone on all new buildings on their central London estate. The Ritz
followed suit with one difference – the ground floor is faced in massive
blocks of grey Norwegian granite, so closely matched in colour that the
difference is not immediately obvious.

The highest praise for the Ritz came from Professor Charles Reilly,
who – writing in the magazine *Building* in 1929 – still considered it 'the
finest modern structure' in the street, 'with all our modern feeling for
mass effect' and 'a refinement of detail and articulation, an elegance of
general form' which more recent buildings did not possess. 'There is a
graciousness about the Ritz hotel,' he wrote, 'with its beautifully modelled
roofs and dormers with which the square setbacks of Devonshire House
and its allies [on the opposite side of Piccadilly] cannot compete.'

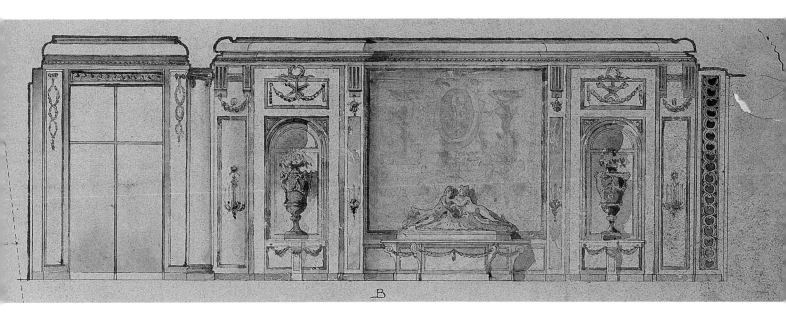

Planning in the Grand Manner

The great suite of ground-floor rooms at the Ritz is one of the all-time masterpieces of hotel architecture. Here is a parade of spaces with the nobility of a succession of state apartments in a royal palace – grand vistas, lofty proportions and sparkling chandeliers. The design for the hotel is a brilliant marriage of Ritz's own formula for a grand yet intimate interior and the Beaux-Arts training of both Mewès and Davis. Beaux-Arts architects relished the play of unusual shapes – circles, octagons and ovals – in a ground plan, and the London Ritz has all of these. As leading motifs, it has two especially French features – the grand axis and the framed vista. Mewès & Davis had seized the opportunity offered by the steel frame to create an open layout that runs the length of the hotel from the Arlington Street entrance to the Restaurant overlooking Green Park.

A grand enfilade – with double doors lined up in a continuous row – had long been a feature of palaces and great houses. Here the architects dispense with doors and walls between different spaces – and more than this, open up spaces to the side – first the staircase, then the Palm Court. Diagonal views multiply the sense of space most ingeniously. Some look through to the Palm Court, while others are filled with mirrors merely creating the illusion of space. It is a brilliant device, artfully enlarging what for the architects was a desperately shallow plot for such a major building. They turned the problem to advantage, however. Guests arriving for lunch, tea or dinner could come in through the Piccadilly entrance into the centre of the hotel, while those arriving to stay could use the Arlington Street entrance, where their luggage would be taken by a porter; they could then continue to the reception desk immediately on the right inside.

One of the showpiece features that neo-classical architects liked to introduce in their plans was a tribune – a circular double-height space overlooked by a balcony at first-floor level – and sometimes from higher levels too. Davis introduces this immediately inside the Arlington Street entrance: three tiers of iron-railed galleries – the landings of the bedroom floors, looking down to the central vestibule and surmounted by a glass dome letting natural light deep into the hotel.

OPPOSITE

The grand sweep of the main staircase seen from the vestibule.

OVERLEAF

Part of the sitting area in the Grand Gallery close to the Restaurant entrance.

30

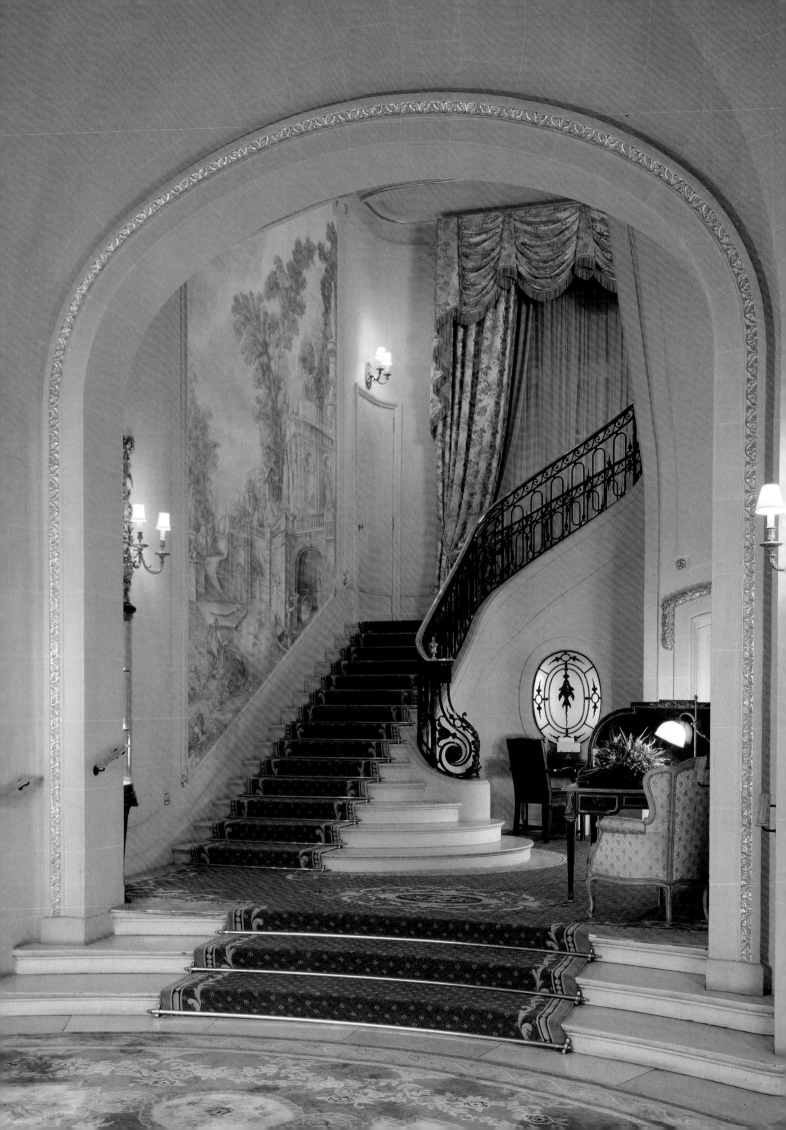

The main staircase descends in a grand sweep directly into the hotel vestibule. It corresponds precisely with César Ritz's direction given in 1912 to the promoters of the Ritz-Carlton in Montreal that a curving stair should allow ladies to make a dramatic entrance and show off their gowns to best effect. By placing the principal staircase and adjoining lifts at one end, the architects also ensured that each successive floor was self-contained and could, if desired, be closed off while the staircase remained in use.

The architects' problem was compounded by the irregularity of the site – tapering from the Arlington Street end towards Green Park. (The Arlington Street frontage was about 115 ft, compared to the 87 ft at the Green Park end.) Davis concealed this with brilliant perspective effects. His Grand Gallery is parallel with Piccadilly, and the use of curving walls cleverly conceals the rapidly diminishing space at the back of the hotel.

The chaste French classical style followed throughout the hotel was the choice of the architects. Marie-Louise wrote: 'Mewès, this time, thought it would be immensely interesting to do the hotel in one style, rigorously keeping it in decoration and furnishings throughout in the period of Louis Seize.' One of the great features of the Louis Seize style, and indeed the whole of French classicism, is to treat the entrance hall as if it was part of the external architecture of the house rather than the internal decoration. Both halls and staircases are often faced in beautifully cut and carved stone. In the later nineteenth century the fashion was more often to employ stucco imitating stone. The best-quality stucco has the texture of stone and the illusion of white mortar joints between each block. Another great feature of Louis Seize interiors is the magnificent ironwork – staircase balustrades, balcony fronts and window grilles.

Credit for the superb quality of the interiors is also due to the well-known firm of Waring & Gillow, 'the general contractors – the Chef d'Orchestre – for the entire scheme

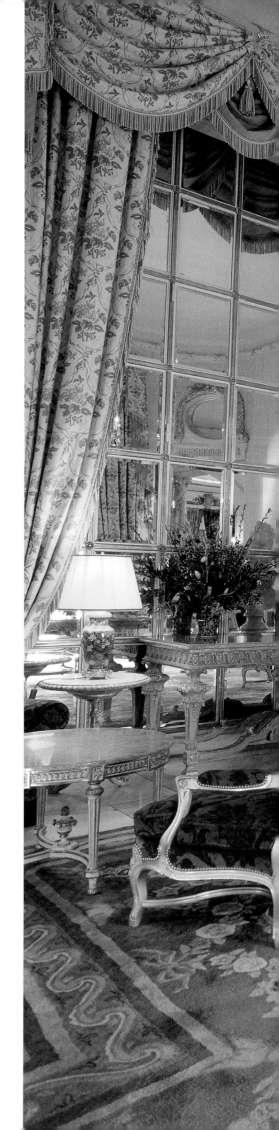

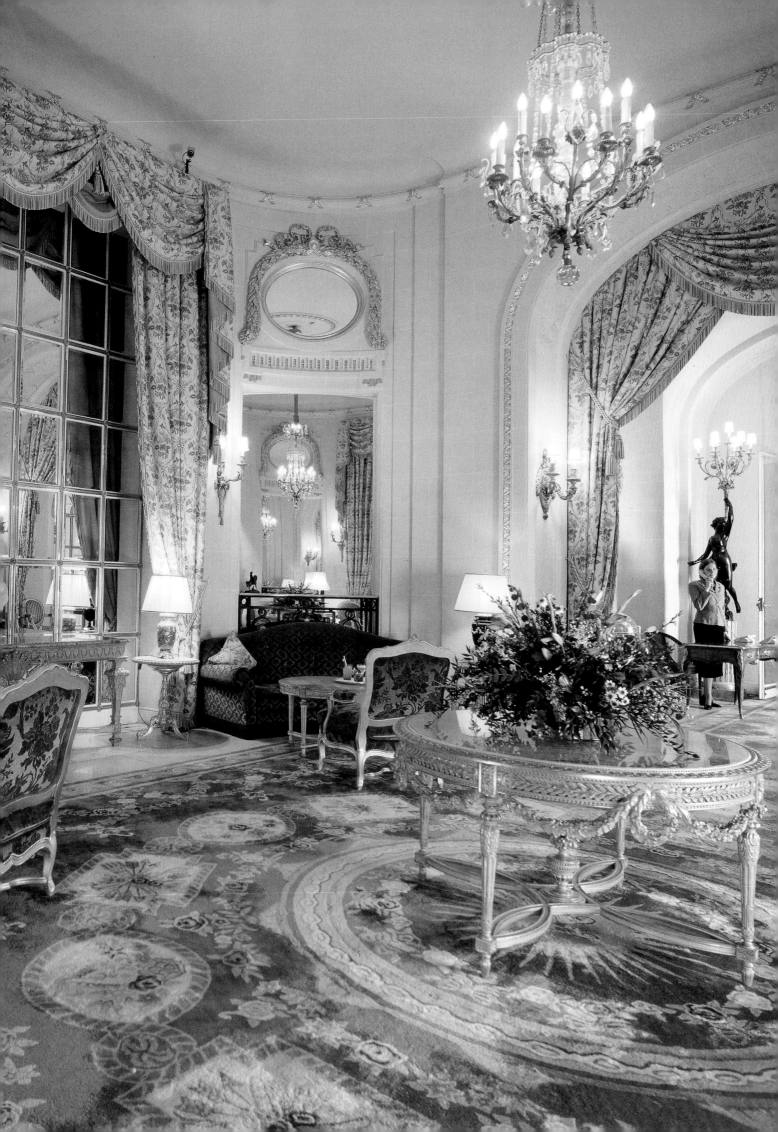

in decorating and furnishing', according to the *Ritz Monthly* (a journal then published jointly by the London and Paris hotels). Waring & Gillow had showrooms in both Paris and London. They had overtaken Maples in prestige and, a fortnight after the Ritz opened on 26 May 1906, they had an even grander opening of their magnificent new store in Oxford Street, with 150 fully furnished specimen rooms in English and French styles, ranging from the parlour of a weekend cottage to luxurious Louis Seize salons and banqueting rooms. A delightful illustrated companion to London, *The Savoyard*, published at the time records the fact that the German Emperor had visited the Wallace Collection and Waring & Gillow's on the same day and that Queen Alexandra had paid several visits to the store. Here was an unsurpassed display of Oriental and British carpets, departments for china, glass and linen, an unrivalled stock of furnishing fabrics, silverware and pianofortes. So confident was the firm of its ascendancy that in the opening week not an item was for sale, not an order could be placed. More than half a million visitors passed through the doors in a single week.

The three tiers of galleries above the vestibule, each providing access to one of bedroom floors from the main staircase; a domed skylight surmounts the circular well.

BELOW

One of the ornately embellished lunettes in the Grand Gallery.

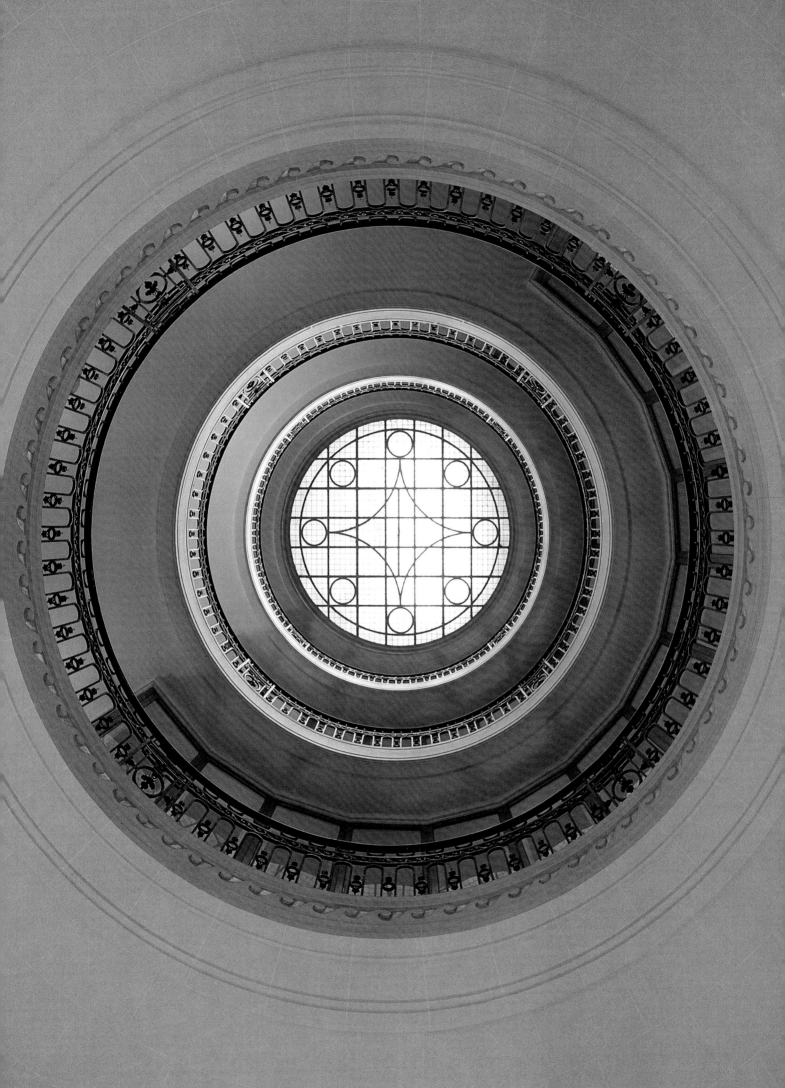

The Palm Court

One of the most attractive features of the French eighteenth-century garden was the imaginative use of trellis. It was used for archways, for pergolas, even to create complete pavilions and arbours. Or it was used in town gardens to cover up bare walls and create an illusion of space. Mewès & Davis used it to lend enchantment to what was originally called the Winter Garden. This was a standard feature of grand hotels at the turn of the century, and indeed of many town houses, particularly in Paris and Brussels. In essence it was the equivalent of the modern conservatory, with *jardinières* for plants, abundant glass to take advantage of winter sun and radiators to keep it warm.

At the Ritz, the Winter Garden was designed to fill the view of everyone who came through the Piccadilly entrance. Seen head-on, it looks almost like a stage-set perfectly framed by steps and widely spaced columns. Much of the charm of the space comes from the very French use of curves, rounded ends, oval *œil-de-bœuf* windows and a deeply coved cornice. Originally a large window at each end (presumably filled with opaque glass) admitted daylight from two lightwells which descend to the kitchen, but these were replaced with mirrors sometime soon after 1972, when the courtyards were filled in to create new service areas.

These replacements match the mirrors on each side of the central niche, which from the start were divided into twenty panels of bevelled glass framed in gilt bronze. Today daylight still comes through the central glazed rooflight, but artificial lighting provides a boost on a dull day and ensures that the glass does not go dark at night.

Once again Davis triumphs with his inventive detail. The trellis painted in gold has a wonderful sheen;

OPPOSITE

The Palm Court transformed for the Christmas-New Year period by seasonal decorations.

BELOW

Sketch of the Palm Court by John Reynolds, published in *The Bystander*, 23 October 1934.

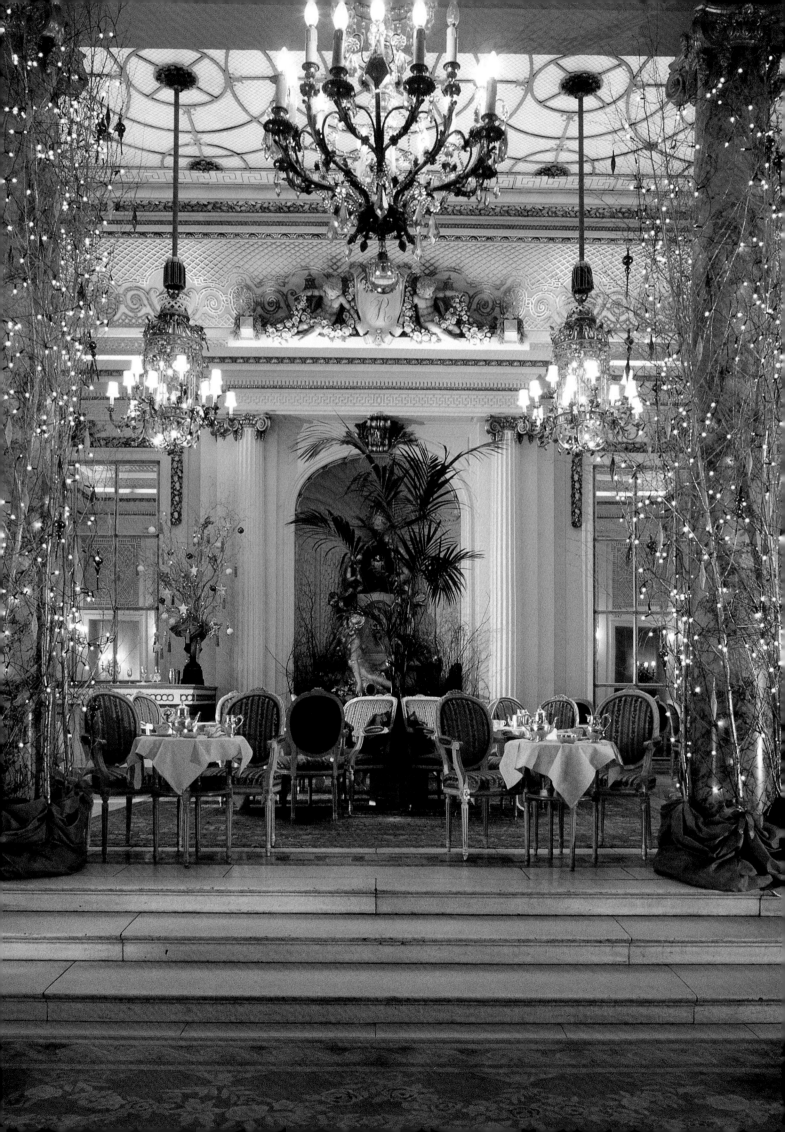

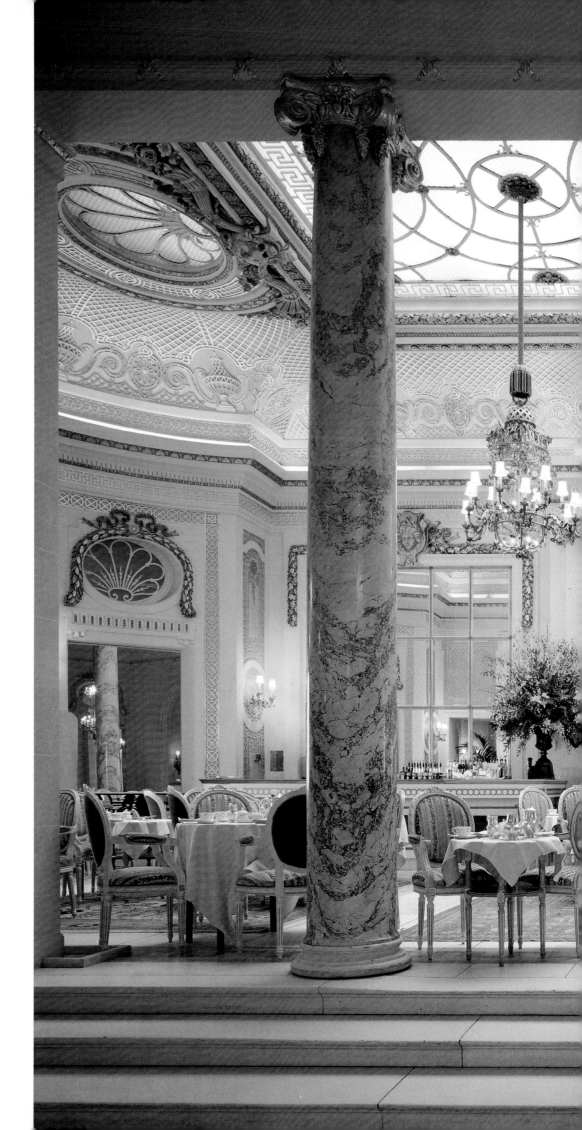

The Palm Court with tables set for afternoon tea.

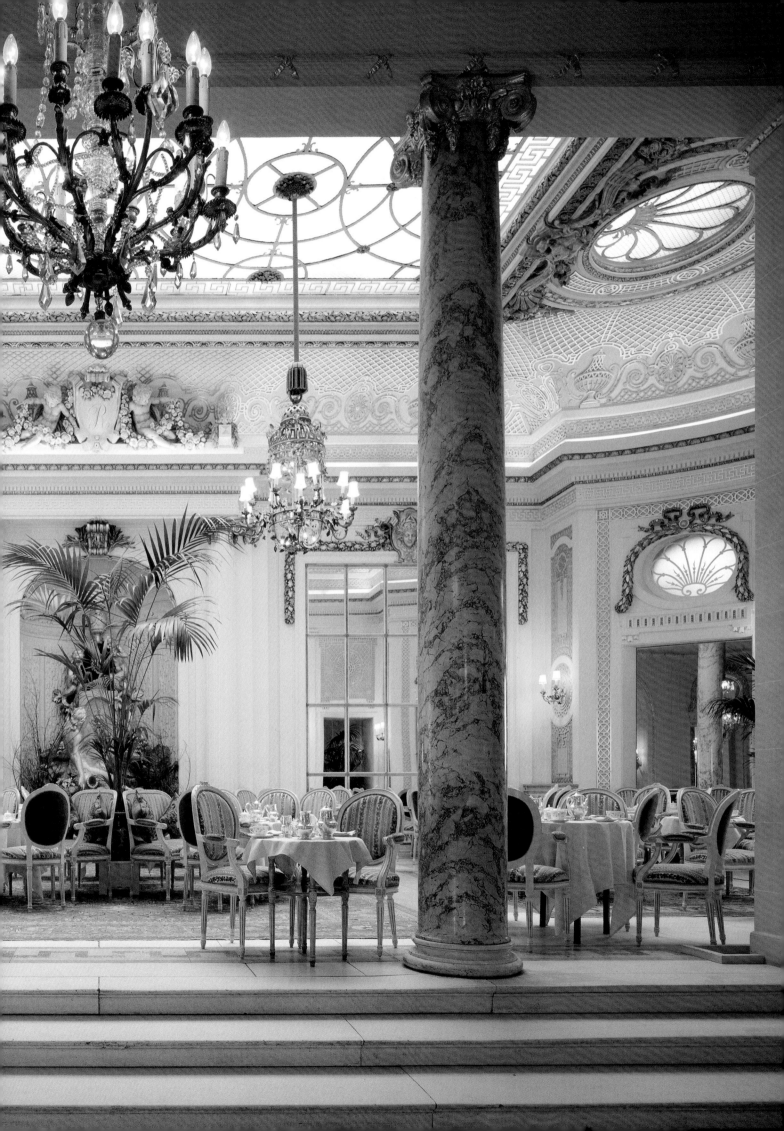

Artists' impressions of the
Palm Court (Winter Garden),
c. 1906:

RIGHT AND OPPOSITE
Designs for murals at the Ritz
by Philip Core.

BELOW
A winter social event depicted
by Peter Miller.

OVERLEAF

Decorative details in the
Palm Court, and table
settings with original
silverware supplied by
Christofle & Cie.

it is composed almost entirely of simple geometric motifs – the interlocking circles known as a guilloche, a Greek key fret, squares, diamonds and circles, varied at points by elements shown in perspective like the urns and the diminishing trellis in the cove.

The pair of hanging wrought-iron lamps are treated like large birdcages, entwined with painted metal flowers – a motif repeated in the wall lights. In the central niche is a sculpture originally called *La Source* after an etching by Hutin, where water trickled soothingly from a small barrel. The *Ritz Monthly* describes how 'she is looking at the tritons on the rocks above her, who support the armorial bearings of the Ritz Hotel while blowing into conches.' The female figure is in gilded lead, following eighteenth-century practice. Above the cornice are two putti garlanded with roses. Other rich motifs are the lion's skins on the ceiling and the two shell windows flanking the central rooflight.

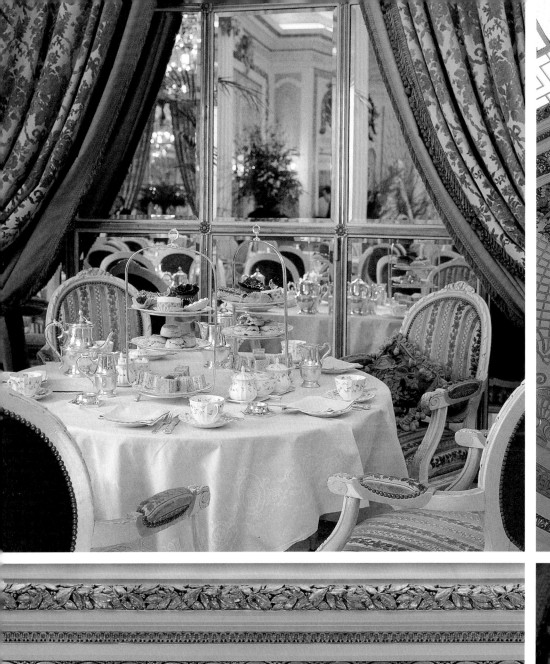

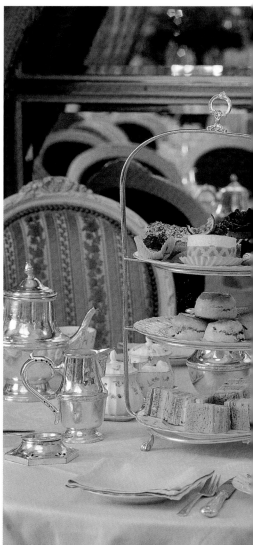

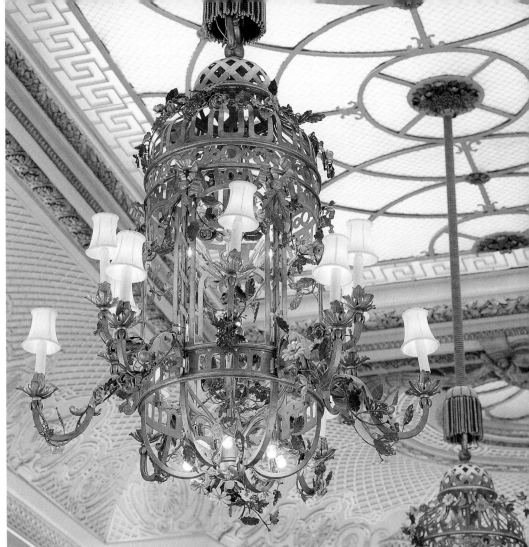

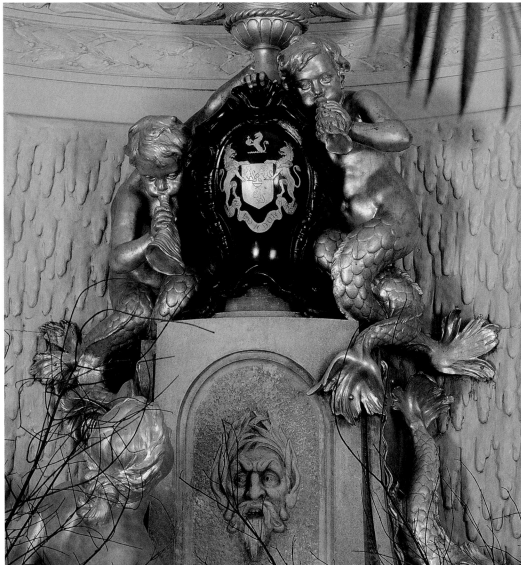

The Restaurant

The Ritz Restaurant is not only one of the most beautiful interiors in London, it can be claimed as the most beautiful hotel restaurant in the world. Davis's genius lay in creating a room that is as ravishing by night as by day, that is at once grand and intimate, ornate yet restful to the eye. The first great motif is the circle of chandeliers which creates the feeling of a room permanently *en fête*. 'Such quantities of bronze I never heard of', Ritz said laughingly to his wife. 'Bronze chandeliers, and even bronze garlands between the chandeliers. Lucky the hotel is steel built or the walls would collapse with the weight of all that bronze.'

The *Ritz Monthly* and other contemporary sources state that the idea for the ring of chandeliers came from a print after Augustin de Saint-Aubin, *Le Bal Paré*. 'As in that picture, these sixteen lustres are joined together by exquisite garlands of flowers in gilt bronze', says the *Ritz Monthly*. These sixteen lustres, alternately large and small, are shown in the photographs taken by Bedford Lemere in 1906 (as well as in the contemporary view in the *Illustrated London News*), and, although the smaller chandeliers have long vanished, the effect is still so rich that their loss is hardly noticeable. The eighteenth-century print shows a room with five festive chandeliers but none of the distinctive garlands between them. The most likely source of inspiration (and Mewès & Davis took pride in basing detail on authentic sources) is another print, *Le Festin Royal* by Moreau le Jeune, showing a *fête* given by the City of Paris for the King and Queen on 21 January 1782 on the occasion of the birth of the Dauphin.

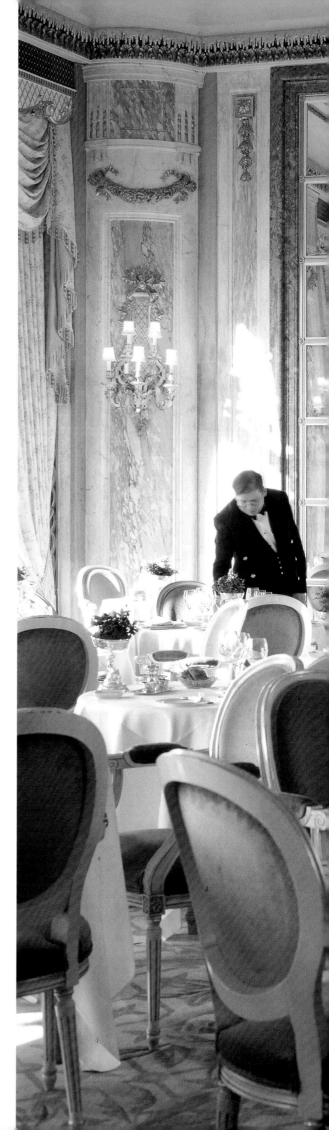

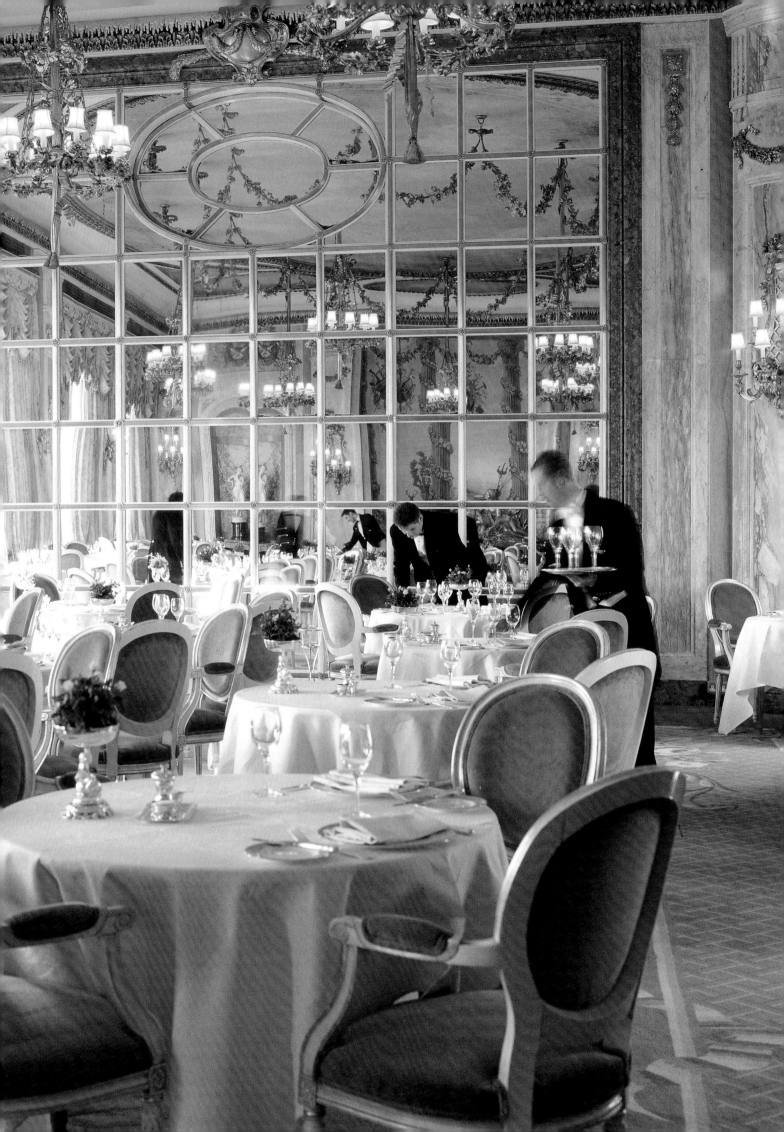

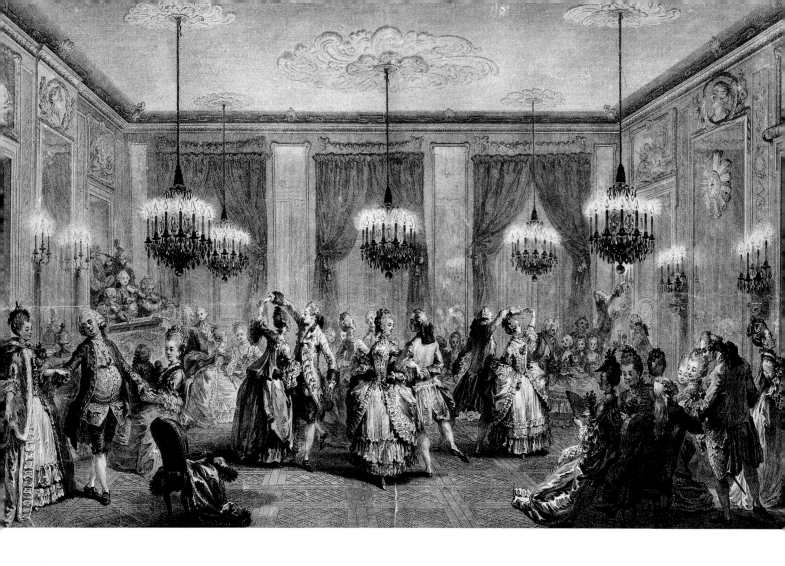

Eighteenth-century sources
of inspiration for the decor
of the Restaurant: (above)
Le Bal Paré, after Augustin
de Saint-Aubin, showing
ornate chandeliers; (left)
a buffet in the house of
M. Thevenin in Paris;
(right) *Le Festin Royal* by
Moreau le Jeune, featuring
a series of chandeliers
linked by garlands.

OVERLEAF

The magnificent painted
ceiling in the Restaurant,
with the circle of eight
chandeliers linked by
garlands.

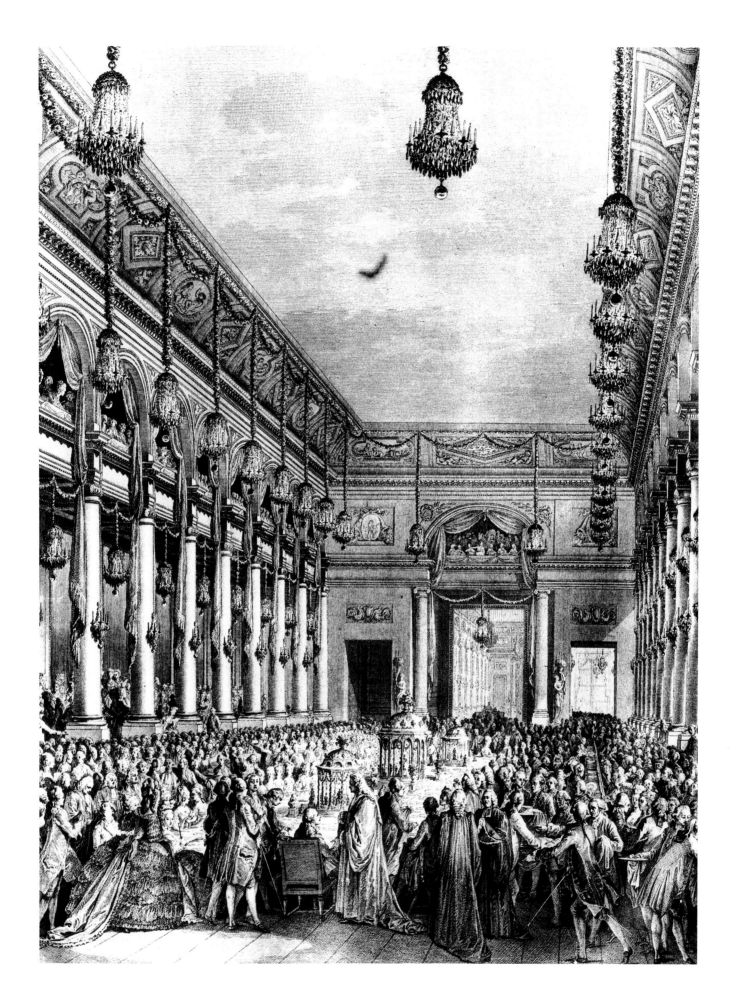

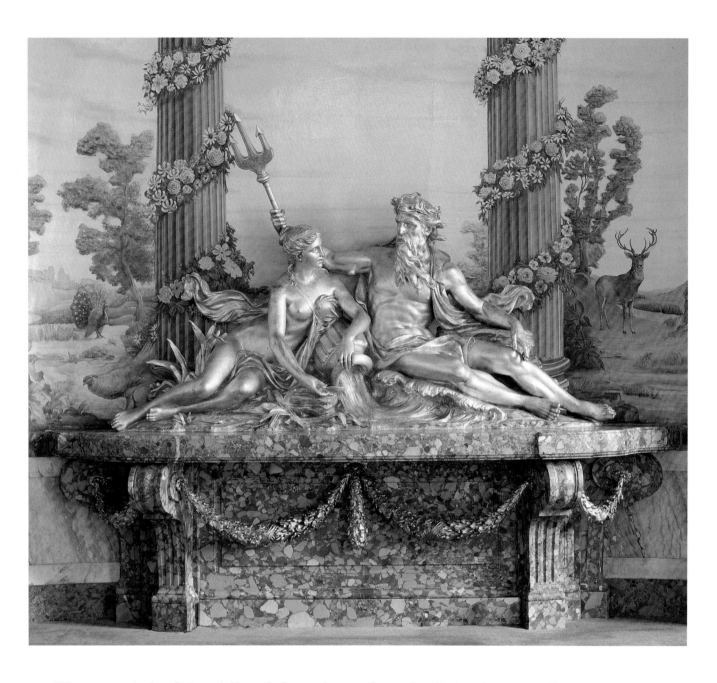

The great circle of chandeliers deflects the eye from the distinctly irregular shape of the room, which is neither perfectly symmetrical nor an exact rectangle as might be expected. Instead it tapers sharply towards the northern end. You do not even enter on axis – facing the centre of the room – but to one side. Such problems the architects simply turned to good effect. Davis used the techniques of the theatre designer. Immediately inside the room a pair of columns is introduced to frame the view, hence you are looking not at the whole room but only a portion of it.

During the years around 1900 architects sought to create a total decorative effect, designing and controlling every aspect of an interior. Davis first of all made ravishing use of colour. Here the marble is as rich

The gilded life-size figures of 'The Thames and the Ocean', with marble buffet below, at the south end of the Restaurant; see also p. 59.

OPPOSITE

Details of the gilt capitals and other ornamental features of the lavish decor.

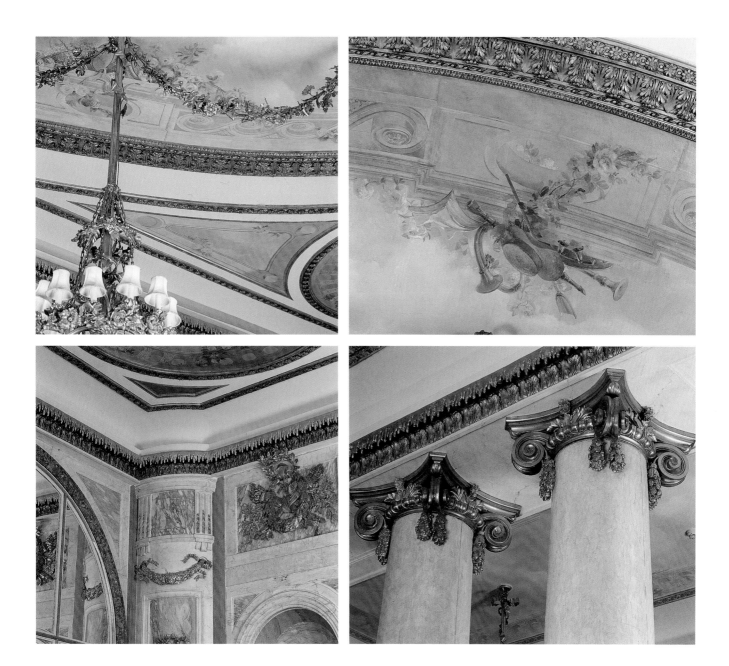

One of the two white
marble statues flanked by
pink-veined marble panels
and two of the twelve
elaborate bronze wall-lights.

The west-facing Restaurant
in early afternoon, with
sunlight catching the
shimmering silks of the
inner curtains.

and varied as in the famous Staircase of the Ambassadors at Versailles
but, as befitted a gayer age, much paler and prettier – a pale veined white,
a soft pink and strips of pale green. To achieve colours of this lightness in
the eighteenth century, resort would have been made to scagliola – a form
of marbling that felt and looked like real marble to the touch and could
be created in any colour or hue. Here only the two pink columns at the
entrance are of scagliola – no quarry could have yielded two such perfect
shafts of pale marble. Then comes the trim: polished bronze bases to each
column and answering flat pilaster, gilt capitals with garlands.

According to the *Ritz Monthly*, the pink marble is a Norwegian '*brèche
d'Alep*' and 'a veined statuary marble' – the second statuary Carrara

marble which contrasts with the pure white first statuary marble used for sculpture. More elaborate gilt-bronze panels are set on the walls above the niches with trophies of torches and arrows surmounted by crowns. The twelve bronze wall-lights ('worthy of a Reissner or a Gouthière', says the *Ritz Monthly*) are among the most elaborate in the hotel, with five lights springing from a lattice shield.

At the end of the room is a handsome sculpture of life-size figures in gilded lead, 'The Thames and the Ocean'; despite the trident, the allegorical figure does not represent Neptune, as is sometimes thought. The buffet below, in more *brèche d'Alep* marble (darker and richer in colour), is said to be 'an adaptation in Louis Seize style of the celebrated Buffet of Mansart'.

The architect's genius lay in his constant variation of detail: two corners are drum-shaped, two are angled. The cornice is not a true classical one but a molten dripping version suggestive of stalactites. This, too, was a later refinement. A pretty watercolour by Davis for the south end of the Restaurant shows a more conventional gilt cornice and more extensive use of white marble, without the green which so beautifully sets off the pink; it also shows two splendid urns – of grey marble with gilt-bronze mounts – in the place where the white marble statues stand today. The three console tables in deep-red marble are shown as white.

The great game at all times of day is with light. The windows face west, but their size ensures that even at breakfast the interior picks up the brightness of the morning light. Shortly after midday, even on a fine winter's day, the sun's rays begin to slant through the windows and play on the marbles. Later the light streams in through the windows (early photographs show a retractable awning outside), illuminating the coral-pink inner curtains to dazzling effect. This is an effect we will rarely see again in great houses where it is everywhere ordained that fabrics must be protected from direct sunlight. At the Ritz, however, where

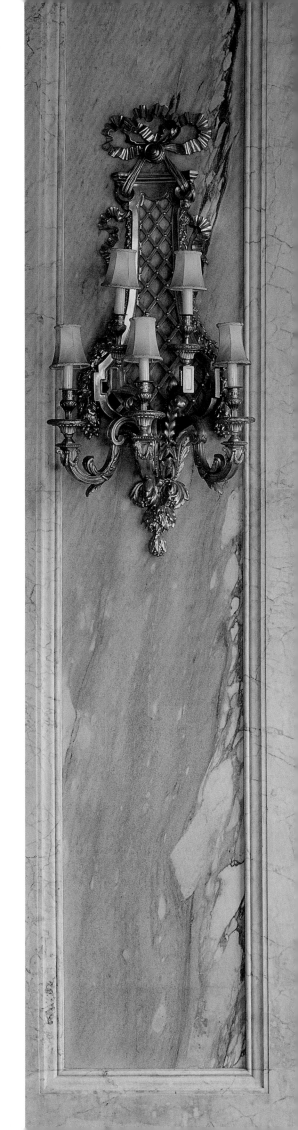

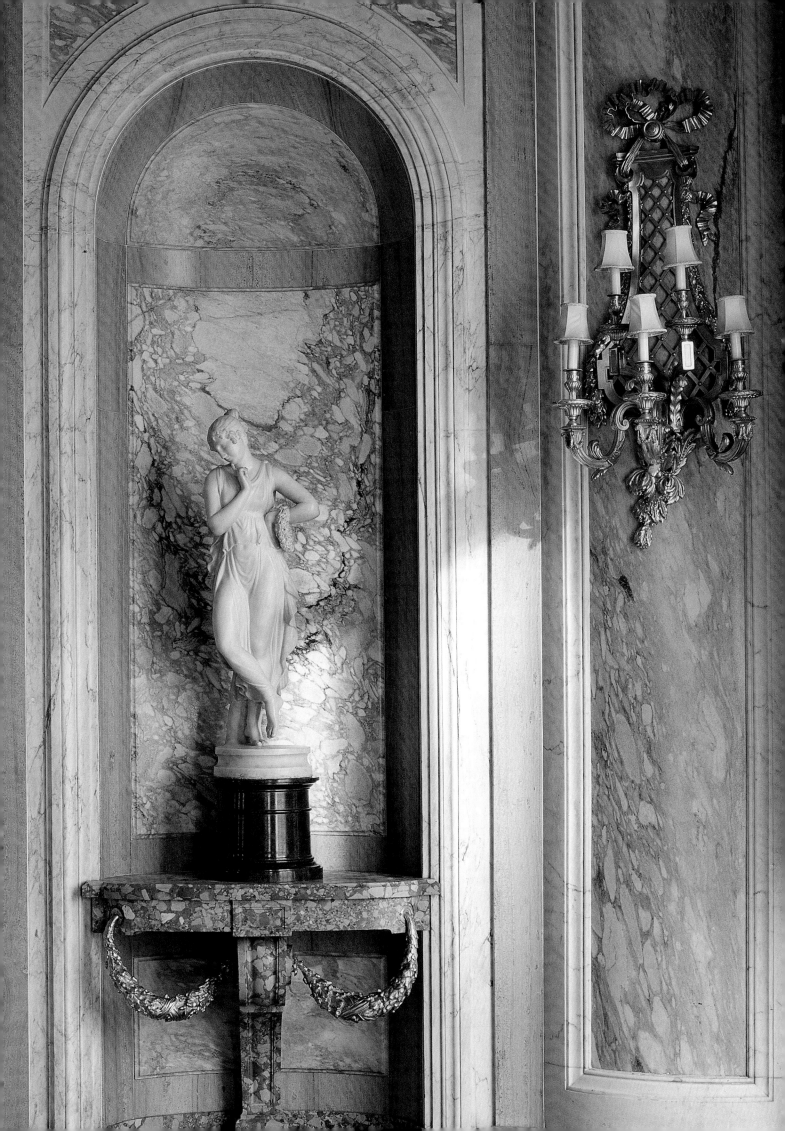

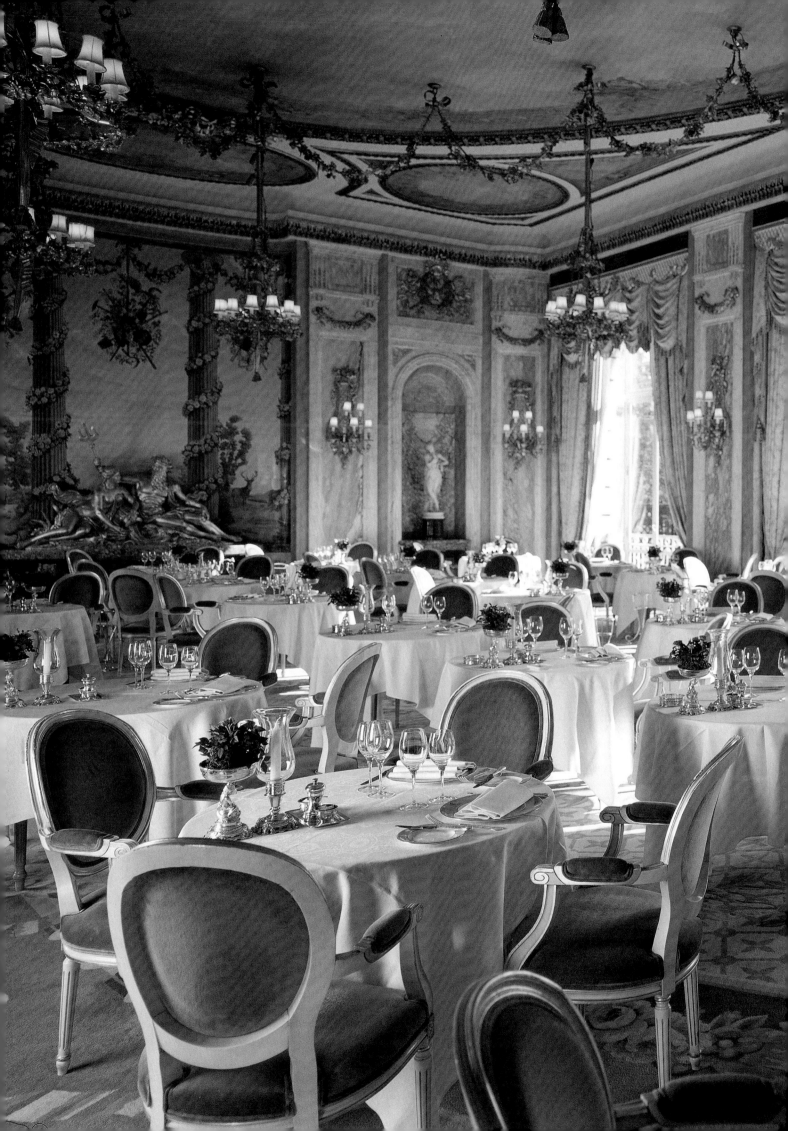

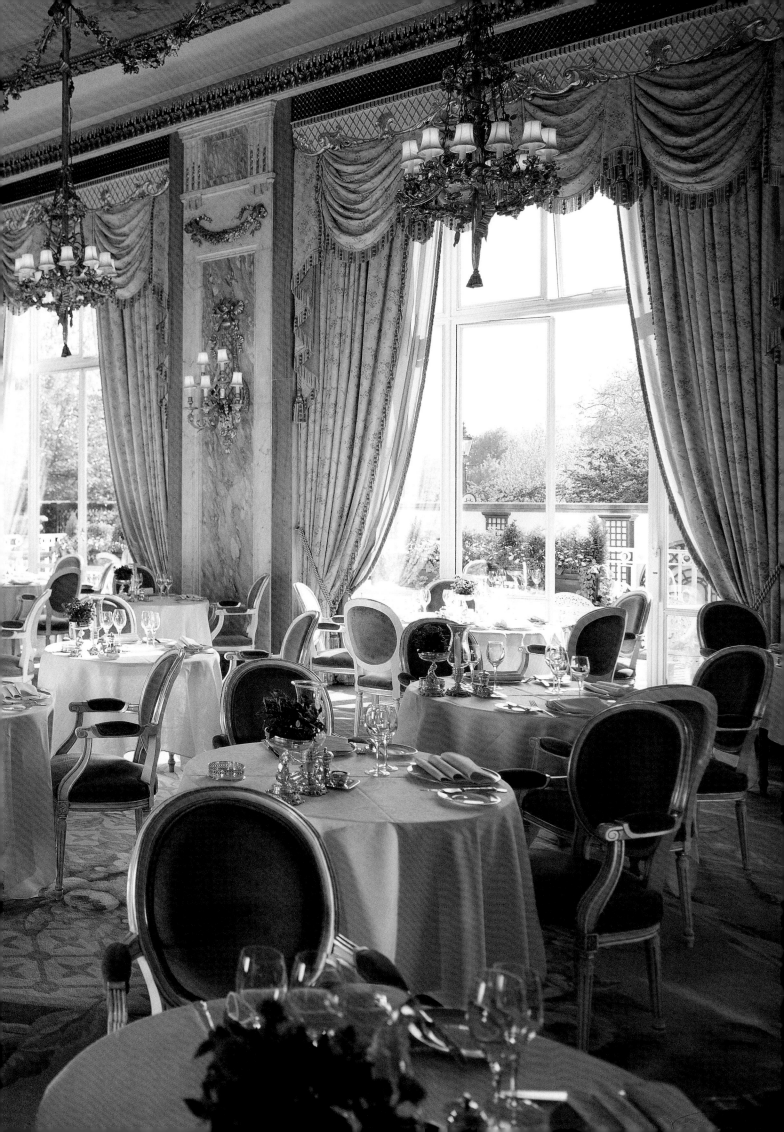

the Restaurant is in use every day of the year, there is no hesitation in creating such dazzling effects.

The architects show their mastery of perspective effects still more by the use of mirrors. The north wall (against the Piccadilly arcade) is filled with one vast mirror divided into panes like windows. Here, Davis has introduced a large oval at the top, set back so that ventilation grilles could be introduced at the sides. Further floor-to-ceiling mirrors are placed on the three walls of the entrance recess, multiplying the sense of space.

To ensure sparkle in winter, the chandeliers and wall-lights remain lit during the day. At night the palette is transformed, particularly when the candles are lit and the lights dimmed. Though dozens, or rather hundreds, of electric bulbs are in use, the effect is of candlelight, best appreciated when the chandeliers are seen reflected, like circles of night-lights afloat on a lake, in the wall-mirror.

OPPOSITE

The carver, Giuseppe Zanré, relishing the task of serving the lunchtime roast at the table.

LEFT

The terrace at the Green Park end of the hotel, seen from one of the Restaurant windows.

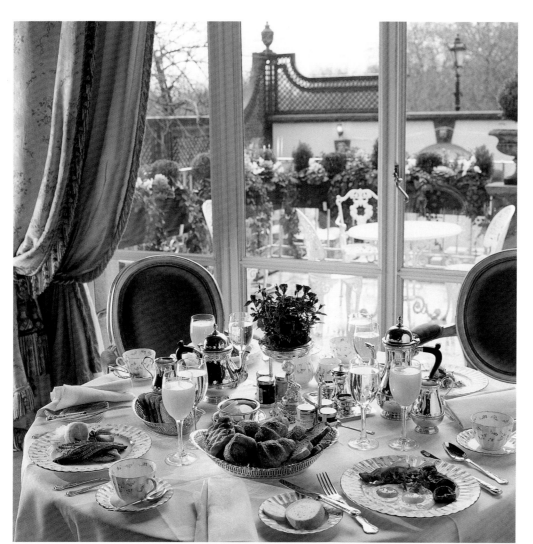

OVERLEAF

The floor-to-ceiling panelled mirror on the north wall of the Restaurant produces a lively effect and a sense of extra space, reflecting both the sparkle of the chandeliers and the individual table lights.

FOLLOWING PAGES

'The Thames and the Ocean' presiding over the dining room.

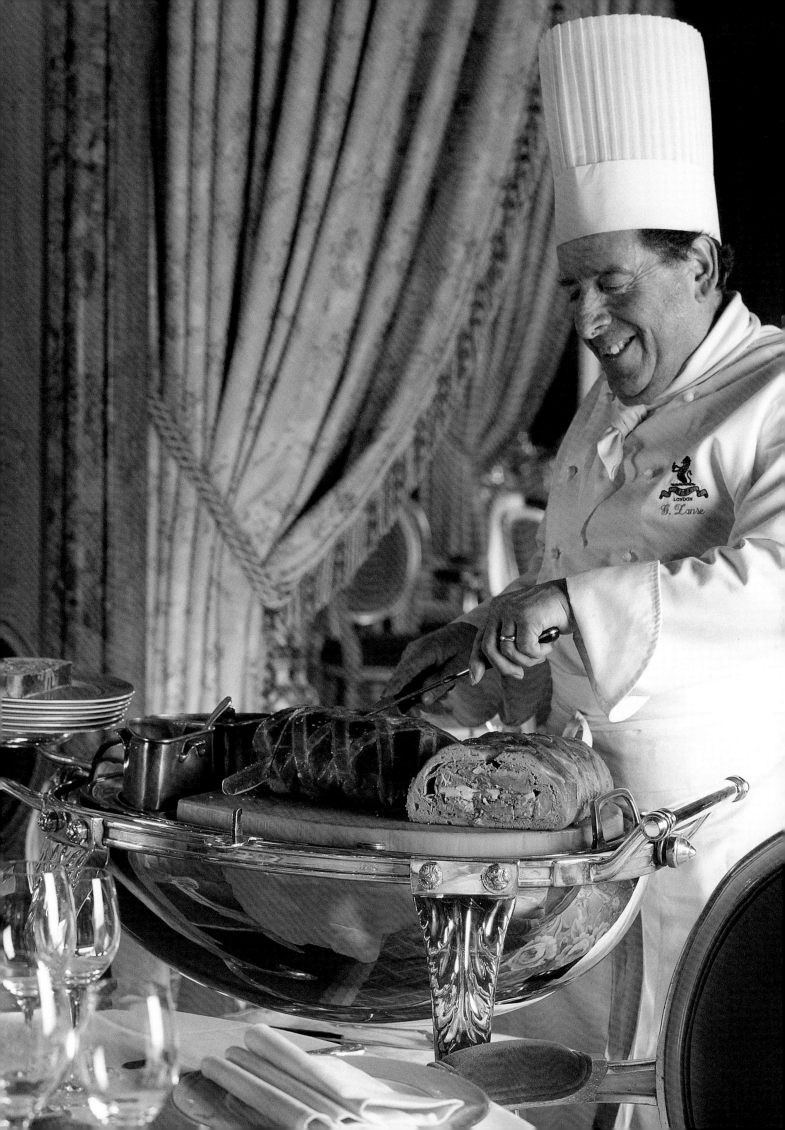

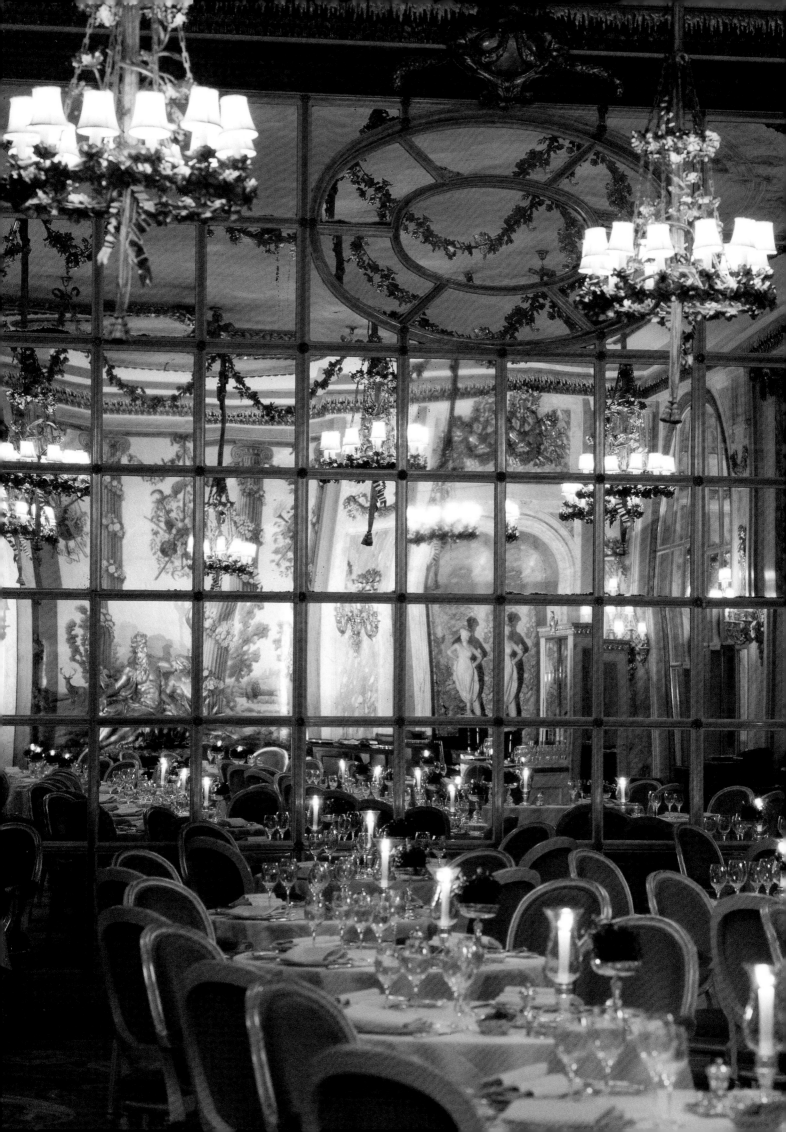

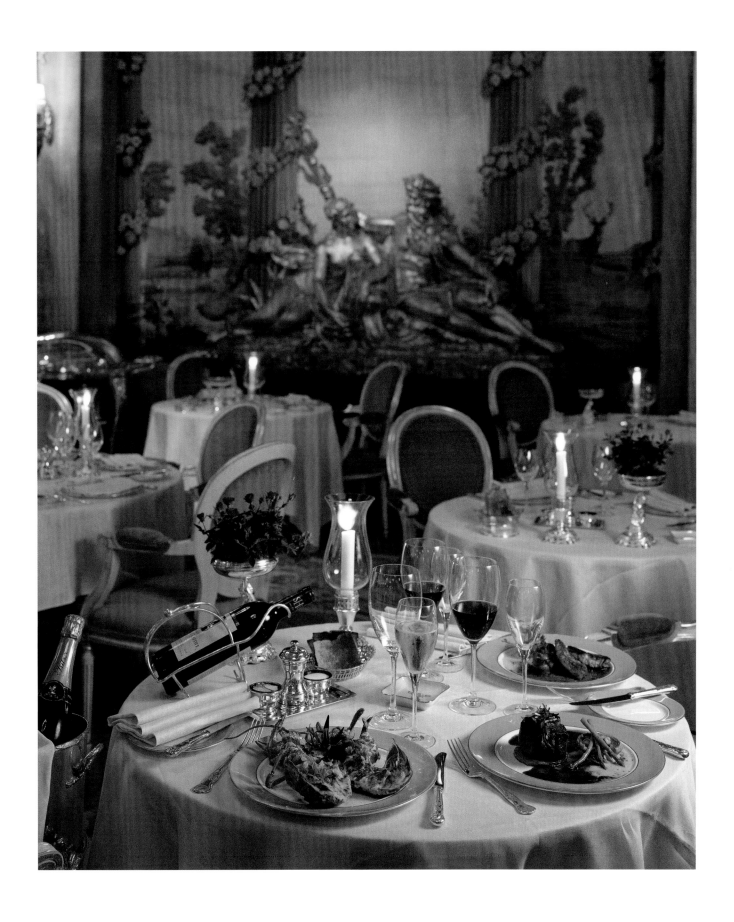

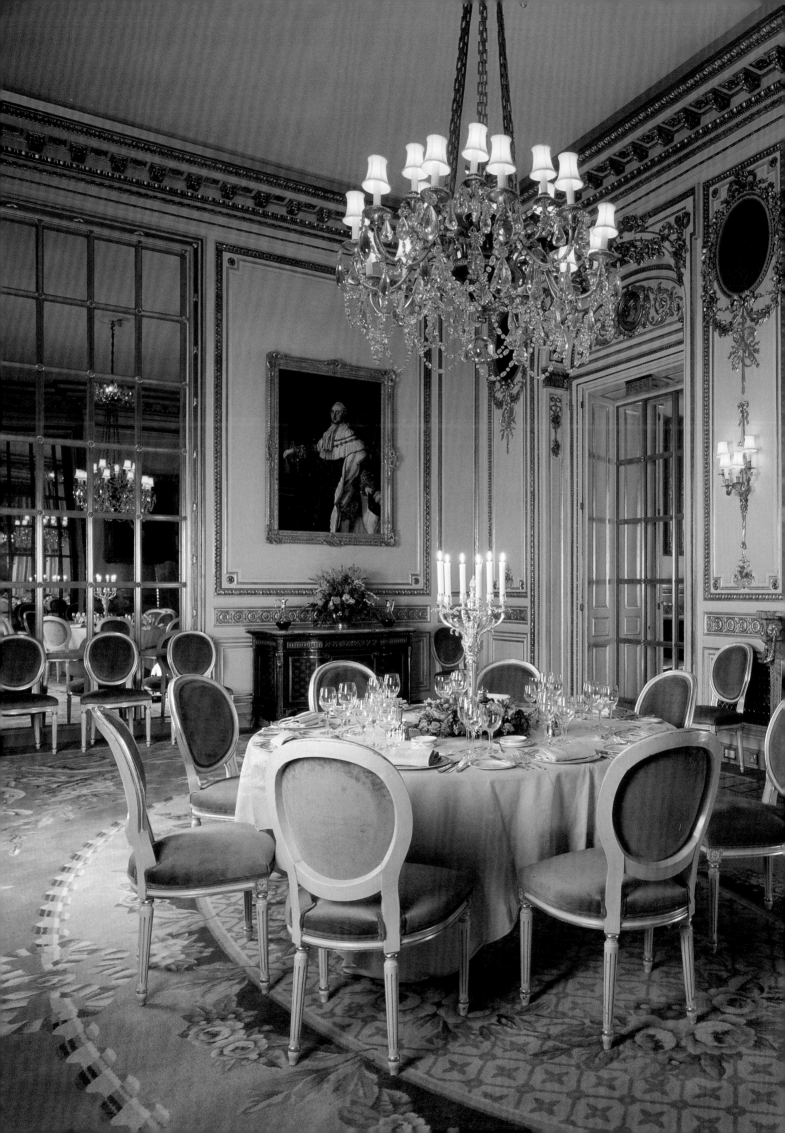

The Marie Antoinette Room

Mewès had ordained that the London Ritz should be in pure Louis Seize style throughout. What could be more natural than for the private dining room, opening off the Restaurant, to be named after Louis XVI's queen, Marie Antoinette. The Austrian-born queen was first famous, and then notorious for her love of pleasure and festivities, and her imprisonment and execution aroused horror and wrath in England. It was the English philosopher and statesman Edmund Burke who wrote, on hearing of her arrest, 'I would have thought ten thousand swords would have leapt from their scabbards to avenge even a look that threatened her with insult.'

The name of Marie Antoinette is forever associated with everything that is pretty, graceful and delicate. This is a room which the young Arthur Davis would never

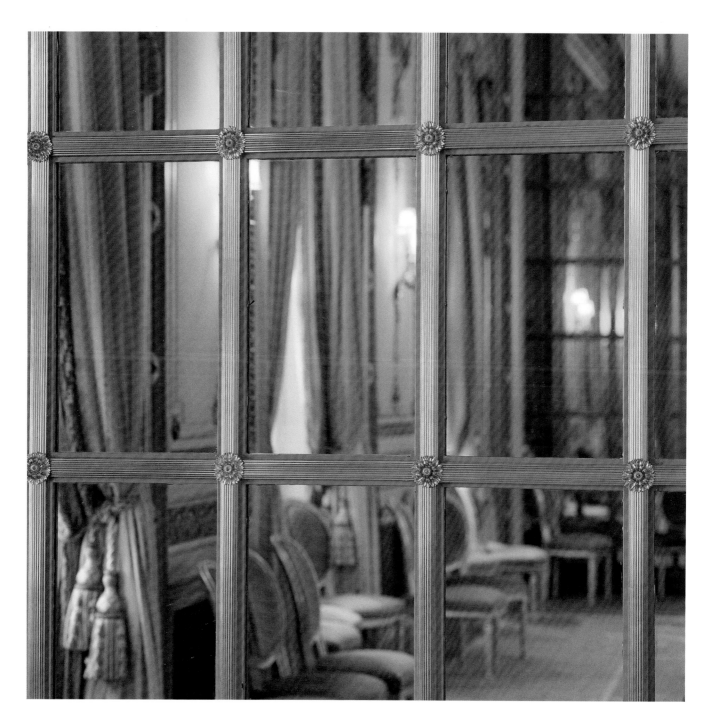

surpass for sheer sophistication and refinement. Here is an opportunity to drink in the whole elegant decorative vocabulary of the Louis Seize style. Not a Rococo S or C curve is in sight – the new style dictated the use of pure classical forms or motifs taken from life and nature.

The decor is rich, opulent, *surchargé*, as the French would say, but the decorative detail is of such intricacy placed with such a sure eye, that nothing seems excessive. Today the room is painted a pale, almost putty colour, setting off the gilded details to perfection. According to the *Ritz Monthly* in 1906, it was originally 'decorated in pale green and gold'.

ABOVE

Reflections in the panelled mirror wall with gilt-bronze framing.

PREVIOUS PAGE

A table set for a private dinner party of eight; a portrait of Louis XVI of France hangs above a handsome commode in late eighteenth-century style.

It was intended from the start as a private dining room – the *Ritz Monthly* shows it set up with small round tables and oval-backed Louis Seize chairs. An early hotel brochure illustrates a single table 'laid for a Dinner given by Royalty' with 'floral decorations by Robert Green Ltd.'

The grand entrance to the room is from the Restaurant, through a pair of folding doors concealed in a huge panelled mirror rising from floor to ceiling at the east side. Immediately inside is a small entrance lobby with a niche on each side containing two terracotta statues of Spring and Summer (Flora with flowers in her hair, Ceres with ears of corn) standing on drum-shaped pedestals ornamented with gilt-bronze flowers and ribbons. The gilded detail of the room has the lustre and crispness of gilt bronze, even the egg-and-dart in the boldly modelled cornice. However, the gilding is not entirely uniform, catching the light in places, absorbing it in others.

As in the Restaurant, Davis had to cope with the problem of providing very large ventilation grilles. Rather than try to conceal them, he made a feature of them, treating them as oval lunettes of the kind that normally contain decorative paintings or portraits, set high on the wall between the windows and on each side of the fireplace. Further ventilation grilles are set in the dado below. Davis avoids a deadening effect by introducing bronzed lattice grilles, a little like those sometimes used in library bookcases, with a much larger mesh below.

Set into the wall panels are the most beautiful wall-lights in the whole hotel, the lamp-holders as finely chased as silver-gilt candlesticks. Beneath each bulb-holder a cluster of some 25 leaves, opens out like the fronds of a palm. Here is a delicious game of *trompe l'œil* with the suggestion that the lights are suspended on cords from ribbons tied in bows, entwined at intervals with flowers, descending to a cluster of tassels. Holding the lamps are miniature Apollo lyres complete with shining bronze cords.

The numerous individual panels of glass in the mirrors are framed in more gilt bronze, with a green metal edging, fluted like columns and overlaid with sunflower motifs at the intersections. A mark of quality in any grand French interior lies in the window fittings. Here they are of the finest precision-made steel and bronze, robust enough to endure centuries of use. The handles and locking mechanisms are all pure Louis Seize with a twist of laurel leaves set in the openwork handles. The gilt-bronze hinges, as in many other rooms, are miniature versions of the favourite ancient Roman motif of the fasces, the bundle of rods symbolizing authority under the Republic.

Proportion is everything in panelled rooms in eighteenth-century style. Davis confidently varies the shapes of the panels to fit the different spaces between the windows and doors, balancing tall upper panels in carved borders with plainer gold-lined panels below. Between them, in place of the chair-rail more usual in England, he places a band of solidly gilt guilloches aligned with the top of the chimneypiece. Again the pattern is subtly varied, featuring sunflowers alternating with peony-type flowers.

Davis varies the surrounds of the wall panels as if they were so many picture frames, with inner and outer mouldings and distinctive treatment of the corners. The larger the panel, the richer and broader the surround. Quite different are the frames of the windows and the wall-mirrors, surrounded by clusters of reeds, with an inset behind which a curtain could hang without obscuring the moulding.

Appropriately for a room named after Marie Antoinette, Davis provided floral features in abundance – swags in the arches over the doors, a basket of flowers above the overmantel, flowers spilling out over the frames of the oval lunettes, as well as posies in the base of each wall panel. Whether laid with a single large table or a series of smaller circular tables, this room is certainly one of the most elegant interiors in London for a private party.

Details of gilded decorative features, a wall-light, window handle and one of the circular ventilation grilles in the Marie Antoinette Room.

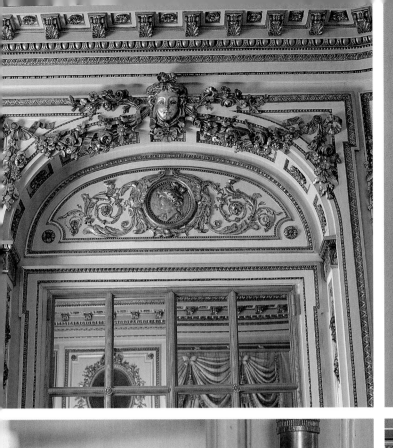
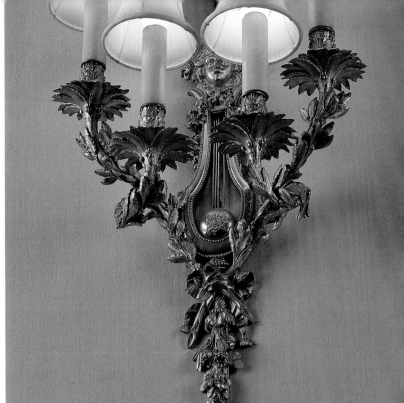

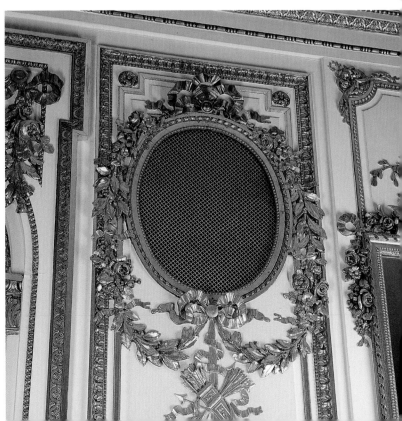

The Banqueting Hall and Ball Room – today's Ritz Club

By 1900, every fashionable hotel had to have a grill room –
an innovation, which, like the cocktail, had begun in
America. Louis Léospo, in his *Traité d'Industrie Hôtelière*,
published in 1918, explains: 'In all modern grand hotels,
besides the restaurant, where one can eat *à la carte*, and
the dining room, with a fixed price menu, there is also the
grill-room. The grill-room is installed by preference on
the ground floor, opening directly onto the street.' Clients,
typically, would be offered a wide choice (which Léospo
describes in English) – 'mutton chops, lamb chops,
beefsteack, kidneys, mushrooms, tomatoes, and mixed
grills'. At meal times, he adds, there would also be 'joints'.
The essence of a grill room was rapid service, with food
cooked on a grill in sight of the diners. Léospo praises the
'silver grill', a charcoal grill of irreproachable cleanliness
(such as supplied by la Maison Briffauld). Nearby, on a
large slab, would be laid out 'in an agreeable and appetising
manner' choice cuts of meat and vegetables prepared for
cooking. The *rôtisseur*, in spotless white garb, would be
ready to grill the meats chosen by the clients. Customers
ordering beer would see it freshly drawn from the cask.

The grill room at the Ritz had its own entrance to the
right of the central doors into the hotel in the Piccadilly
arcade. A spacious stair led down directly to a grand run
of double-height vaulted rooms set beneath the pavement.
The eastern section served as a grill room; in the original
plans the longer western secion is indicated as a private
dining room. These connected at the western end with
a large Banqueting Hall beneath the Restaurant, which the

Staircase from the ground-floor entrance down to the Ritz Club in the basement.
OVERLEAF: The restaurant within the Ritz Club premises.

66

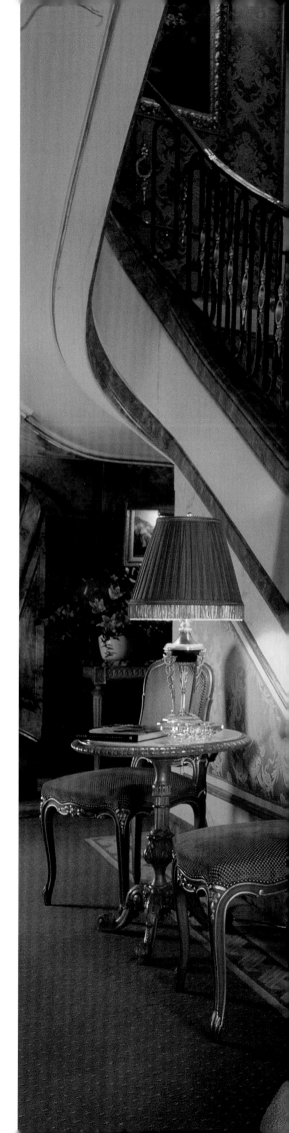

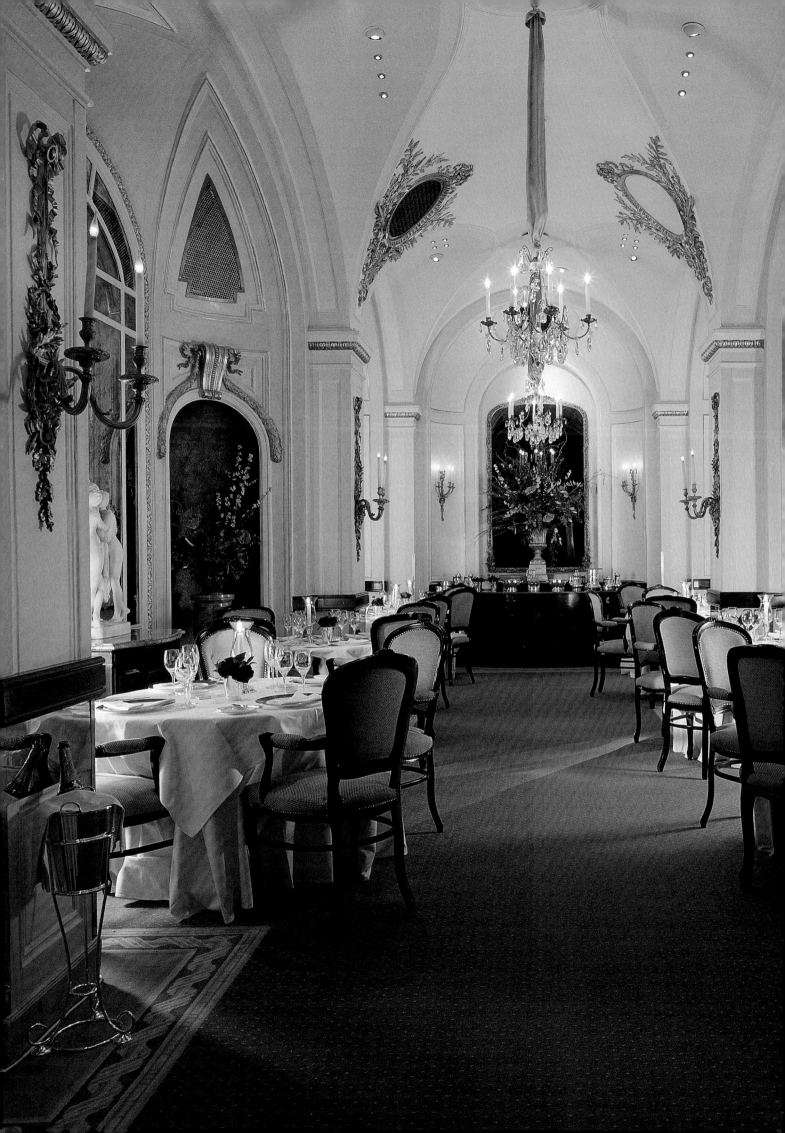

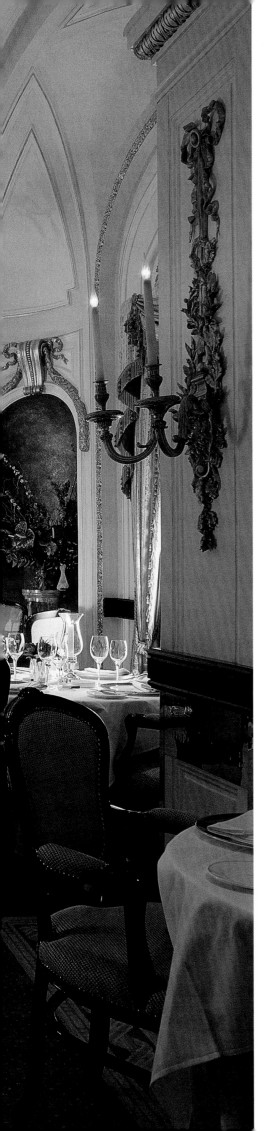

architects ingeniously provided with generous French windows opening onto the Green Park terrace. Though the banqueting hall was entirely below Piccadilly street level, the fall in the land at the Green Park end, combined with some judicious excavation, gave the impression that the room opened onto the park almost at ground level.

The *Ritz Monthly* states that these rooms were used 'for dinners, receptions and theatrical entertainments (a raised stage is fitted at the south end of the banqueting hall)'. The magazine *Truth*, in the issue of 30 May 1906, also commented on 'the fine banqueting hall with its reception rooms, all ivory-white, the mirrors on the walls reflecting an endless intersection of arched ceilings'. The basement, it noted, is simply palatial.

A 1926 brochure shows that the Grill Room had been moved into the Banqueting Hall, and illustrates it laid out with circular tables and wicker chairs with oval backs, describing it as 'airy and spacious' and 'particularly cool in the summer and warm and comfortable in the winter'. Another photograph reproduced in the same brochure shows the same space when adapted for use as the ballroom, with the carpet removed to reveal a fine wooden dance floor. 'It has been the scene of some of the finest private and public balls ever given in London', proclaims the brochure.

During the Second World War, the Grill Room became a well patronized night-spot, known as La Popote, but in the years of austerity after 1945, it became more difficult to sustain a separate grill room and in the early 1970s the basement rooms were closed. In 1977, Trafalgar House decided to lease the premises, and the Ritz Club – a joint venture between Mecca Sportsman and Pleasurama – took a 21-year lease, making use of an existing gaming licence transferred from premises in Curzon Street.

In 1998, London Clubs (as the casino operators had since become known) decided to purchase a new building rather than renew the lease and to move round the corner to the

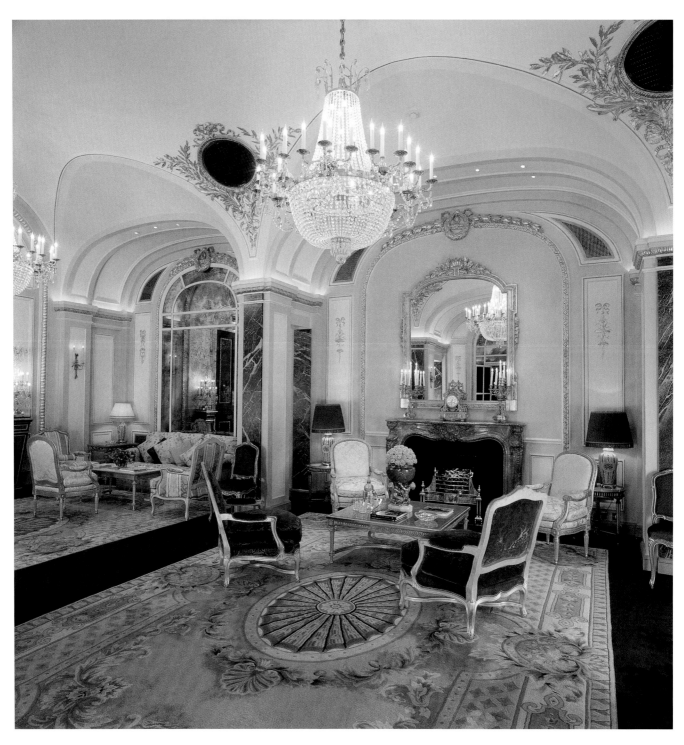

The Club lounge (above) and the gaming room (opposite).

former Devonshire Club in St James's Street (originally Crockford's and later the Jamaican High Commission), transferring their casino licence to these premises.

In June 1998, a newly formed company, The Ritz Hotel Casino Ltd, was granted a licence to operate a casino in the Ritz basement following an appeal to the Crown Court. The company took over on 1 July and, after speedy redecoration and refurbishment, the new club opened on 12 September. A casino in London, as elsewhere in the United Kingdom,

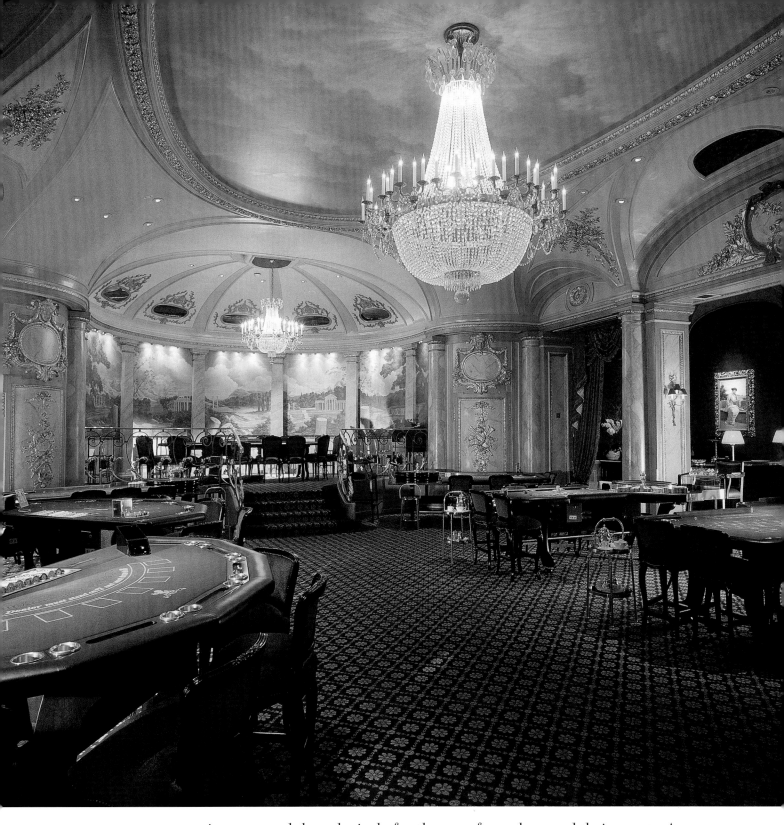

is run as a club exclusively for the use of members and their guests. Any person who wishes to game must first apply for membership or enter the premises as a guest of an existing member. In accordance with Britain's strict gaming laws, the club must be a completely separate entity. The long vaulted gallery beneath the pavement is now divided into a succession of four elegant spaces – restaurant, bar, lounge and private gaming room – while the former banqueting hall now serves as the main gaming room.

Construction – Chicago and New York come to London

'The Ritz has been built in record time, the foundation stone having been laid little more than twelve months ago,' reported the *Illustrated Carpenter and Builder* on 22 June 1906, less than a month after the hotel opened. This remarkable achievement is due above all to one man, the Swedish engineer Sven Bylander, who supplied the vital construction drawings and calculations.

Bylander deserves to be recognized as one of the engineering giants of the Edwardian age. He designed the steel frames for both the Ritz and Selfridge's. Remarkably, Bylander's practice survives to this day – as the Bylander Waddell Partnership in Harrow – and the firm retains many of Bylander's original drawings (all done to metric measurements, making them all the more useful today), as well as a set of his lantern slides which he evidently used to illustrate numerous lectures around the world.

Bylander himself noted later that 'the first steel-frame building of importance in London was the Ritz Hotel' in an article in *The Structural*

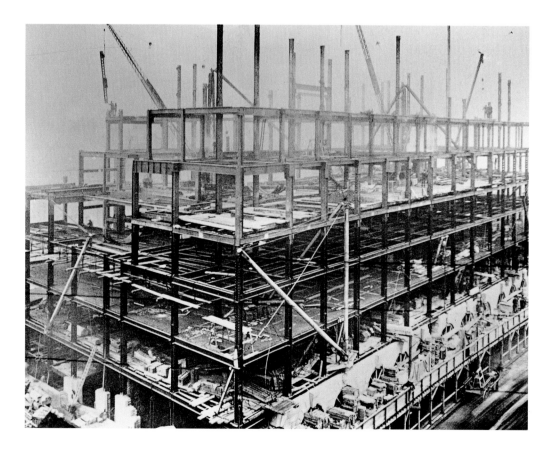

The Ritz while under construction in 1905, with the steel frame partially completed; the arches of the Piccadilly arcade are seen in the right foreground.

Workmen on the Ritz site in 1905 posing for the camera beside shuttering below street level.

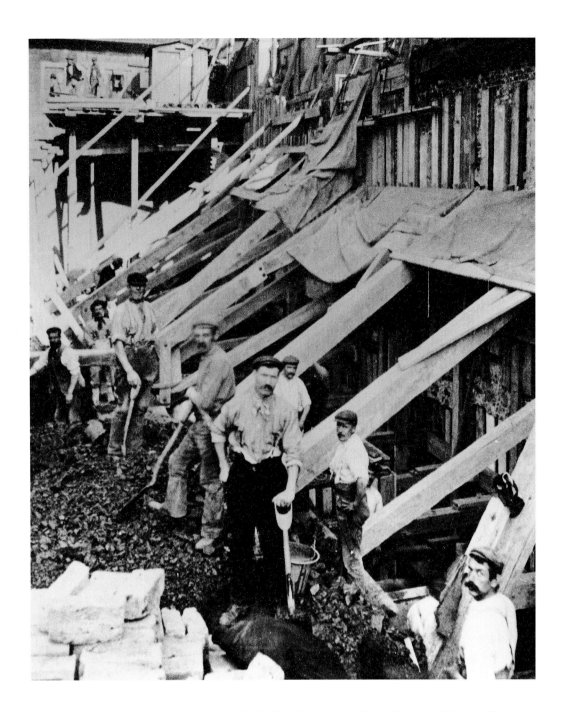

Engineer in January 1937, entitled 'Steelwork in Buildings – Thirty Years' Progress'. Here he explained that 'before the year 1900 many skyscrapers had been erected in the United States of America and steel-frames were quite usual there . . . Meanwhile steel-frame buildings were not general on the continent of Europe. Factories and railway stations were in prominence; sometimes light ornamental steel and glass structures occurred such as the Kursaal in Ostend.'

Bylander had gone to the United States at the turn of the century and worked on two key buildings – a flatiron building in Chicago and the Times Square Building in New York. In designing the first wave of steel-

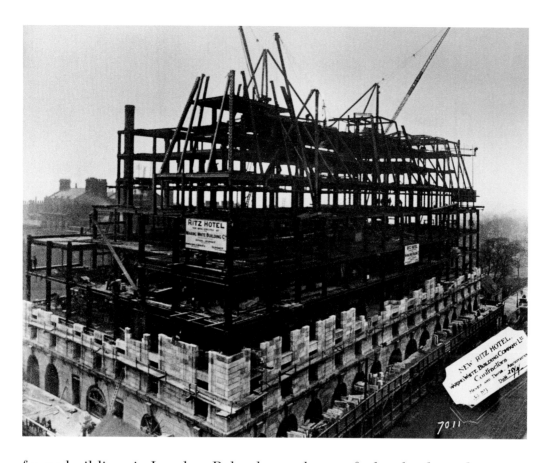

frame buildings in London, Bylander made use of a key book on the
subject, *Architectural Engineering with especial reference to high building
construction* (the Carnegie Steel Company's handbook) by J.K. Freitag –
his copy of the 1902 edition survives in the office. Freitag provides the
background to the new methods of construction. It began with the
invention of the iron I-beam in France and England in 1853, followed by
the manufacture of rolled-steel beams by the Carnegie Steel Co. in the
USA in 1885. A big breakthrough occurred in 1883 when the architect
W.L.B. Jenney drew up plans for a ten-storey office building in Chicago
for the Home Insurance Company using cast-iron columns to carry the
floor loads, taking the weight off the masonry walls. This technique was
followed rapidly by the adoption of complete skeleton construction –
a framework utilizing steel beams and columns. The Chicago Building
Ordinance defined the latest technique as follows: 'the term "skeleton
Construction" shall apply to all buildings where all external and internal
loads and strains are transmitted from the top of the building to the
foundations by a skeleton or framework of metal.'

Next came the concept of cage construction – as at the Ritz – where
the framework becomes complete in itself, like a wire cage. The steel

Progressive stages in the construction of the hotel: (left) non-loadbearing masonry walls rising simultaneously with the completion of the steel frame at roof level; (right) the exterior taking on its final appearance, as seen from the north-east.

OVERLEAF

The Ritz today, showing part of the Piccadilly frontage and the west end facing Green Park, with the four large windows of the Restaurant at ground level partly hidden by a canvas awning.

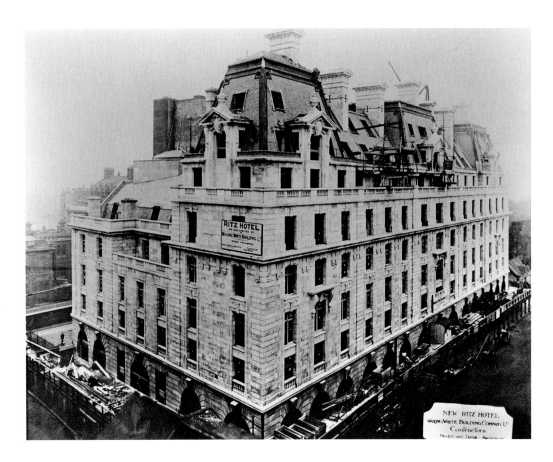

framework was originally introduced to carry vertical loads, but now became so well braced that the substitution of curtain or veneer walls in place of solid loadbearing masonry walls was possible, thus allowing larger windows and increased floorspace, as well as the omission of heavy internal walls.

When demolishing Walsingham House to make way for the new Ritz, Bylander 'noted with interest that it was built on a continuous plain concrete raft over the entire site 4 to 5 ft thick. This raft had cracked and tilted several inches, showing that the subsoil had given way where heavy loads had occurred.' He therefore opted instead for a series of individual foundations. Alan Knight, a partner at Bylander Waddell, explains, 'Sven was a leading authority on excavations and temporary works as well as steel frames. Buildings like the Ritz needed big excavations.' This was partly to obtain generous basement space – a full two stories below ground level at the Ritz – and partly to get down to a secure footing. He continues, 'A frame structure brings concentrated loads down the columns. Engineers had to find out how to spread those loads.' At the Ritz, Bylander began with a concrete base on which he placed a grillage of steel I-beams measuring 3.20 x 4.60 metres. On top of the grillage he

set a cast-iron base (a metre square) as support for each steel column. Special measures had to be taken along the party wall with Arlington House at the back – its owner, Lord Wimborne, was difficult at the best of times. To gain maximum space inside the hotel Bylander could have placed the steel columns against the party wall, but obviously the base could not be centred underneath without digging below the party wall. So Bylander had to set the footing well inside the wall and 'cantilever out' to take the full weight of the columns at the back of the building.

Another challenge was presented by the Restaurant, which runs from the front to back of the site without internal columns to bear the weight of bedroom cross-walls above. To achieve the required strength Bylander relied not just on huge beams concealed above the Restaurant ceiling, but created a girder truss – like the side of a railway bridge – with diagonal braces descending from a second set of steel beams hidden above the ceiling of the first floor. Guests visiting the Trafalgar Suite on the first floor overlooking Green Park get a glimpse of this where (quite a solecism for Davis) the top of a massive slanting beam is just visible.

The rapid rise of the Ritz was recorded with high excitement by the technical press. A dramatic series of photographs taken in 1905 show the skeletal steel frame rising above the street, storey by storey, to be topped by the three distinctive pyramid frames of the giant mansard roof. The stonework skin followed, with crisp ashlar stone being manœuvred into position by jibs (that is hoists rather than cranes). These were described as 'American cranes' and included 'a derrick of American pattern specially constructed for the builders' with a 360° arc. In terms of speed of construction, the great advantage of a frame has always been that construction workers could use the steel frame as a building platform, so dispensing with the need for external scaffolding.

Almost from the start there were those who decried the lack of honesty of a concealed structure. Mewès & Davis were nonetheless bound to comply with the London Building Act of 1894, which laid down that 'every building . . . shall be enclosed with walls constructed of stone, brick or other incombustible substances' with a thickness (in buildings of eight stories such as the Ritz) of 30½ inches on the ground floor, decreasing by stages to a minimum of 13 inches. While it seems likely that Mewès & Davis would in any event have concealed all the steelwork (a few daring

76

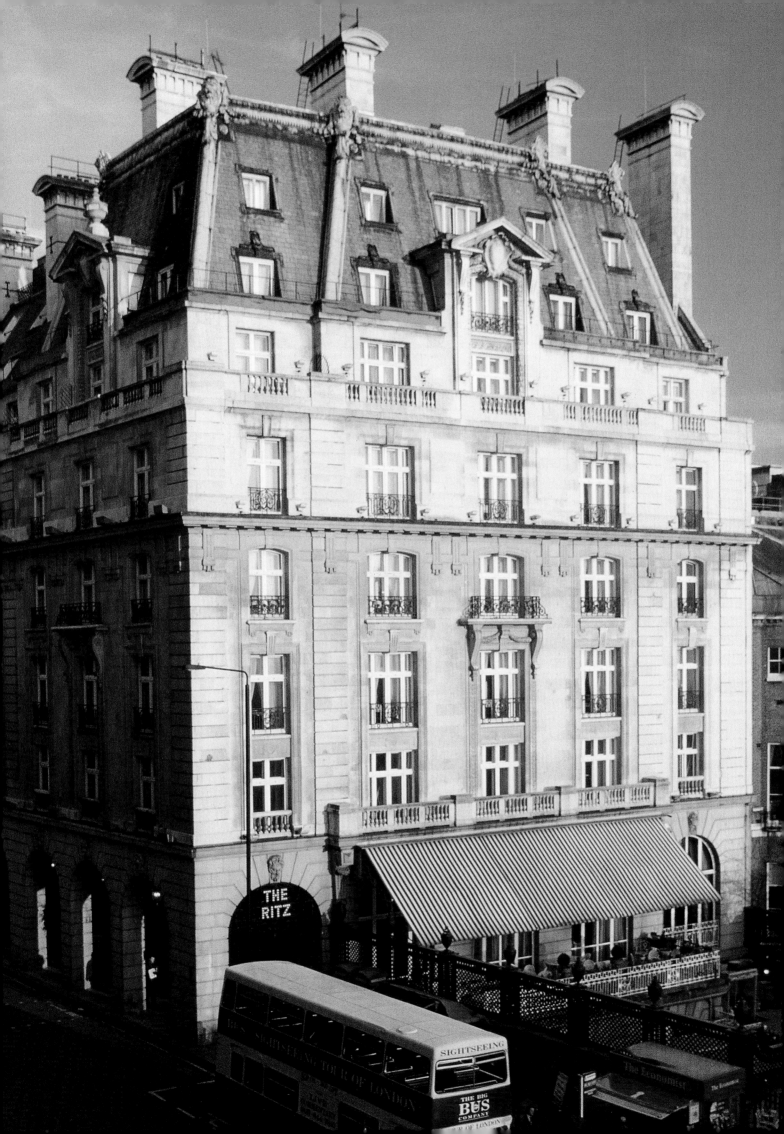

Art Nouveau buildings in Paris and Brussels of this date reveal steel girders over windows) they would certainly, on economic grounds alone, have preferred to use a thinner stonework skin.

The London Building Acts stipulated wall thicknesses for the simple and obvious reason that traditional walls were loadbearing, carrying the weight of everything in the building – floors, ceilings, furniture, etc. As a result of the lead shown by the Ritz, the Building Acts were amended in 1909 by the addition of a new clause which made it 'lawful to erect . . . buildings wherein the loads and stresses are transmitted through each storey to the foundations by a framework of metal or partly of metal'. The framework nonetheless still had to be encased in masonry, whether brick or stone.

Bylander did however receive one quiet waiver, which he later explained in his 1937 article: 'according to the 1894 Building Act it was not permissible to rivet the connection between beam and pillar . . . this requirement was not insisted on by the authorities for the Ritz Hotel.' He continued, 'I have always contended that the connection between the pillars and the beams must be riveted and be strong so as to assure the lateral stability of the building. Not only winds, but also loads placed eccentrically must be resisted.'

The steel frame made the construction of internal walls or partitions all the quicker. These were built with terracotta blocks (called tiles in the United States) mostly of three-inch thickness and each weighing 10 pounds. Each block had three air spaces. One advantage was that they were easy to cut to fit corners or bends. Here was a whole new world of fast building techniques. For example, at skirting level softer and more porous blocks were used, so that woodwork could be nailed to them. Hollow terracotta had another advantage for a grand hotel – it was good for soundproofing, so ensuring that guests did not overhear voices from adjoining rooms.

The setting out of partitions was done by the supervisor, who marked the lines with a trowel on a coat of rough plaster on the concrete floors. These marks were indelible and were not obscured by the constant passage of boots and barrows as chalk would have been. The partition blocks served another vital purpose, they were used as coverings to protect the steel columns from fire. The partitions were plastered with

selenitic cement and finished with a layer of Keene's – the most durable of plaster finishes. The hollow spaces above the ceilings were used to provide an early form of air-conditioning, with warm and cool air forced through with the help of large fans.

Most adventurous architecture of the late twentieth century is the result of a close collaboration between architect and structural engineer. The Ritz was an early example of this practice in Britain. By the turn of the nineteenth century internal steel frames were increasingly common in Chicago and New York, but in Britain architects dreaded the necessary study or the increased dependence on engineers. Bylander observed that, when he arrived in London in 1902, 'builders, in using steelwork in building simply piled one piece on top of another, stuck a few bolts in and called it constructional steelwork', a process he contemptuously dismissed as ironwork. Bylander also stressed the importance of the American system of using building tables. Every architect's office, he wrote, has a set of standard tables which 'are used throughout the office by each member, and this produces uniformity in methods and design'. The *Builder's Journal* explained to its readers how this practice produced major economies for the client. Such was the exactitude of the drawings, with every dimension inscribed, that nothing needed to be scaled off. The German steelworks, chosen to supply the steel, were therefore able to execute the work at reduced price without preparing templates, as was the usual English practice.

Ironically, there is just a chance that the front wall of the Ritz was doing more of a job than was intended. During the 1980s, the newsvendor in the arcade suddenly heard a loud explosion like a bomb going off. Soon afterwards a series of major cracks was noticed in the massive blocks of granite along the Piccadilly arcade. An engineer working on the Piccadilly Line below confirmed that he and his colleagues had heard the same fearsome bang and 'nearly made a run for it'. One possible explanation is that the stone had carried the weight of the structure all along and that sudden settlement had caused a transfer of the load to the steel frame – the stone being rigid and the steel inherently flexible. No-one has ever been asked to seek the answer and to this day these recent cracks represent the only blemishes in the façade, while the original steel frame shows no hint of corrosion.

The Opening of the London Ritz

Though César Ritz's health remained poor after his collapse at the Carlton in 1902, he was able to take an active role in organizing the opening dinner at the London Ritz on Thursday, 24 May 1906. The dinner was given by the directors of the hotel and the printed guest list as well as a table plan survive. Ritz was well enough to attend with his wife Marie-Louise. This was less of a society occasion than the opening of the Paris Ritz had been, and a large proportion of the guests were representatives of the press – including the numerous national dailies of the time, the *Daily Chronicle*, the *Daily Express*, the *Daily Graphic*, the *Daily Mail*, the *Daily Mirror*, the *Daily Telegraph* and the *Morning Post*. All this was a reflection not only of a flourishing press, but of the avidity with which newspapers and magazines were purchased. Ritz was evidently intent on ensuring that reports of the new hotel should ring round the world – the *Berliner Tagblatt* was represented, as well as the *Bombay Gazette*, the *Calcutta Pioneer*, the *Kölnische Zeitung*, the *New York Herald* and the *New York Times*, the *Sydney Morning Herald* and the *Times of Ceylon*.

Afterwards Ritz penned a charming note of appreciation (in French) to Davis, who had been unable to attend, though his intended place was at the main table between Baron de Gunzburg and Sir Roger Parkington: 'The Press Dinner took place yesterday evening and everyone admired the hotel and I must say myself that it is really superb – it is the prettiest in the world. We drank to your health. Mewès and you should be proud of your work. . . .' If neither the architects nor the engineer Sven Bylander could attend, the Warings and Whites who had built and furnished the hotel were out in force, both Mr and Mrs J.W. Waring and Mr and Mrs S.J. Waring Jr and Mr J.B. White, also of the Waring White Building Co. Gordon Selfridge, whose magnificent store was then rising (with a steel frame even more massive than that of the Ritz), came too.

The dinner was presided over by the Hon. Arthur Brand, younger son of Viscount Hampden and a director of the Ritz Hotel Co., with other key directors also present, notably William Harris and the Marquis d'Hautpoul (whose wife was a lady-in-waiting to Queen Alexandra). The directors also generously included the wives of principal members of staff – Mrs Henry Elles, wife of the General Manager of the Paris and

Note from César Ritz to Arthur Davis, penned in 1906 after the press opening, expressing his appreciation of the architect's contribution to the success of the hotel venture.

London Ritz hotels, and Mrs Aimino, wife of the Acting Manager of the London Ritz.

Ritz's tactics paid handsome dividends – he may indeed have first observed the workings of the press in Britain from the press coverage at the opening of the Savoy in 1889 when D'Oyly Carte had brought him in to supervise the opening of the restaurant. Within a very short time the new hotel was as fashionable as he could have wished, despite rivalry from established grand hotels like Claridge's and the Savoy and newer ones like the Berkeley (opposite the Ritz, which had opened in 1901).

As Ritz doubtless intended, the hotel became the venue for a continuous series of gala events. By 1914, New Year celebrations at London hotels were worthy of an article in *The Times* the next day. 'Decorations at the Ritz included an avenue of festoons of foliage, scarlet flowers and chrysanthemums intertwined, while from the ceiling of the foyer hung a giant illuminated cracker in red and green bearing the figures 1914.' At midnight, as was the custom then, the New Year was heralded by 'a fanfare of trumpeters and the chiming of bells'.

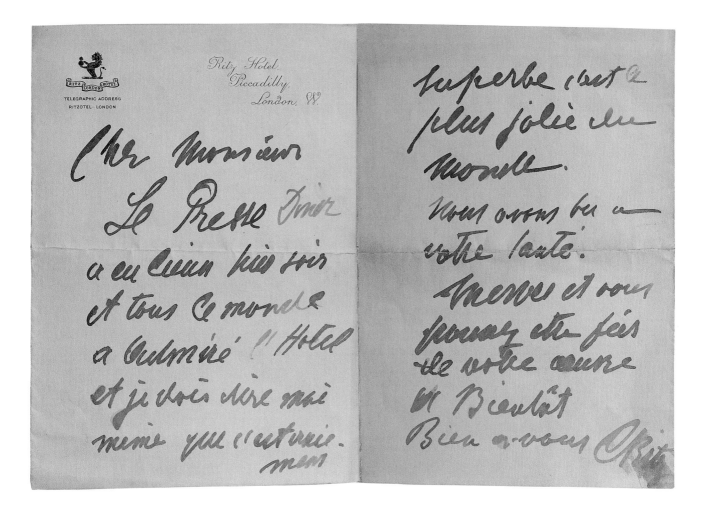

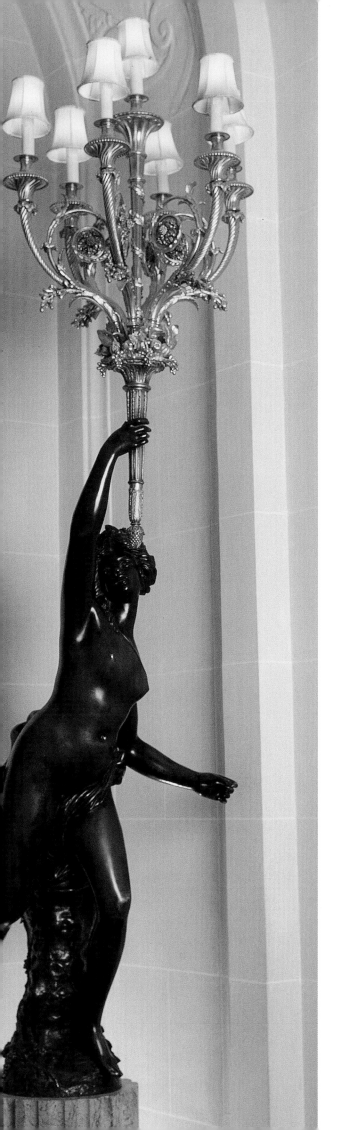

THE SEARCH
FOR LUXURY AND
COMFORT

'London Full – Visitors hunt all night for
Rooms – French invasion – Leading hotels crowded'
ran the breathless headlines in the *Daily Mail* on
3 June 1905. 'It is the height of the season and it is
Derby week,' said the report, continuing, 'this year
the Entente Cordiale has caused a vast influx of
French visitors, the Americans in London are more
numerous than usual at this time of year, and
Germany, Austria and Belgium are for some reason
more numerously represented in town than usually.'
The coming visit of the King of Spain was due to
bring 2,500 Spanish delegates to the Royal Albert
Hall. The Savoy was reported as 'Full up. Wiring
to stop intending visitors.' The Cecil next door was
'Refusing scores'. The Grand on Trafalgar Square
had 'never had such a busy week since the opening
night'. Buckingham Palace Hotel was so desperate
'that we are now fitting up beds in the offices'.

The Board of the Ritz had chosen their moment
well. This was the very time that photographs show
the exterior of the Ritz as it neared completion. On
2 February, the *Daily Express* published a report by
Francis Stopford, its society editor, headed 'London

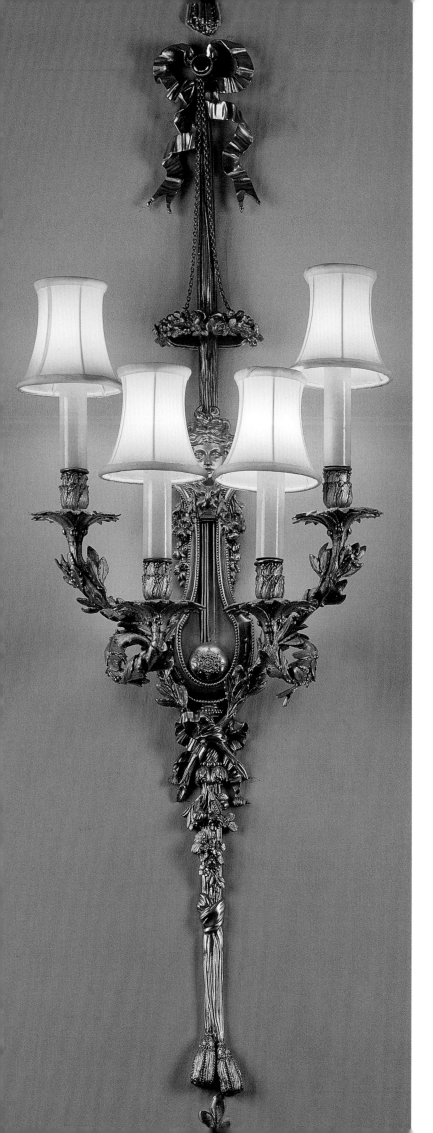

a City of Hotels – Metropolis becoming the Pleasure Resort of the World – Demand for Luxury'. The article continued: 'At the moment there are six first-class hotels either being built or about to be built in London. Each of them will be a palace of luxury. The new Ritz is rising on the site of the old Walsingham House. The Piccadilly will occupy the site of the St James's Hotel and restaurant. A new and enlarged Gaiety Hotel has risen from the ashes of the old one, and will soon be opened; and close by there will be a London Waldorf-Astoria.' The article pointed out that even ten years earlier more than 30 then well-known hotels, including the Carlton, the Russell, the Cecil, the Hyde Park and Claridge's, were not yet in existence.

Ritz's efforts with the press paid handsome dividends. The new Ritz, reported *The Graphic* on 9 June, 'seems to touch the highwater mark of convenience, beauty and comfort'. An approving professional eye was cast on the Ritz by *The Caterer and Hotel-Keeper's Gazette* after its opening. 'Luxury is generally the word which comes to mind in describing a modern hotel palace, but at the Ritz it is the feeling of cool refinement which at once impresses the visitor. . . . as soon as one comes inside . . . one finds everywhere that light, aesthetic colouring and delicate artistic form which is peculiarly French.'

The years leading up to the opening of the Ritz saw a series of technical innovations that were to transform life in

grand hotels. First there was electric light, replacing gas and candles, next came running hot water and private bathrooms, and then the telephone. In all these developments the Ritz was intended to surpass everything that had gone before. The dramatic increase in the number of bathrooms required the provision of a vast volume of water. This had to gush in abundant quantities through both hot and cold taps at all times of day. To provide this, two huge lead-lined tanks were installed in the roof. The first, measuring 14 x 13 ft x 6 ft 6 in., held 34 tons of water; the second, measuring 18 x 20 ft x 6 ft 6 in. and weighing 5 tons, contained 73 tons of water – the combined equivalent of three fully laden heavy lorries sitting in the roofspace.

The Savoy had been an important pioneer. A report in the *Home Journal* of 26 November 1890 stresses the extent of the change: 'In all Parisian hotels candles are a separate charge: in nearly all European hotels attendance is a separate item [since clients usually travelled with their own staff], and in most hotels in the civilized world you must pay extra for baths. Not so at the Savoy. When you are told the rate for an apartment everything is included – everything of course but the meals – bedroom, light, attendance, baths.' The *Ritz Monthly* provides an illustration of one of the bathrooms in the London Ritz, showing a freestanding white porcelain bath, pedestal washbasin standing on

a short fluted column, and a heated towel-rail 'furnished by Waring & Gillow'. The walls and floors in the illustration have as much marble as the plushest of modern hotel bathrooms – pale white marble with bands of richer coloured marble on the walls and a border of tiles around the edge of the floor. *The Caterer and Hotel-keeper's Gazette* also talks of the hotel's 'exceptionally spacious' bathrooms with 'glazed tiles, whose green tint relieves the general whiteness'. Sanitary fittings, according to *The Times* of 26 May 1906, were supplied by Messrs Doulton & Co.

At the London Ritz every bedroom was provided with a working fireplace, and the architects' sections through the building (see p. 28) show the elaborate arrangement of flues which rise in the chimney breasts to the fifth floor and then ascend diagonally to become the central rooftop clusters of chimneys. The fireplaces were coal-burning and there were large coal-cellars situated in the basement. A considerable number of the original copper coal-skuttles in the shape of classical urns (presumably designed by the architects) survive.

From the start the London Ritz had 75 bathrooms for its 150 bedrooms, many of which could be arranged in suites. In contrast to the modern

PREVIOUS PAGES

Decorative features of the hotel: one of a pair of wall-lights in a bedroom; free-standing candelabrum at the entrance to the Restaurant; a wall-light in the Marie Antoinette Room; barometer on the ground floor inside the Piccadilly entrance (for the matching clock see p. 11).

BELOW AND OPPOSITE

Original bathrooms installed in 1906, with sanitary fittings supplied by Doulton & Co. and opening windows for ventilation.

practice of internal, artificially ventilated bathrooms, every bathroom and
separate w.c. at the Ritz had an opening window overlooking a small
lightwell (marked as 'area' on the floor-plans) or the larger open court
backing onto Wimborne House. Grandest of all were the Green Park suites,
two to a floor and each with a bedroom and sitting room (marked 18 and 19,
20 and 21 on the plan, see p. 91). The charm of these rooms, now as then,
is their unusual shape, some rounded at one end and semi-octagonal at
the other. The space cut off at the corners is not wasted, and is used for
entrance vestibules, interconnecting lobbies and cupboards. A large suite
was also to be found on each floor overlooking the corner of Piccadilly and
Arlington Street. Here, the handsome sitting rooms provide a view towards
Piccadilly Circus – an outlook such as no other building in Piccadilly
enjoys. The irregular site of the Ritz produced potentially awkward room
shapes at either end. Mewès & Davis resolved this by introducing small
rooms on the Arlington Street front which could form suites of two or three
bedrooms with one or two baths.

Suites of rooms overlooking Piccadilly opened off short arms from the
main hotel corridor. Between each two bedrooms was a sitting room which

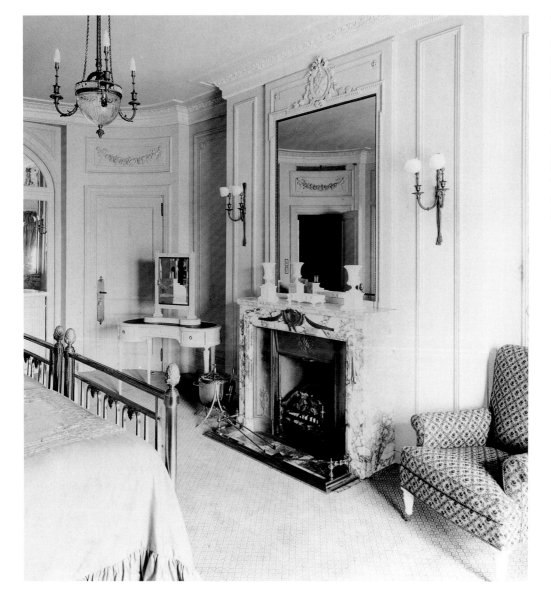

Three interiors photographed in 1906, showing (left) an original bedroom with brass bedstead facing the fireplace, and (opposite) lounges forming part of private suites. The photographs on the left and opposite below are from the archives of Mewès & Davis Architects Ltd, Plymouth.

could be assigned to one or other bedroom – each bedroom having its own lobby and door into the sitting room. Alternatively, the two could be combined to form a grand suite with sitting room and two bedrooms and two bathrooms. Further sets of doors allowed guests to have a pair of bedrooms opening into one another if they wished. The bedrooms along the opposite side of the corridor, i.e. those overlooking the rear court and intended for the use of couriers, personal maids or valets, did not have private bathrooms, but were equipped with fireplaces.

One of the most remarkable features of the Ritz bedrooms today is the number of original light fittings that survive – not only chandeliers but gilt-bronze wall-sconces, quite a few of which bear the stamp of the maker Vian. The chandeliers hanging from the bedroom ceilings vary considerably. Some are inset with engraved glass bowls, some have pendent lustres.

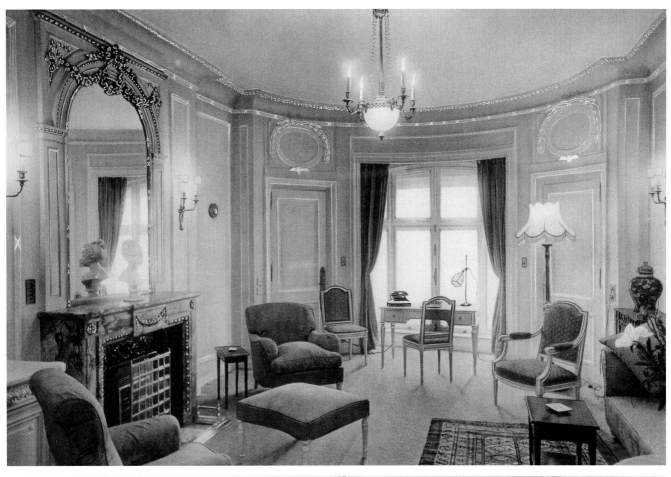

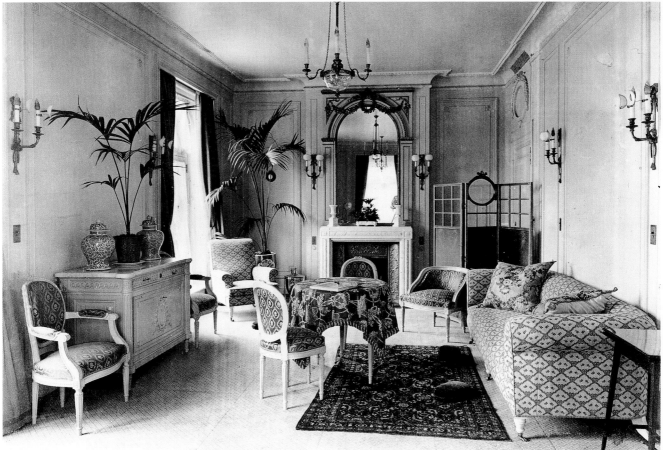

The hotel retains a copy of an early brochure which was evidently
sent to potential customers. It contains two floor-plans, one showing the
arrangement of the 1st, 2nd and 3rd and the other of the 4th, 5th and 6th
floors. These enabled guests to request a room of particular size and
outlook and to ascertain the arrangements of cupboards, bathroom and
often separate w.c. (Similar floor-plans of grand hotels at St Moritz survive
in the local library; they were printed on very thin paper, evidently to
reduce the cost of postage.)

The charm of the Ritz bedrooms lies in their beautiful classical
proportions. Mewès & Davis had been retained to design the bedrooms
as well as the public rooms, and large numbers of drawings for individual
bedrooms survive, with a plan and elevations for each wall, all described

Bedroom with original
furnishings, including twin
brass bedsteads and a large
mirror over the fireplace.
From the archives of Mewès
& Davis Architects Ltd,
Plymouth.

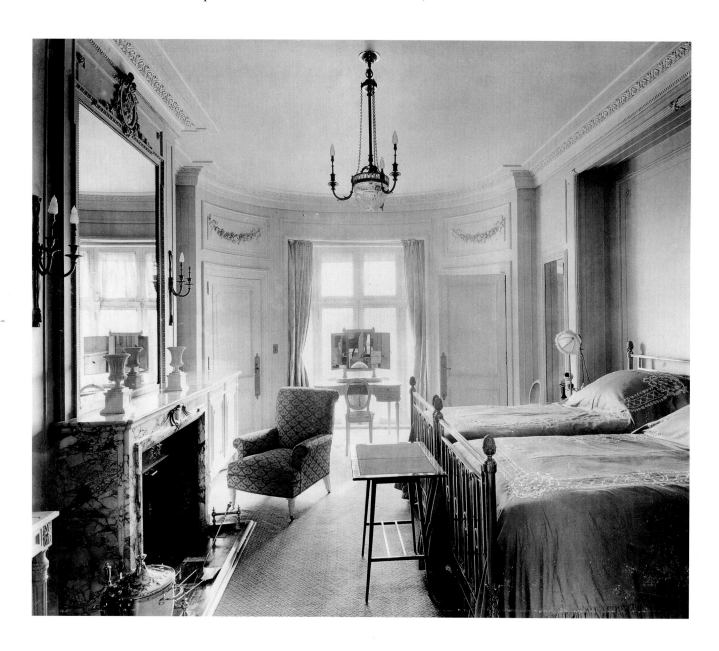

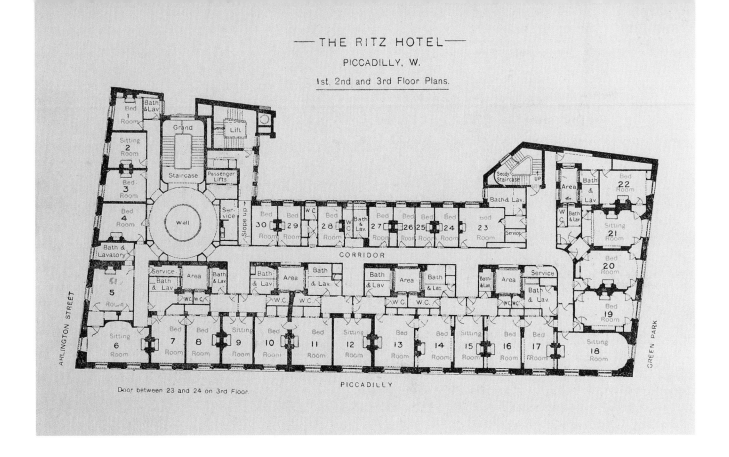

The following text appears within the floor plan image:

—THE RITZ HOTEL—
PICCADILLY, W.
1st, 2nd and 3rd Floor Plans.

Door between 23 and 24 on 3rd Floor.

PICCADILLY

ARLINGTON STREET

GREEN PARK

Plan of the first, second and third floors, from a brochure issued by the Ritz as a guide for potential clients.

as Louis Seize. For the first floor the Mewès & Davis collection includes sets of drawings for more than a dozen different bedrooms.

The floor-plans at Plymouth have the added interest of indicating the position of the beds, which almost invariably faced the fireplace. The hotel's principal bedrooms were each equipped with twin beds, equating with the handsome pairs of brass bedsteads (with pineapple finials) that are shown in the *Ritz Monthly* and other early photographs. Interestingly, the bedrooms at the back of the hotel looking out towards Wimborne House are marked in red, not green, to indicate that these were intended for occupation by couriers (who sometimes accompanied guests to assist in making their travelling arrangements) but which usually served for personal maids or valets (and even the occasional butler).

Ritz had a horror that freestanding wardrobes would collect dust, and so cupboards were built in, with doors matching the panelling. In some of the Green Park suites the doors are curved and retain their handsome gilt-bronze hinges, designed as miniature versions of ancient Roman fasces. The majority of rooms also have a large mirror built into the panelling over the fireplace, often crowned by a decorative motif such as a medallion or pair of swags. The sitting rooms overlooking Piccadilly at the Arlington Street end had particularly pretty fireplaces with mirrors set in arches in which the decorative detail appears to have been gilded from the beginning.

91

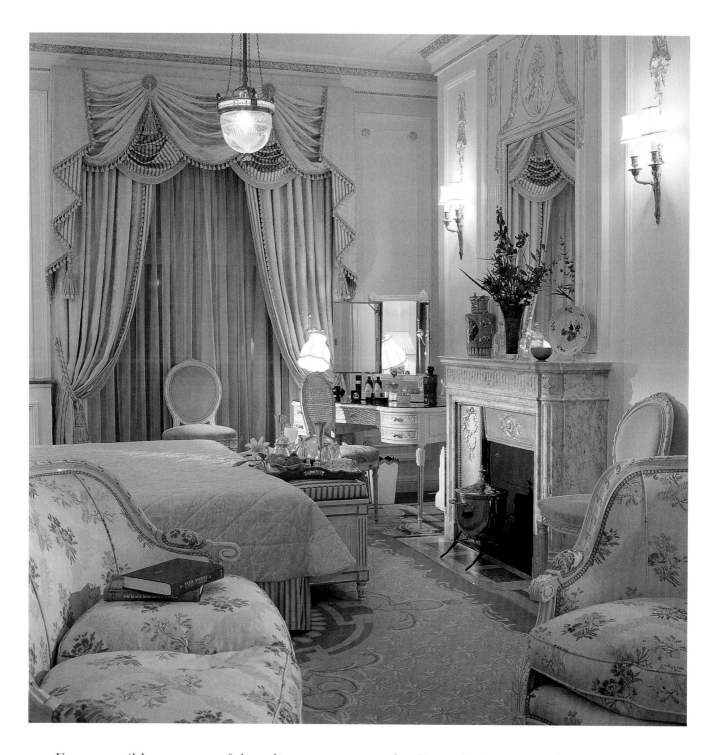

Every possible new or useful appliance was put at the disposal of guests. The *Sunday Chronicle* for 5 March 1905 mentions New York hotels where 'in every room or suite there is a silver curling iron for a lady's use, with an electric heating attachment'. In the vaults of the Ritz two pairs of silver-plated tongs for stretching the fingers of gloves have recently emerged – a very important accessory when gloves were wet.

Air-conditioning is seen as an invention of the last few decades. The Ritz, completed in 1906, had a system of ventilation reaching every room,

A refurbished bedroom featuring an original copper coal-scuttle placed in front of the fireplace.

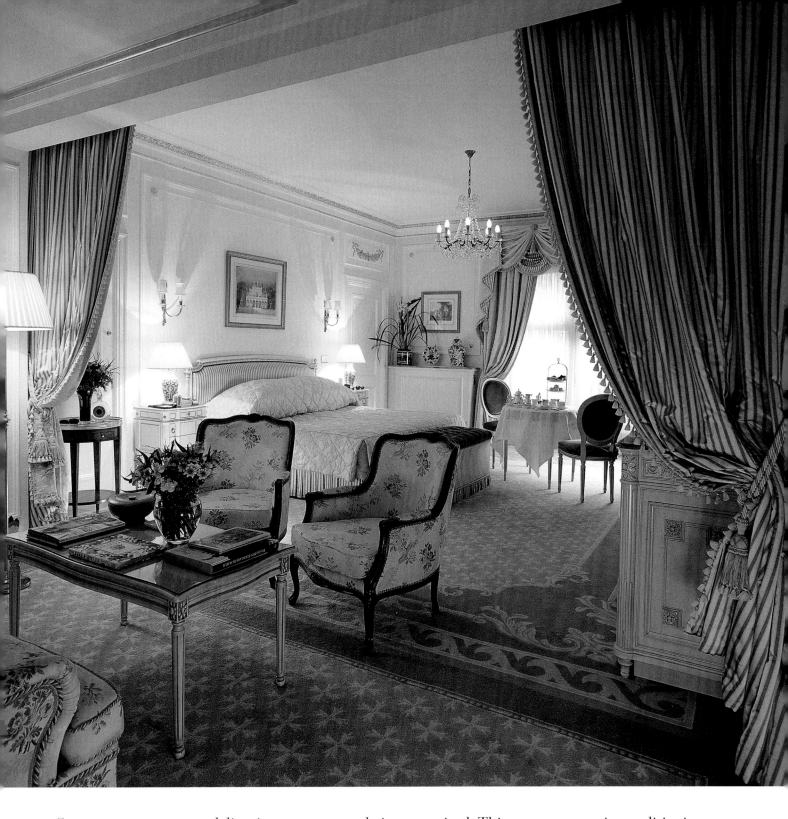

Sitting and sleeping areas
divided by full-length
curtains in a large room on
the third floor.

OVERLEAF

A third-floor suite at the
west end overlooking Green
Park.

delivering warm or cool air as required. This was not true air-conditioning
in the sense of circulating artificially refrigerated air, as has become
standard in recent years, but interestingly it was a precursor of the more
eco-friendly natural cooling systems that are being installed in some of the
latest modern buildings in preference to air-conditioning.

The Caterer and Hotel-keeper's Gazette of July 1906 adds that each
floor 'is furnished with pneumatic tubes (put in by the Lamson Pneumatic
Tube Company) for the dispatch of notes, letters and keys'. Another use

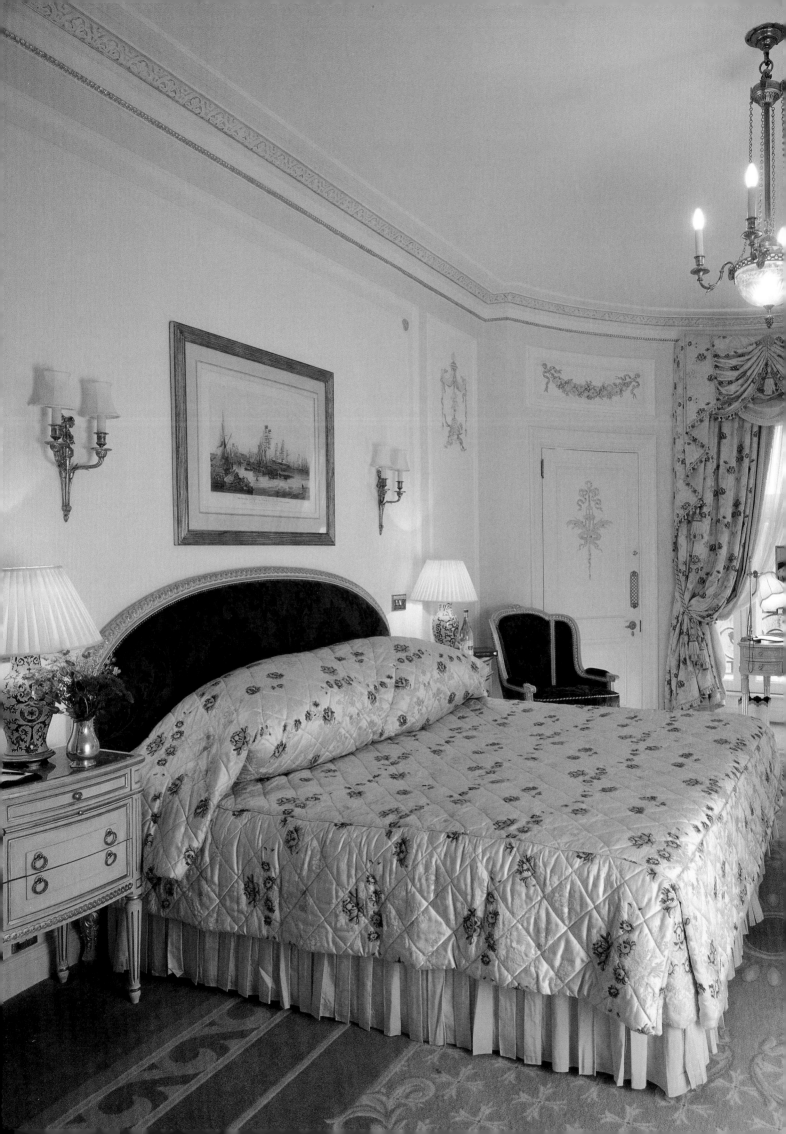

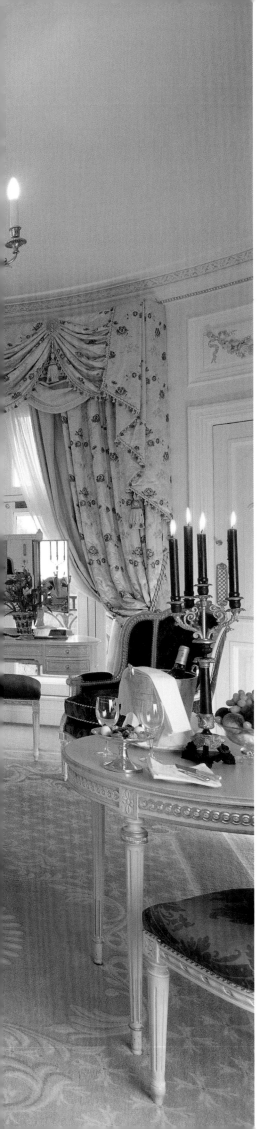

for this 'pneumatic messenger' is found in the *The Illustrated Carpenter*: 'A visitor wishes to communicate with a resident in the hotel, and his card is pneumatically conveyed to the attendant on duty.' The seven floors, it adds, are constantly patrolled by attendants, making it very difficult for any unauthorized person to enter the rooms in the absence of the rightful occupant. This was the age when calling cards, like the modern business card, were in vogue, and people would leave cards rather than write or telephone to let friends, acquaintances or important visitors know that they were in town.

Further details are provided by a long-forgotten trade journal, *The Illustrated Carpenter & Builder*, in its issue dated 22 June 1906, which mentions 'the system of ventilation which is as near perfect as it is possible to attain. Big fans are on the roof extracting all the foul air; and by an ingenious device the fresh air is cooled in summer and warmed in winter.

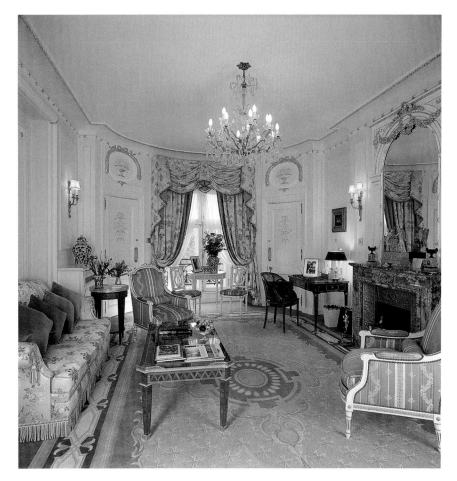

The Ritz also offered its guests the altogether newer luxury of a telephone in every bedroom. By this time the telephone cabin, near the hall porter or concierge, had become an important feature of grand hotel life. The Paris Ritz had telephones installed in all main bedrooms in 1898. In the London Ritz, according to *The Caterer and Hotel-keeper's Gazette*, 'every suite is furnished with a telephone which can be switched anywhere, whether to a guest's next-door neighbour or the farthest limit of the public exchange.'

The detailed floor-plans of the Ritz which survive at the London Metropolitan Archives show the care which went into the proportion and layout of every suite and bedroom. There was for example a subtle and progressive reduction of ceiling heights. The public rooms on the ground floor had a floor to ceiling height of 19 ft 6 in. The first and second floor bedrooms had 12 ft ceilings, those on the third and fourth floors were 11 ft 8 in., on the fifth the height was further reduced to 11 ft 2 in. and on the sixth to 10 ft 4 in. The seventh floor, then reserved for staff, was well under the eaves of the mansard roof, with a height of just 9 ft 8 in.

Sitting rooms in one of the Green Park suites and (overleaf) a suite overlooking Piccadilly, with a close-up view of one of the central ceiling light fixtures with crystal lustres and four candle lamps used in both rooms.

96

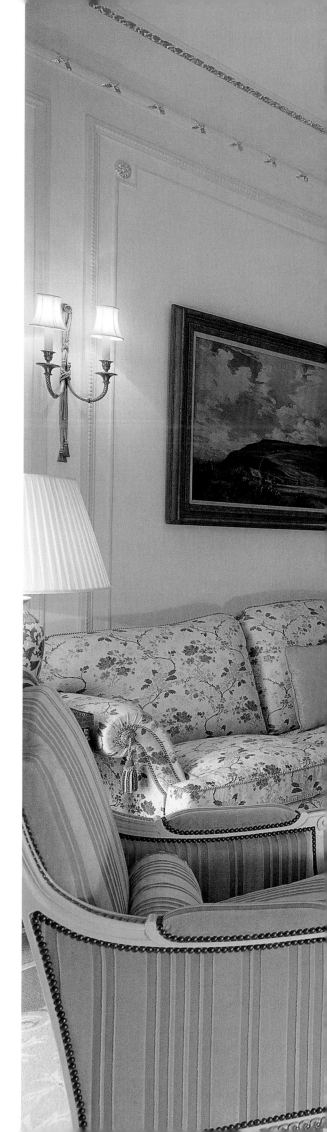

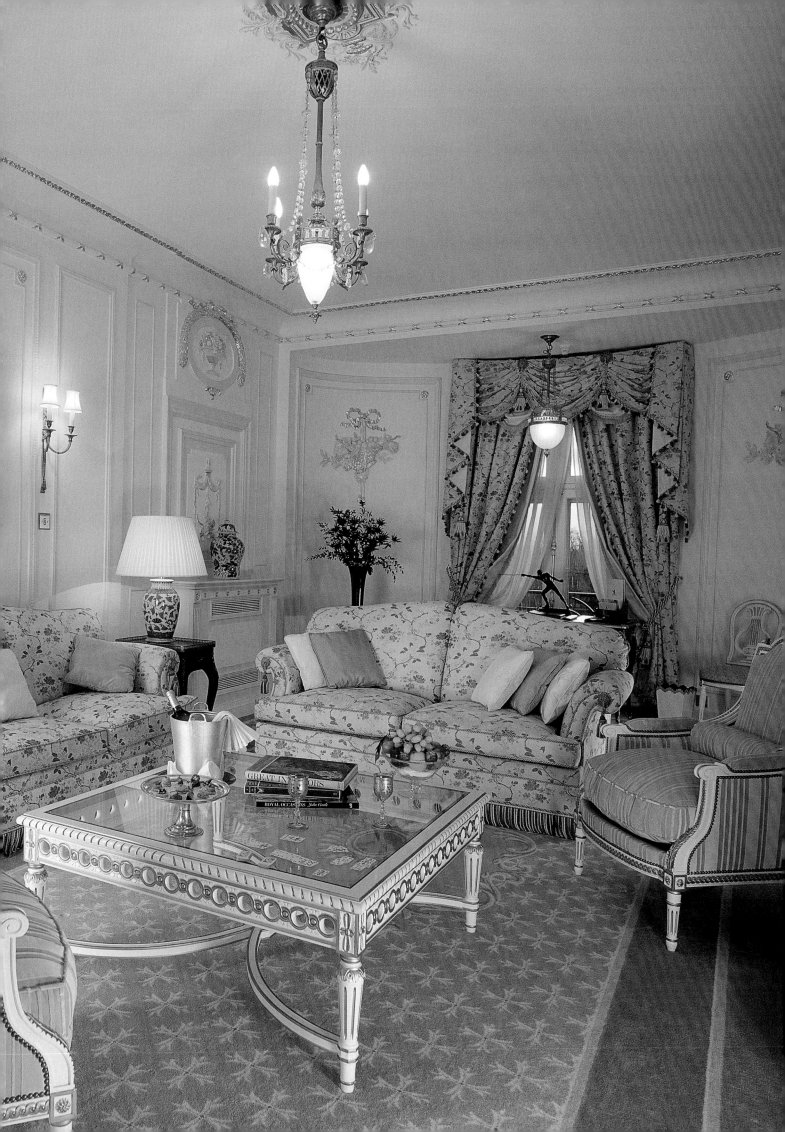

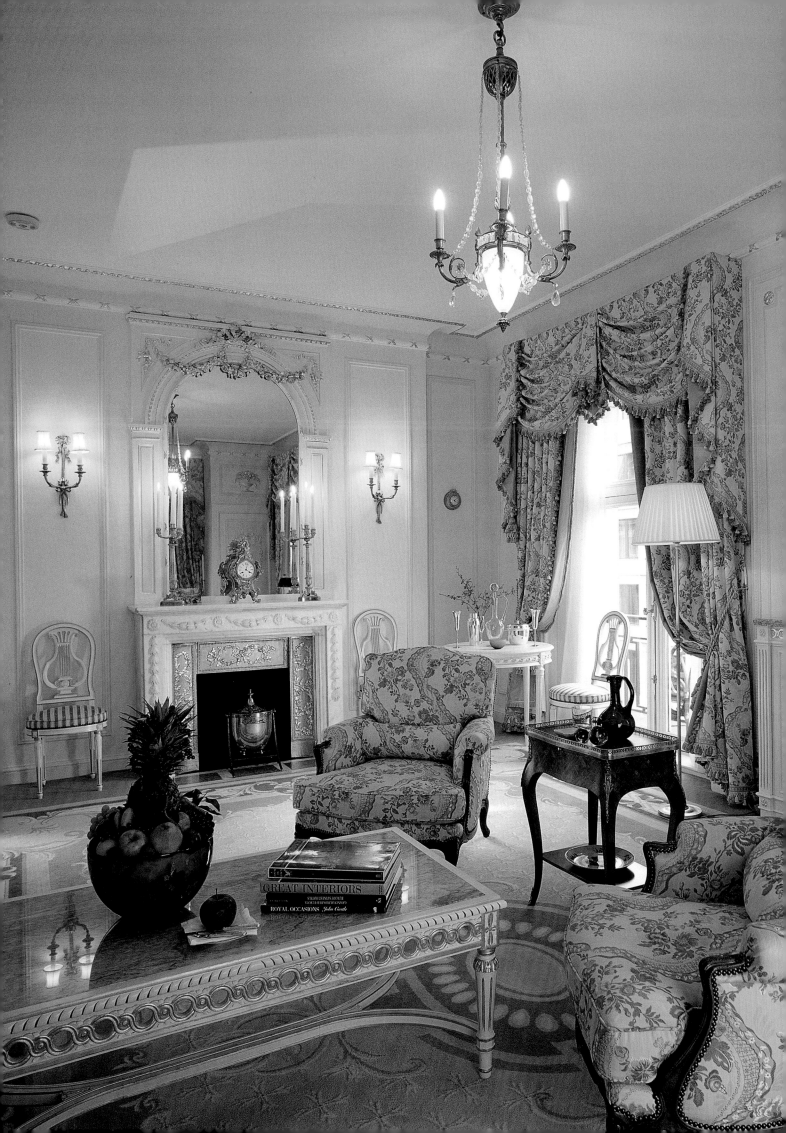

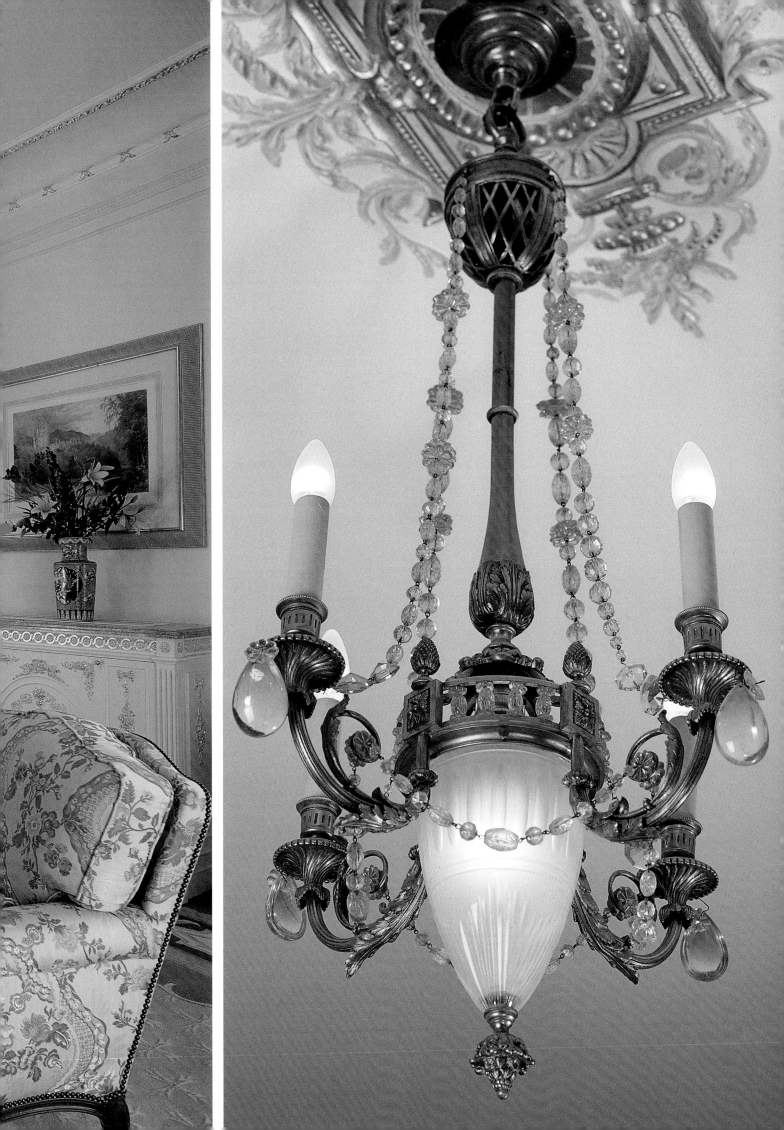

Early Cuisine

Looking at Edwardian menus today, it is hard to believe that diners could eat so many courses. Were some of these dishes simply offering a choice, say, between chicken or beef? Were other courses very small, like the miniature cup of soup served as an appetizer in the Ritz restaurant today?

An answer is provided by Diana's Diary in the now long-forgotten *Illustrated Sporting and Dramatic News*. Her entry on 1 November 1890, describing her stay at the newly opened Savoy Hotel, runs: 'Although Mr Ritz has gone to Cannes to open his hotel, cooking at the Savoy remains as it was. Bob and I and a couple of congenial souls dined there and we had one of the best cooked dinners we have had since we left Paris. . . . We commenced with Bortsch soup, the speciality of this restaurant . . . Then *filet de sole à la Savoy* was served. A perfect dish. The fillets are stuffed with finely chopped truffles, and covered in a white sauce, in which there are large pieces of lobster, truffles, mushrooms and all sorts of other things that taste nice. All this is laid on a bed of small macaroni. . . . I could have been content to make my dinner off this one *plat*, without going further. It was so good and delicate. Then came cutlets of chicken, with *quenelles* of truffles. Yes, I can find fault. The cutlets were too large and therefore made the dish somewhat coarse. (A general fault with restaurant cooking is to serve too large portions.) Next came a *fricandeau* of veal braised, and served with carrots and turnips. It was good but unnecessary when it was followed by the best tasting snipe I've eaten since I was in Ireland. The vegetable was artichokes, with a real Hollandaise sauce, and we finished up with poached peaches.' These had been lightly poached in boiling water, the skin removed and the fruit laid into an iced sauce flavoured with Kirsch and vanilla.

The first chef at the Ritz was M. Malley, who had come direct from the Paris Ritz. Before that he had worked in two great Paris restaurants, the famous Grand Véfour in the Palais Royal and the Café Anglais. As Lt.-Col. Newnham-Davis reports, Malley had a talent for inventing new dishes; those at the Ritz included a splendid dish of salmon with a mousse of crayfish, which he named after the Marquise de Sévigné, a reminiscence of his days at Vichy, and his Pêches Belle Dijonnaise. Russian soups were

a speciality of the kitchen – witness the opening dinner – and Malley had a Viennese pastry cook (the best and the most expensive). According to the colonel, Edward VII had a special fancy for cakes made at the Ritz, and a supply used to be sent to Buckingham Palace. The manager of the Ritz told the colonel this was 'a State secret for M. Ménager, the King's chef, might not have liked it to be known that anything from another kitchen entered Buckingham Palace' – a point which the colonel tactfully delayed reporting to his readers for several years.

By the time Newnham-Davis came to write about the Ritz, M. Kroell from the Berkeley had crossed Piccadilly to succeed M. Elles as manager. The menu (above right) the colonel sat down to eat with his guest seems long for two but, he assures us, it was 'an exceedingly light dinner, and we neither of us ate the tiny cutlets which were the *gros pièce* of the feast.' His description notes that the melon was delightfully cold; the Madrilène soup beautiful in colour and flavoured with tomato and capsicum; the sole admirable and served with small slices of apples and artichokes and with mussels, the apple giving a hint of bitter sweetness. The quails came to the table in an old blue willow pattern pie-dish filled with coxcombs (oysters) and truffles. The *poulet en chaudfroid* was a noble bird, all white, and in it and with it was a pink mousse delicately spiced with curry powder. The Ritz salad was of *cœurs de romaine* (Cos lettuce hearts), with almonds and portions of tiny oranges. The *Pêche Belle Dijonnaise* was one of the creations which had made Malley famous and was a combination of peaches and black currant ice with some cassis, a liqueur of black currants and was named from the old Burgundian proverb 'A Dijon, il y a du bon vin et des jolies filles'. For this magnificent dinner, washed down with a bottle of Roederer 1906, the bill came to £2 10s.

The Ritz banquets were altogether more elaborate affairs, though the colonel insists that they too were 'exceedingly light'. The menu of a banquet given by Lord Haldane in June 1912 is shown on the right. We are assured that the saddle of veal was the only substantial dish of the feast, while the *aiguillettes* of duckling were a special dish of the Ritz and the hotel's soufflés and mousses always ethereal.

Melon
Consommé Glacé Madrilène
Filets de Sole Romanoff
Cailles des Gourmets
Côtes de Pauillac Montpensir
Petits Pois
Velouté Palestine
Poulet en Chaudfroid
Salade à la Ritz
Pêche Belle Dijonnaise

Caviar d'Esturgeon
Kroupnick Polonaise
Consommé Viveur Glacé en Tasse
Timbale de Homards à l'Américaine
Suprême de Truite Saumonée
à la Gelée de Chambertin
Aiguillette de Jeune Caneton
à l'Ambassade
Courgettes à la Serbe
Selle de Veau Braisée à l'Orloff
Petits Pois. Carottes à la Crème
Pommes Mignonette Persillées
Soufflé de Jambon Norvégienne
Ortolans Doubles au Bacon
Cœurs de Laitues
Asperges Géants de Paris,
Sauce Hollandaise
Pêches des Gourmets
Friandises
Mousse Romaine
Tartelettes Florentine
Corbeilles de Fruits

VINS
Gonzáles Coronation Sherry
Berncastler Doctor 1893
Château Duhart Milon 1875
Heidsieck Dry Monopole 1898
G.H. Mumm 1899
H. Croft's Port 1890
La Grande Marque Fine 1848

The early menu covers were almost certainly designed by Arthur Davis, and have a strong resemblance to eighteenth-century engravings by Neufforge which the architects are said to have used. One of the most elegant, used for a dinner on 29 June 1906, soon after the opening, features the characteristic Roman fasces gracefully entwined by serpents. Others still in use in 1916 are draped with the swags of flowers that Davis used so frequently in the decoration of the hotel.

The event that transformed Ritz's career more than any other was his partnership with the great chef Escoffier, who came to London with Ritz in 1890 to take over the Savoy and subsequently helped him open both the Ritz in Paris and the Carlton in London. Ritz had astutely realized the path to success lay in attracting fashionable society to the restaurants of his hotels. This was one thing in a resort such as Monte Carlo or Baden-Baden, where guests might naturally eat in the hotel restaurant, another in a capital city like London or Paris. In London, hostesses entertained exclusively in their houses, and their husbands, when they went out, would dine at their clubs. Ritz and Escoffier saw a new way forward – to prepare meals that would appeal directly and primarily to the ladies, offering not the great roasts and cassoulets, but food that was light and attractive to the eye. Another of Escoffier's great changes was to replace the traditional *service à la française* by *service à la russe*. His grandson Pierre Escoffier recalls, 'the great chef Carème had established a system of enormous show pieces. One great *plat* might consist of three different dishes, say lobster, game and beef. You wonder how diners made a choice – or did they simply have to eat what happened to be nearest to them?' *Service à la russe* by contrast consisted of waiters offering successive dishes around the table – a practice that continues to this day at formal dinner parties in some private houses. Latterly it has been largely replaced in hotels by *service sur plat*, where each course is arranged on the plate before it leaves the kitchen.

Menu for a dinner held at the Ritz on 29 June 1906, the cover featuring fasces entwined by serpents.

LIFE BELOW STAIRS

The world behind the green baize door, the upstairs-downstairs life of an aristocratic mansion, has been a source of intense popular fascination in recent years. The nether world of a grand hotel is naturally even more remarkable in this respect. A vivid description of life in the kitchens of one such London hotel is provided by Pierre Hamp in *Kitchen Preludes*, published in 1932. Hamp was a remarkable character who began life as an apprentice pastry cook and later became a factory inspector, writing a whole series of books and novels about different trades and professions. Life as a pastry cook in Paris was hard, and his great break came when Escoffier agreed to take him on at the Savoy.

What delighted the young Hamp was the abundance of good food, very different from the communal bean stew and occasional boiled beef in Paris. At the Savoy, 'we lived off fresh meat, taking whatever we fancied off the ice and cooking it on the grill. I was able to fill myself up with beef-steaks and mutton-chops.'

An added reason why French staff were favoured in the kitchens was their willingness to work long hard hours. Many young Frenchmen came from families with their own restaurants and hotels, or had aspirations to start one. The French cooks would watch in amazement as English building workers promptly laid down their tools as soon as the signal for a break was given. If one of them was halfway up a ladder, Hamp relates, he would come down and put his hod on the ground rather finish his climb to the top. For Hamp and his colleagues at the Savoy, it was 'the

commands of the diners we had to obey, not the law. No matter how tired we were, we had to do our job creditably and carry out the orders yelled at us as well and as quickly as possible. Our calling required a soldier-like devotion to duty.' A diner's impatience could lead to the dismissal of a cook. Meals had to be ready in a certain number of minutes, no matter how many guests appeared. 'The breathless speed at which we worked, while having at the same time to exercise the greatest care, explained our contempt for the slow-moving builders whose unruffled brows were never bedewed by a single drop of sweat; whereas we men round the stoves were wet through with it.'

Life in the kitchens of the Ritz was similar to the kind of smooth-working world beneath the pavements that Hamp evokes. The hotel was built with a double basement, providing extensive accommodation for food storage, preparation and staff. At the Green Park end, however, the Banqueting Hall occupied the full height of both stories, as did the private dining rooms, Grill Room (see pp. 66-71) and the wine cellars situated under the Piccadilly arcade.

The lower basement level (2A – see plan overleaf) contained a staff kitchen, as well as a series of individual dining rooms – for valets, waiters and workmen; for porters; for couriers; and for clerical staff. There was also a huge fan room, a room housing the motors for the lifts, another housing the cold-storage plant, the boiler house and separate cellars for steam coals, kitchen coals, and house coals. From the lower level there was an 'open wood step ladder up to [the] upper part of the wine cellar'. There was also a staff dressing room and three sets of staff lavatories, as well as various service rooms.

The lower ground floor, where the main kitchen was located, was laid out with separate functions on either side of a long corridor or gangway, the kitchen area on one side and cool storage rooms on the other. Stairs led up to the Restaurant and down to the Banqueting Hall at the Green Park end. A third stair more centrally placed led down to the Grill Room and private dining rooms. The kitchen originally had natural light and ventilation at either end from windows looking onto two open courts. Opening off the kitchen was a scullery.

Ranged opposite the kitchen for ease of access was a series of stores. Those for glass, china, silver and plate were followed by the food stores –

the first for hors d'œuvres had two walk-in cold cupboards – preceded by lobbies. Facing the kitchen was a large day cellar, with two very sizeable racks or cupboards for champagne, backing onto the hors d'œuvres cold cupboards. A spacious room marked 'larder entrance' led on to the General Larder and Butcher. From here, two small lobbies, each with double doors, opened into separate cold stores for meat and game. Further along was a large still-room and next to it an ice room with adjoining cooler and cold cupboards. At the Arlington Street end was the Pastry Room with two large ovens and the kitchen stores. All this corresponds with the layout described by Louis Léospo in his treatise on the hotel industry, first published in 1918 but largely written before the First World War. In the sous-sol, he says, are to be found the kitchen and associated offices, the stores, the cafetière, the wine cellars, the dining rooms for staff and couriers, the plant rooms, the heating, the workshops.

The introduction of refrigeration naturally changed the whole pattern of food storage. You might not expect *The Cold Storage and Ice Trades Review* to be much of a read, but the issue dated 15 December 1905 provides a vivid description of the problems that manufacturers faced in coping with situations where staff were working at a hectic pace. 'Possibly the most difficult task which refrigerating machinery can undertake is the maintenance of definite and low temperatures in cold rooms and refrigerators at hotels, the kitchen staff of which is composed, as it almost always is, of Frenchmen. Apparently the laws of heat and cold across the Channel are entirely different – I have been told that in Paris and France the cold rooms generally get much colder if the doors are left open. Add to this the fact that a French cook is the most hustling person in the world and never has time to shut a door.'

By 1900 the London County Council fire regulations were already very strict and precise details are given on the floor-plans. 'Doors marked fire-resisting will be self-closing, of hard timber, 2 inches thick, and where glazed, the glazing will be of fire-resisting glass divided into panels the length or breadth of which will not exceed 2 feet.'

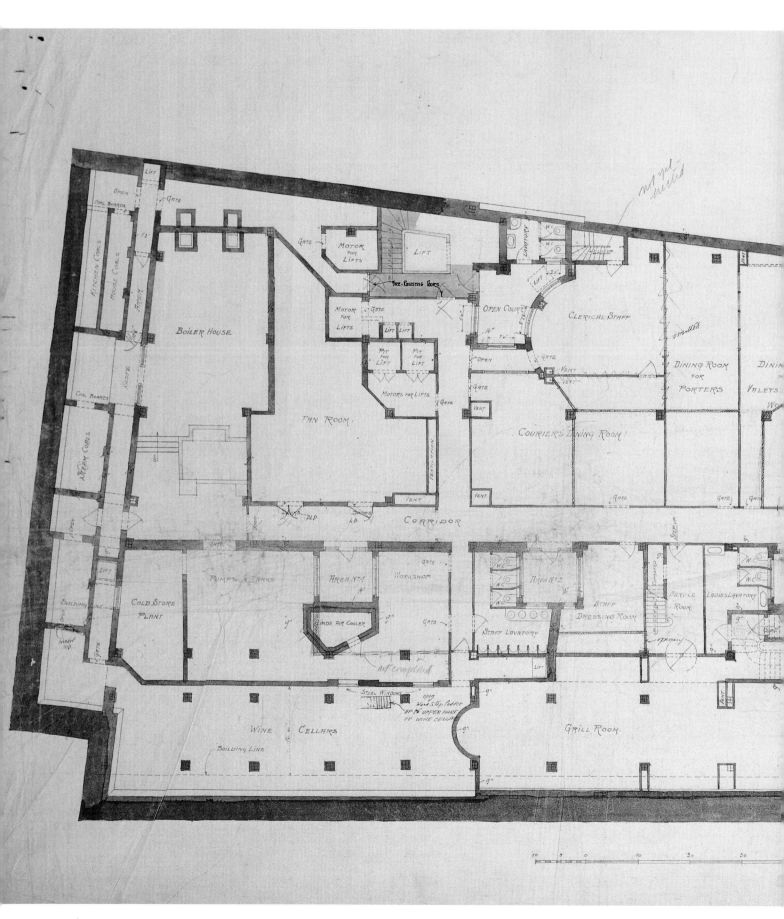

Architects' plan of the lower basement level (2A)
showing storage and working areas.

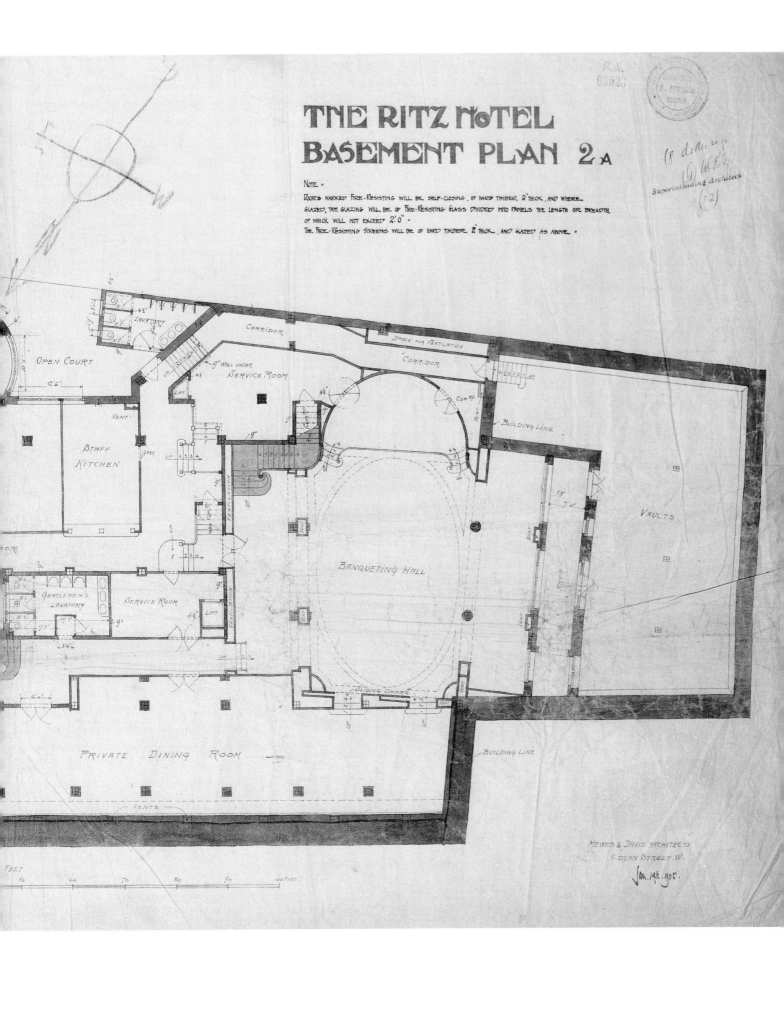

THE RITZ HOTEL
BASEMENT PLAN 2A

NOTE.

DOORS MARKED FIRE-RESISTING WILL BE SELF-CLOSING, OF HARD TIMBER 2" THICK, AND WHERE
GLAZED, THE GLAZING WILL BE OF FIRE-RESISTING GLASS DIVIDED INTO PANELS THE LENGTH OR BREADTH
OF WHICH WILL NOT EXCEED 2'0".
THE FIRE-RESISTING SCREENS WILL BE OF HARD TIMBER 2" THICK, AND GLAZED AS ABOVE.

R.A.
03923
Superintending Architect

OPEN COURT

LAVATORY

CORRIDOR

SPACE FOR VENTILATION

CORRIDOR

SERVICE ROOM

9" WALL UNDER

CUPBD

BUILDING LINE

STAFF
KITCHEN

VENT

GATE

VENTILATION

VENT

VAULTS

GENTLEMEN'S
LAVATORY

SERVICE ROOM

LIFT

BANQUETING HALL

PRIVATE DINING ROOM

VENTS

SLIDING DOORS

BUILDING LINE

MEWES & DAVIS ARCHITECTS
6 DEAN STREET W.
JAN. 14th. 1905.

FEET
50 60 70 80 90 100 FEET.

Silverware and China

Mewès had ordained that the style of the Ritz should be purest Louis Seize. To Waring & Gillow fell the task of finding craftsmen who could achieve the quality and authenticity desired. According to the *Ritz Monthly* in 1906, 'Ritz, the Napoleon of hotels, had opened a new path to the hotel industry, completely transforming the character of these edifices.' Ritz wanted to create a grand hotel having the atmosphere of a beautiful aristocratic mansion, and this meant surrounding guests with 'the works of art, the luxurious furniture, and above all the beautiful silver ware to which they are accustomed'.

For this, the Ritz turned to the great Paris firm of Christofle & Cie, which still flourishes today, with its own well-ordered archives and museum at Saint-Denis, just north of Paris, and the Goldsmiths' and Silversmiths' Company of London. The latter is not to be confused with the Worshipful Company of Goldsmiths, one of the leading City livery companies; it was a firm of silversmiths specializing in supplying the needs of major hotels and other large organizations, both government and commercial; based at 112 Regent Street, it was later absorbed into Garrard's and now into Asprey's. According to the *Ritz Monthly*, more than three thousand separate large pieces of plate were supplied to the hotel, consuming over five and a half tons of metal in their manufacture.

The style adopted was predominantly Louis Seize, but Christofle had made a beautiful Régence service for the Paris Ritz (in the style of the early

OPPOSITE

A selection of the Ritz's silver-plated tableware and decorative candelabra, much of which was specially designed in 1905 and made for the Ritz by Christofle & Cie of Paris.

BELOW

Designs for individual pieces of silver teasets supplied by Christofle & Cie

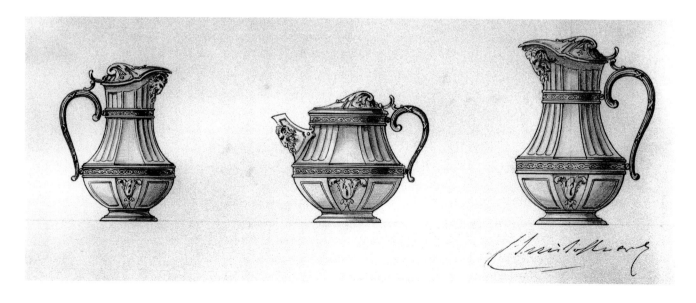

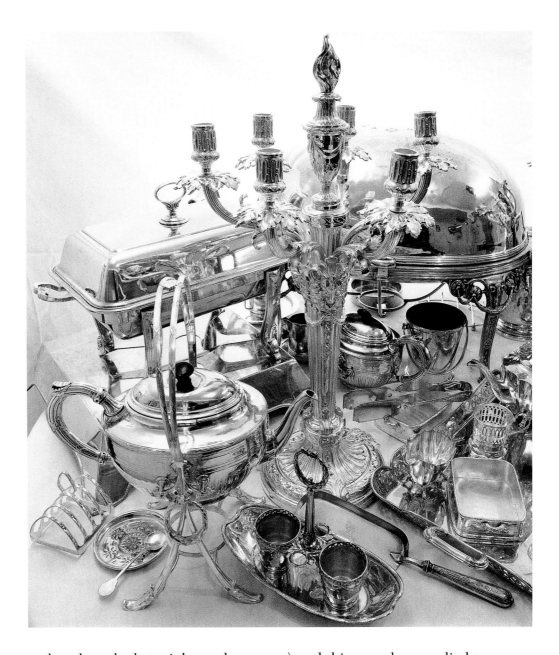

rather than the late eighteenth century) and this was also supplied to
London. Foremost among the items supplied is a series of splendid six-arm
candelabra, each with a central flaming urn, which still regularly grace the
Restaurant dining tables. The most beautiful individual pieces are a series
of champagne buckets (described as champagne ice pails) on elegant tripod
stands. These have delicate ram's heads and feet and echo the design of
later eighteenth century neo-classical engravings. An engraving by Vien of
1763 shows just such a stand smoking with incense – Christofle ingeniously
adapted the bowl to catch the condensation from the ice bucket. For the
London Ritz, Christofle supplied in addition spoons, forks and knives,
oil-and-vinegar stands, salt cellars, pepper grinders, and plain and cayenne
pepper boxes, tea caddies, sugar basins, bowls, candelabra, flower vases,

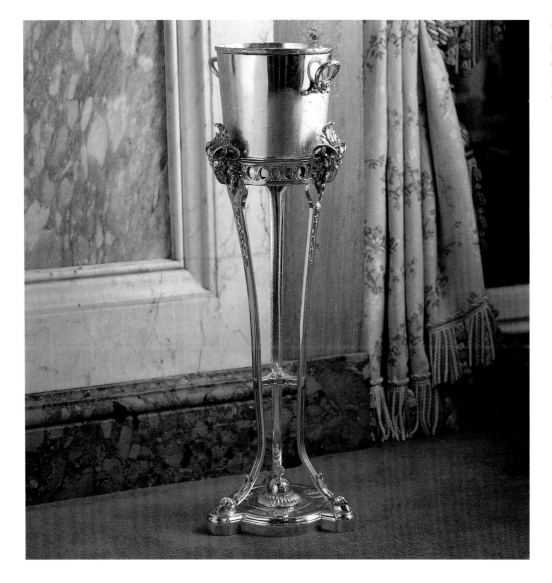

One of the elegant silver-plated champagne buckets on its tripod stand designed for use in the Restaurant by Christofle & Cie.

tea and coffee pots, milk and boiling water jugs, 'the number of which is over 19,300 pieces'.

This was all very different from today's trend of *service sur plat*. The Goldsmiths' and Silversmiths' Company supplied a silver-plate service that included covered vegetable dishes, sauce boats, soup tureens, dishes and matching domes and fruit timbales. The Goldsmiths' and Silversmiths' Company were not manufacturers, but acted for a whole range of master cutlers in Sheffield. The Ritz service was not solid silver such as might have been found in an aristocratic household, but the finest plate available. The best plate at the time was supplied by Elkington & Co., who had developed a system of triple plating – known as 'life-time' plating. This silverware contrasted with standard 20-year plate or 10-year plate (single plated). *The Caterer and Hotel-keeper's Gazette* confirms in 1906 that 'Elkington have supplied a good proportion of the plate'.

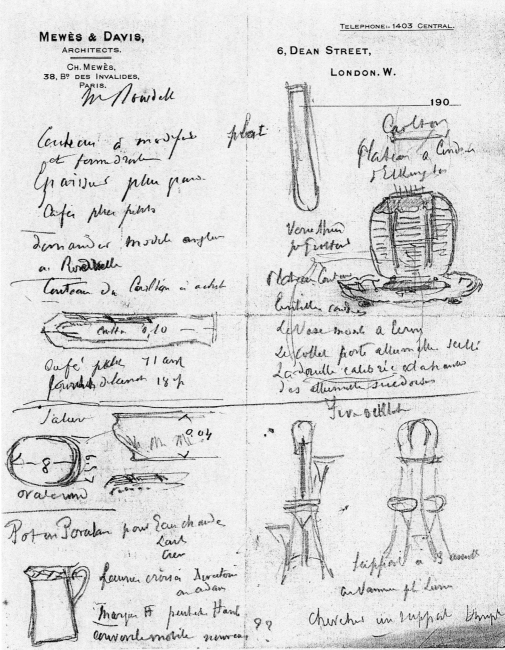

Design sketches for tableware supplied to the Carlton and Ritz Hotels, and (lower left) an original duck press.

A letter to Christofle from the Blackpool Building & Vendor Company (the company name was only changed in 1906) dated 9 October 1905 mentions designs for salt cellars (*salières simples*) and for match stands (*porte-allumettes avec plateau*), but cancels designs for toast racks and bottle stands.

Another letter to Christofle, dated 29 September 1905 and written from the Carlton Hotel, is of the highest interest as it shows that César Ritz was still taking an active, if restricted interest, in the equipping of the London Ritz. He regrets that he has arrived in London too late to modify the

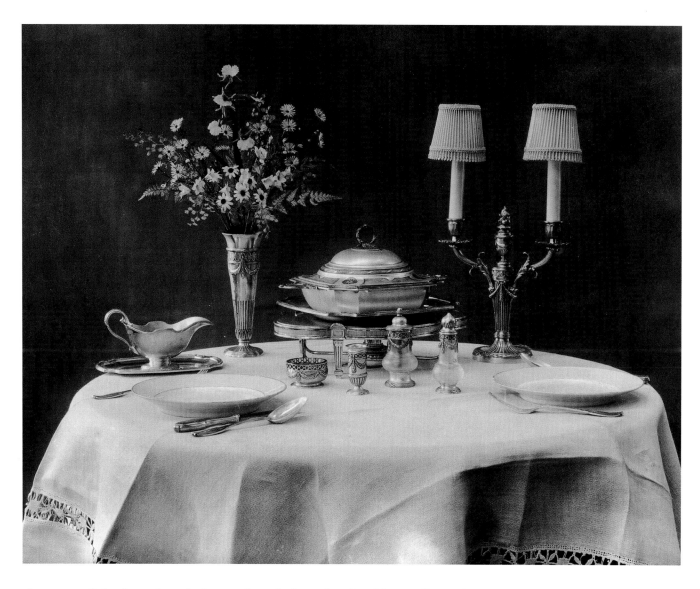

decision of the board and obtain the whole order for Christofle. The Board decision, he writes, is 'to give to Christofle everything which will be set on the table . . . to the English Silversmiths everything that serves for the kitchens and offices'. As if to soften the blow, Ritz adds: 'I do not wish to leave London without telling you that I am nonetheless satisfied with the result obtained, as everything which the public see, everything that will be held in the hand will be of our house and will do honour to the name Christofle and the name Ritz, which has done so much for the well-being and the comfort of travellers.'

Christofle were not going to give up easily, however, and had written the day before offering a new price. The letter mentions 'studies we have been preparing over more than six months for the silverware [*orfèvrerie*] destined for the Ritz Hotel now under construction', and recalls the fact that M. Mewès, after his last visit to London, had told them it was only

A table setting photographed in 1906, showing a selection of original silver pieces.

OPPOSITE

A group of Ritz table china, including examples of dinner and tea wares in use at various times. The original services were supplied to the hotel by Doulton & Co.

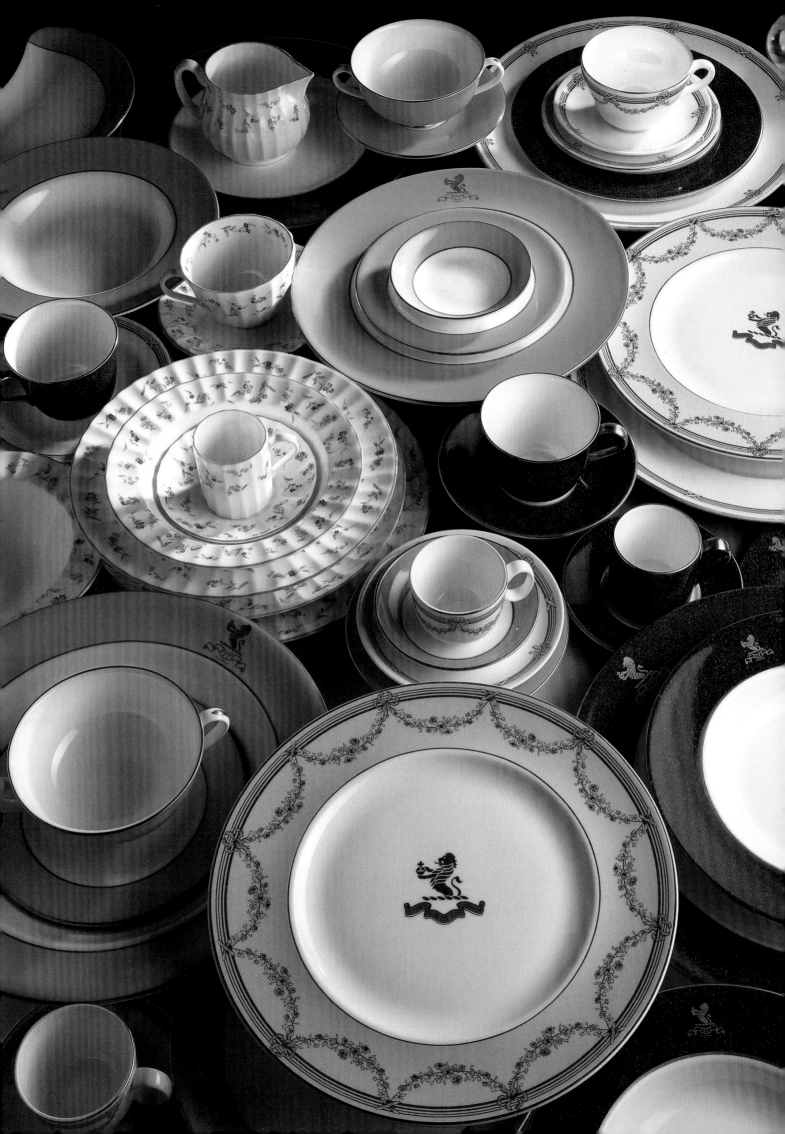

a question of price and advised Christofle to prepare a new proposal. The letter then continues: 'On the advice of M. Mewès, who saw with regret that the models . . . prepared under his direction were not accepted by the board', the firm's representatives had decided to come to London in person to give explanations.

The prices come tumbling down from 260,083.95 francs to 196,484.60, with discounts of 25% on the *couverts* and 20% on the *orfèvrerie*, and the letter from Christofle ends by reminding the Ritz Board of the enormous sacrifice the firm was making – thus proving that their interest was more a matter of honour for the House of Christofle than one of profit for the company's shareholders.

The china services for the new hotel, boasted the *Ritz Monthly*, were inspired by some of the finest designs of the Louis Seize period. The entire set, numbering over 20,000 items, was made by the King's Potters at the Royal Doulton factory in Burslem, one of the famous five towns making up the Potteries centred on Stoke-on-Trent. The various services included one for luncheon with entremets plates decorated with a narrow turquoise-blue band edged with a gold line and scattered roses. The same design was repeated on the breakfast cups and saucers. The dessert service was adorned with festoons of pink roses, with plain blue lines and a gold band as edging, with matching coffee cups and saucers. The cups and saucers used for afternoon tea, as well as the cake and bread-and-butter plates, were decorated with a blue forget-me-not design. The hallmark of the hotel dinner service design was simplicity – all plain white, with some pieces emblazoned with the Ritz crest and others decorated with a broad turquoise band and gold lines.

In 1906 Doulton was still a relative newcomer to the Staffordshire Potteries. Founded in London in 1815, the firm had prospered as the manufacturer of stoneware drainpipes which heralded the dawn of modern sanitation. Henry Doulton had bought a factory in Nile Street, Burslem, in 1877. He had rapidly overcome the problems facing an interloper in the Potteries and in 1887 had become the first potter to be knighted. Later, Edward VII granted the company a royal warrant and authorized it to use the 'Royal' prefix in describing its wares and factories. After moving to Burslem, the firm began to concentrate on producing high-quality hotel ware, as well as sanitary ware.

LIFE IN THE RITZ

Following the outbreak of war in 1914, Kroell the general manager resigned and all the German and Austrian staff were told to go. A new law made it compulsory 'to accept English officers and members of their families at all hotels at ten shillings a day each, including rooms and board'. Though the streets were dark, and everything had closed by 10 p.m., the bedrooms were well occupied. In September 1917, a bomb exploded in Green Park, shattering the windows of Wimborne House next door, but the Ritz survived the war unscathed. A picture of life in these times is given by the long-serving hall porter, George Criticos, in his memoirs, *George of the Ritz*. 'Every day one or other of the directors, Mr Harry Higgins, the Marquis d'Hautpoul or Lord Lurgan, would be in the hotel to chat with the guests, of whom the majority were their personal friends, and to keep a vigilant watch on every detail of the service, administration and maintenance.'

In September 1921, when Charlie Chaplin made a triumphant return to London after an absence of nine years, forty policemen were needed to shepherd the star to the Ritz, where a first-floor suite on the corner of Arlington Street had been prepared for him. However, the presence of cheering crowds made the Ritz wary of stars for years to come, though those who arrived more discreetly, such as Douglas Fairbanks in the 1920s, were welcomed. Noël Coward, another famous *habitué*, penned the lines

Children of the Ritz
Sleek and civilized
Frightfully surprised
We know just how we want our quails done
And then we go and have our nails done

Other frequent visitors between the wars included the Aga Khan; he would place all his bets, running into thousands of pounds a year, through George, who also had the task of receiving telephone calls, telegrams and parcels of money sent to the Aga Khan by his ten million Ismaili followers. Another, King Boris of Bulgaria, had a passion for steam locomotives. Early one morning he returned to the Ritz from Euston, his face black with soot after riding on the footplate of the night express. 'Don't you recognize me, George?' he asked on being told to take his delivery to the coal chute. King Zog of Albania was an altogether more dapper figure, who arrived in 1940 with a lorry-load of luggage guarded by eight fearsome looking Albanians. This included gold (later transferred to the Bank of England) which had to be stored in the hotel strong room. Every week the King's secretary, Mr Martini, would withdraw a £1,000 banknote to pay the hotel bills for the thirty-strong entourage.

Both the Gulbenkians, father and son, were patrons of the Ritz. Calouste, known as Mr Five Per Cent, once asked George to accompany him to his apartment, saying 'I have something good for you'. In the room Gulbenkian *père* pointed to a case and told the hall porter to take it home. Full of anticipation, George finally opened it, only to find that it contained nothing more exotic than carrots; raw carrots, it seems, were one of the oil tycoon's favourite foods. Nubar Gulbenkian had his eccentricities too – he always insisted on having a candle and matches placed by his bedside for emergency use long after the end of the Second World War had rendered them unnecessary.

An amusing vignette of life at the Ritz in the 1930s is provided by *The Bystander*, which ran a monthly column 'London Nights' describing the life of leading hotels. 'The Ritz is terrifically sophisticated and smart, especially at lunch time. If you're a woman, don't go there unless you've got the greatest confidence in your clothes.' The set-lunch price at this time was 8s 6d and booking was essential as the restaurant and approaching passages were always packed. Theatre dinners began at 10s 6d; a full five-course dinner, including oysters or caviar, cost 17s 6d; after-theatre suppers could be had for 15s 6d. 'How Aletto manages to conjure tables from palm trees and chairs from marble pillars is as unfathomable as the Indian

Life at the Ritz: sketch by John Reynolds published in *The Bystander*, 23 October 1934, with the caption 'One of "Les Girls"'.

New Year's Eve 1950-51

RITZ-HOTEL.
W.1.

Gala dinner menu on the occasion of the Coronation of King George VI and Queen Elizabeth, 12 May 1937.

Menu cover, New Year's Eve 1950, at a time when postwar austerity in Britain was coming to an end.

rope-trick, but he repeats the miracle daily with unfailing aplomb,' wrote *The Bystander* on 20 January 1937.

After war broke out in September 1939, the cliff-like solidity of the Ritz, with its steel frame and concrete floors, was to prove a positive boon. Elegant meals continued to be served in the Restaurant but very quickly the hotel had also opened the fashionable version of a dugout – a new night-spot in the basement bar and grill known as La Popote. The interior was buttressed with sandbags, struts and crossbeams. Chandeliers were wittily formed of old champagne, brandy, liqueur and beer bottles with candles stuffed in their necks. Allied generals and naval officers in uniform thronged the dance floor.

Sure enough, Lord Haw-Haw got to hear about this and in his propaganda broadcasts from Berlin sneered that only plutocrats could enjoy such luxuries. In fact, prices were well below the highest – two of the new blue £1 notes sufficing for supper, wine included. During the Blitz a team of fire watchers stood guard on the roof of the Ritz, putting out incendiaries with sand and stirrup pumps. Seven heavy bombs landed in the streets nearby, as well as a massive land-mine in Stratton Street. The Ritz itself was struck twice. A 250-pound bomb made a direct hit on the sixth floor, twisting steel girders and destroying two suites, and two 500-pound bombs landed on the terrace facing the park, penetrated to the basement and did severe damage to the refrigeration plant. But the Ritz was lucky compared to its sister hotel, the Carlton, which was badly damaged by bombing and never reopened.

Owing to restrictions on building activities after the War, it was not until 1947 that the Ritz received permission from the Ministry of Works to carry out essential renovations. Sir Bracewell Smith, Bt, who had steered the hotel through difficult years, had earlier come up with a regrettable plan to redecorate the interior in modern style. The author James Lees-Milne relates in *Caves of Ice* (1983) how the interior decorator Sybil Colefax told him, over lunch at the Ritz, that before the war the management had called her in to redecorate the hotel. She not only turned the commission down but told them that if anyone else took it on she would have questions asked in Parliament and induce her friends to write angry letters to *The Times*.

In 1960, a recommendation to list the Ritz Hotel as a building of
special architectural interest was quietly shelved. Five years later,
Richard Crossman, who as Minister of Housing and Local
Government at last gave the listing system some teeth, announced the
listing of the Ritz at question time in the Commons, deploring the
delay. David and Frederick Barclay, who acquired the Ritz in 1995,
had first offered to buy the hotel in 1971 for £4 million. In 1970, they
had become friends with Sir George ('Guy') Bracewell Smith, Bt, and
begun a series of regular visits to each other's hotels. The Barclays
owned the Londonderry Hotel, and Guy Bracewell Smith took
a particular interest in the food at the hotel's restaurant, the Ile de
France (then under the chef Gerhard Reisepatt), as well as the
Lowndes Hotel in Lowndes Square, which the Barclays had built
with the developers Capital & Counties Properties.

Guy had inherited both the family title and the Park Lane Hotel
and the Ritz Hotel from his father. He took a great interest in the
running of his hotels, and spent most of his time between the two.
He was a connoisseur of good food and wine and a great authority
on César Ritz and Escoffier. In 1971 he presented the Barclays with
Stephen Watts's book on the Paris Ritz inscribed 'To my good friends
David & Frederick who follow in the master's traditions'.

During the stock-market crash of 1973–74, Guy became very
concerned. He had very large investments in the stock-market which
had dropped considerably in value and both his hotels were trading
badly. He was also chairman of Arsenal Football Club and chairman
of Wembley Stadium and owner of a racecourse. It was during the
worst period of 1974, when the stock-market had reached its lowest
point, that, at one of his usual four-hour lunches, well fortified with
good claret, he walked across to the table of Lord (Victor) Matthews,
managing director of the Trafalgar House Group and said to him,
'You always wanted to buy the Ritz Hotel. I will sell it to you on
condition that you buy it this afternoon.' The price he quoted was
£3 million, and Matthews replied, 'I will do it this afternoon, but it
has to be £2.7 million.'

The transaction was duly agreed. When Matthews arrived at the
next meeting of the Trafalgar House Board, he informed the Directors

DERBY DAY

Menu covers for the Ritz's
annual Derby Day dinners
in the 1930s.

that he had acquired a hotel, and that if they did not want the company to buy it, he would raise the money himself. This was at a time when, due to the adverse financial climate, the Board had decided against any further acquisitions. When the Ritz was mentioned, however, opposition quickly melted away.

In April 1974 the Board agreed the sale of the hotel to the Trafalgar House Group for £2.7 million. The immediate cause was that the directors felt they could not afford to carry out much-needed modernization, the cost of which had been estimated at £4.5 million. In February, the Ritz had just announced a thumping loss of £109,710 in the previous year, compared to a modest profit of £28,869 the year before. Minority shareholders, who had seen the value of their shares plunge from £20 to about £6, were incensed; they claimed that leading hotel groups from Britain and overseas had shown interest, including Americans, Italians, Canadians and even a group of Iranians (though they 'disappeared into the sand' after the Greater London Council turned down a plan to convert the top two stories into offices). The Board insisted that no-one had come forward with a better offer and that the hotel was only worth what someone would pay for it.

Lord Matthews, Trafalgar House's managing director, said his plan was to revive the Ritz by promoting it jointly with the liner *QE2*, flagship of the Cunard Line which the group also owned. 'Everything will be discreet. But on board the *QE2* it will be easy to remind Americans coming to London that the Ritz still exists', he said, adding cautiously that the new owners would popularize it a bit. The renovation was controversial. All the magnificent original brass bedsteads complete with handsome pineapple finials (similar to those supplied to the Paris Ritz) were thrown out. New bedrooms were created by adapting the sitting rooms of the suites overlooking Piccadilly and using the old chauffeurs' rooms at the back of the hotel facing Wimborne House, and a great furore was caused by the removal of the original Ritz bathrooms, with their marble floors, tiles and Doulton baths and basins.

In the early 1990s day-to-day management of the hotel was handed over by Cunard to the Mandarin Group (which had shareholders in common), owners of Hong Kong's fabled and gloriously traditional Mandarin Hotel. Less popular was the management's attempt to replace the Ritz lion (emblem of the hotel from its opening) with the Mandarin fan.

Naturally it is the staff of the Ritz themselves who provide some of the best recollections. Michael de Cozar, the present hall porter, started at the age of fifteen in 1973. 'I had been coming for two years already, helping my father who worked in room service. I assisted him in the evenings preparing tables.' He began officially as a page-boy. 'Most of the staff had been here a very long time. Everybody had a nickname. In the staff canteen ladies sat on one side, sectioned off, and Walter Green who ran the canteen would go mad if any of us sat down there. Everything in those days was done in the hotel, even the printing. At busy times the hotel would take on college students who served as chambermaids and cleaners and had living quarters on the seventh floor.'

Regular clients would ask not for a specific room or type of room, but a particular floor. In those days people had got to know the permanent staff from previous visits and would often change the day of their arrival to be sure of getting a room on the floor they wanted. Each floor had a maid at either end (some had been at the hotel for 40 years or more), and a valet who unpacked for the guests. 'A client didn't have to ask for breakfast. The staff already knew the order. Toast, buttered or not. Porridge with salt or sugar', recalls de Cozar.

Many guests gave lunches and dinners in the private suites. The waiter would be in attendance serving canapés. A commis chef would be on hand to take orders. 'In those days no-one phoned for service. You rang the bell and a light would come on in the corridor, yellow for the maid, green for room service and red for the valet.' The magnificent enamel baths caused their own problems, for they had 'no handles and the valet often had to help elderly clients out'.

A page-boy would often be sent out on shopping errands, not only by hotel guests but by regular clients who suddenly found themselves in need and rang for assistance. 'Go to the shirtmakers, buy some chocolates at Charbonnel et Walker. I'd get a list of shopping that might take two or three hours.' Page-boys were also required to make deliveries from hotel to hotel and to rush to the bookmakers to place bets for guests.

Many suites were occupied on a permanent basis. An overseas client might come from South America for two or three months. One American gentleman always came with his butler, who would fly over in advance to ensure that everything was prepared.

Cartoon from the series
Lee's London Laughs
(originally published in the
Evening News): the Ritz
doorman bristles as he is
asked 'Do you serve fish
teas?'

The doormen were usually ex-Guardsmen, over 6 ft tall. One of their tasks was to polish the brass handrails and clean the marble entrance steps twice a day. In those days it was usual for the doormen (and the cloakroom attendants) to pay the hotel for their position. The luggage porters would come in at 6 a.m. Their duties included hoovering the front hall and polishing the reception desk. Night porters came on duty at nine in the evening and continued till nine the following morning. One of their jobs was (and still is) to clean all the shoes left outside bedroom doors and deliver the newspapers. The aim was in part simply to stop them dozing off while on duty.

Then as now, the hall porters kept a service book. 'Whatever the request, we would respond to it. If someone wants a bathrobe, I would never say ring the housekeeper. If a guest rings up at two in the morning wanting tickets for the opera the next evening, it will be put in book and dealt with the next morning. No-one will ever be asked to ring back. If someone wants a prescription at three in the morning, we will get it. The hall porter's job is all about dealing with impossible requests', says de Cozar.

A big change has come with the disappearance of the liftman, who in years past could make a living from the guests. At the back of the lift there was a small shop stocked with packets of cigarettes, newspapers, sweets, headache pills, shaving cream and the like. Most of the money was made when guests said carelessly 'keep the change'. Problems arose if the liftman happened to walk off deep in conversation with a guest, for the page-boy then had to be sent haring up the staircase to retrieve the lift, if necessary without the liftman. The liftman also acted as hotel security. If he had doubts about anyone, he would say 'Please contact the porters' desk so that they can announce you.'

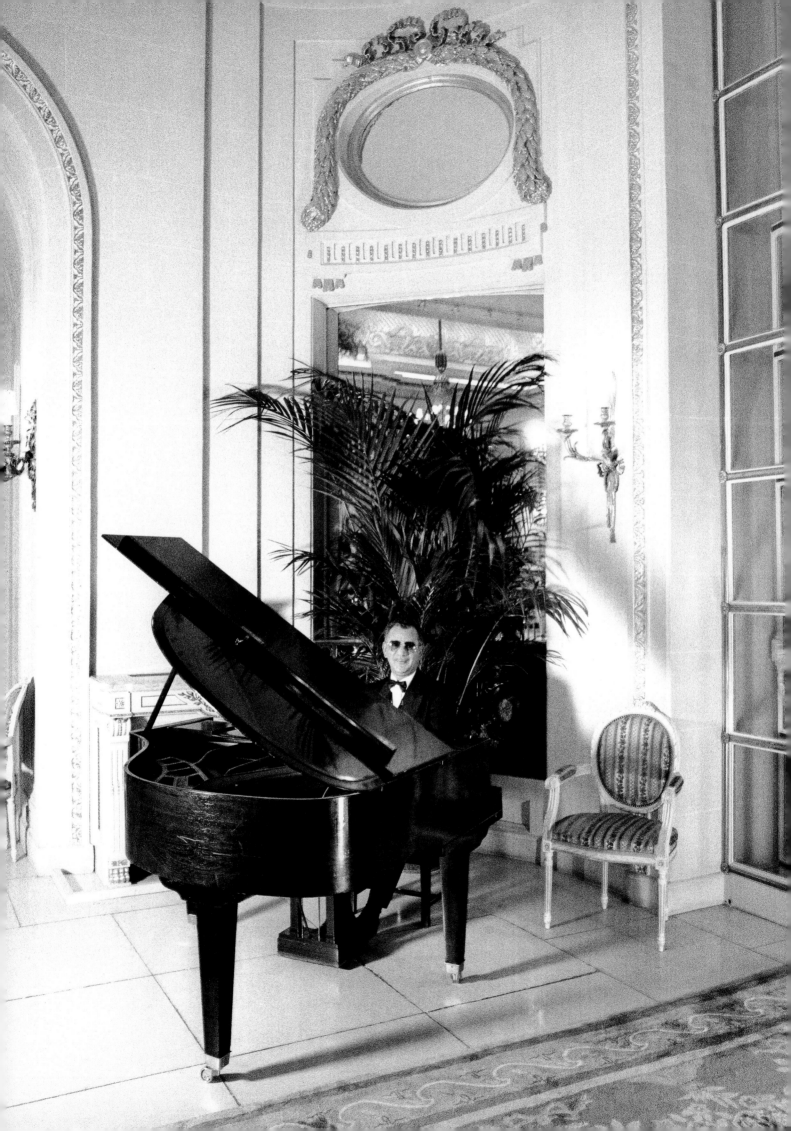

NEW OWNERSHIP

When David and Frederick Barclay acquired the Ritz in October 1995, the hotel had been for sale on and off for several years. Trafalgar House had sold the Stafford and Duke's shortly before and the Ritz was the group's last remaining hotel. The new owners astutely saw that the Ritz must not be part of a chain and must keep its family atmosphere and with it the loyalty of its long-serving staff. Initially, Michael Day, who has managed London hotels for the Barclays for 30 years, took control. The Barclays' first move was to recruit as managing director Giles Shepard, who had been running not only the Savoy, but Claridge's, the Connaught and the Berkeley, until 1994. Shepard, they saw, was a man, like César Ritz himself, whom the clientele would follow. Giles Shepard has been aptly described by *Country Life* as 'custodian of the Ritz's soul'. During the first year seven new heads of department were appointed, and Michael Bentley – a hotelier *par excellence* with 43 years' experience, 34 of them at Claridge's – joined the management on a part-time basis. His principal role has been to promote the interests of the Ritz both at home and abroad and to provide invaluable expertise in the context of staff training. Giles Shepard believes fervently that success depends on the mood of the staff. 'They have to be happy. If they impart charm, look happy, it makes a world of difference. If they are not, it shows in their faces and can manifest itself in surliness to the guests, which must not happen.'

Shepard's own background was as a King's Scholar at Eton and an officer in the Coldstream Guards. Later he became a member of the board

OPPOSITE

Ian Gomes entertaining guests at the piano in the Grand Gallery.

of the Dorchester Hotel, where he took such a keen interest in the running of the place that he attracted the attention of Sir Hugh Wontner, the legendary chairman of the Savoy. When the Dorchester changed hands, Wontner invited him to become his deputy and for 15 years Shepard served as managing director of the Savoy Group. He recalls that 'the typical staff pattern in a grand London hotel was French in the kitchen, Austrians as pastry cooks, Italians in the restaurant, Swiss managing the accounts, and Irish chambermaids'. He compares the running of a grand hotel to an antique clock: 'beautifully balanced, but shake it, let alone drop it, and springs and cogs are spilling all over the place'.

Luc Delafosse, the present general manager, is a man very much in the mould of the young Ritz himself, full of charm and enthusiasm, fast-working and decisive. He says with precision, 'without any doubt it was César Ritz who created the five-star hotel. True, there was a M. Martinez in Cannes and a M. Negresco in Nice, but Ritz is known and remembered the world over.'

The hotel business is one in which traditionally people start at the bottom, but can – if they are energetic and talented – rise very fast to positions of responsibility, often alternating, as Ritz himself did, between large and small establishments. Amidst such competition, the challenge to the hotel management is to retain the loyalty of staff – a point on which the Ritz has excelled beyond any other London hotel. M. Delafosse is a true professional who has set out to acquire first-hand knowledge of every aspect of the hotel business, moving from hotel to hotel as Ritz had done. Catering school in France was followed by two years at the Savoy Hotel, working as a commis waiter and in the bar and the kitchen, finally becoming back of house manager at the age of 23. Next he worked at the Hôtel de Paris in Monte Carlo – a century ago in fierce rivalry with the Grand where Ritz worked. Then he was approached by an English company to oversee the building of a five-star hotel in Le Touquet. Following a spell at the Hôtel Mirabeau in Monte Carlo (owned by the Barclays), he arrived at the Ritz in 1995 soon after David and Frederick Barclay acquired control. The experience he had earlier gained from his involvement in building a modern hotel from scratch put Delafosse in the best possible position to undertake and supervise the extensive refurbishment of the Ritz.

Robert Fauchey, Rudy
Dalusung and Jesus
Louro-Candal on duty
in the Palm Court.

For him, the first key is to motivate his staff. 'The heads of departments must be very strong mentors. They have to be prepared to share their knowledge and skills with staff who are keen to learn.' The staff of the Ritz are in no doubt about their mission – to pamper their guests, that is to ensure that they are well looked after, made welcome and to feel at home.

The Ritz day begins at the 9 a.m. staff meeting in M. Delafosse's office. It starts with a review of all guests arriving that day, listed by name. Mr G is to have a traditional car to go sightseeing. Mr B, a repeat client from Switzerland, is having room 622 as always. Mr A, a client from Jordan, has requested a specific room 'but this might be an opportunity to show him new rooms'. Mr L likes his window free of furniture and does not like *petits fours*, so there must be a bowl of fruit but no bananas. Mr and Mrs D need a valet and a maid to unpack. The Bibles must be removed from the rooms of a party from Brunei, as must the alcohol from the minibars. The chef's special canapés are to be served to a party in the Palm Court. A party leaving the next morning requires three limousines at 7 a.m. – this will mean that early rooms are available for new arrivals.

Some members of the
Ritz management and staff:

(top row) Giles Shepard,
Managing Director; Andy
Colairo, hall porter; Jason
Matthews, Marcus Whiteley,
Nicholas Conlin and Catherine
Belal at the reception desk.

(middle row) Janette Glynn,
executive housekeeper, with
Debbie Adekoya (left) and
Helen O'Donoghue; Luc
Delafosse, General Manager;
Michael de Cozar, hall porter.

(bottom row) Umberto
Schioppa, floor manager; and
the hotel barber, Mr James,
with a client.

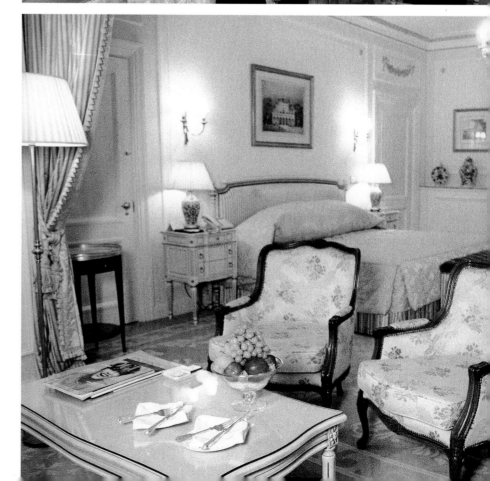

Stephen Boxall took over as restaurant manager aged 30. He also had a classic training with the Savoy, then worked on the *QE2*, at St Ermin's Hotel and for the Sheraton group. The full complement of staff in the Restaurant consists of himself, a deputy and two assistants, a hostess in charge of reservations, a carver, at least three sommeliers and eight to ten food waiters (three head waiters who move between stations, a *chef de rang* and the commis waiters). The *maître d'hôtel* wears a morning coat at lunch and a dinner jacket in the evening, as do his deputy and assistants. The head waiters wear tails with black waistcoats, black bow ties, a stiff shirt and stiff collar. A *chef de rang* wears tails, a white waistcoat with white bow tie, a stiff shirt and collar. The standard dress for each of the commis waiters is a white apron, black jacket, white shirt and black tie.

Observant guests may notice the tail-coated figure of Andrew Jarman, whose task as food and beverage manager is to ensure the smooth running of the Restaurant, the Palm Court, the bars and all areas where drinks and snacks are served, including room service.

The Ritz Restaurant is in intensive use, for breakfast, lunch and dinner. This leaves only short intervals: between 11 a.m. when breakfast ends and

Stephen Boxall, the restaurant manager, flanked by Simone Pogli (*chef de rang*; left) and Alfredo Ramagosa (head waiter).

12.30 when the first guests may arrive for lunch; and between 4.30 or 5.00, when the last lunch guests depart, and 6.30 when the Restaurant reopens. No-one, it need hardly be said, is ever put under pressure to leave.

In these short intervals the Restaurant layout may have to be largely reconfigured, tables moved, enlarged or reduced and the breakfast buffet spirited out of sight. 'I never do a table plan till the day', says Boxall. The essential task is achieve what he calls a 'balanced' room. For this reason he will never accept bookings for more than three large parties at one meal – to do so might create the feel of a banqueting room – and the parties are spread judiciously about the Restaurant. The number of window tables may vary from one meal to another, from tables for 12 to tables for two. The corner tables are special favourites with important customers.

For breakfast, bread is freshly baked every day, orange and pink grapefruit juice are freshly squeezed in the kitchen each morning. The Ritz prepares its own muesli, and fresh strawberries and raspberries are on the buffet every day of the year. There are also the hotel's own, specially delicious compôtes, of cranberries, apples, pears, plums and, naturally, prunes. Also on the buffet are freshly sliced smoked salmon,

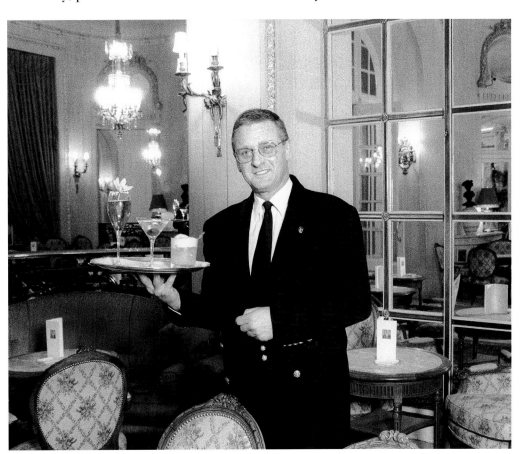

Bob Burton, the bar manager, serving drinks.

wild of course, and the finest York ham. Every day there is fresh fish – the fishmonger delivers whatever he considers best and most appetizing, which could be lemon sole or fresh (not smoked) Finnan haddock. A newly arrived guest unable to face the airline food on an overnight flight can quickly be served a sirloin steak with eggs and mushrooms. 'Ladies who breakfast' and who intend to eat no more than a pear and a few grapes rarely fail to be tempted by smoked salmon and scrambled eggs. Gone are the days when rich Jersey milk was considered to boost the health; skimmed milk, cottage cheese and margarine are in demand instead.

The lunch menu changes every Tuesday, though Ritz specialities like crabcakes are always available. Before the Restaurant opens Boxall will summon his brigade and go through the day's menu and various aspects of service. He will talk to the carver, who will advise how many portions of rib of beef (from a named Aberdeen Angus herd, Glenbervie) or saddle of lamb will be available, or how many ducks (perhaps 20), so avoiding the danger of over-ordering. This is also the time to consider the numerous birthday cakes and flowers ordered by clients for special occasions.

The cheeses for the Restaurant are chosen not by the chef but by Boxall and a group of his colleagues, including the sommeliers, who serve the cheese and thus have the most immediate feel for guests' preferences. Care is taken to choose a balanced range on English and Continental varieties at their prime, providing a range of soft and hard, blue and cream cheeses, each of which is taken out from the cold store from midday onwards to ensure that when served it is at the perfect temperature.

Today the tendency in smart restaurants is towards *service sur plat* – what in English is referred to rather inelegantly as 'plated food'. The Ritz of course does this with supreme aplomb, the dish arriving covered by a silver dome which is removed with a flourish at the table. The hotel is also keen that waiters should retain all their traditional skills, such as filleting a Dover sole at the table. Smoked salmon will be sliced in front of the guest, as will the evening favourite, Bœuf Wellington. The balance between dishes served *sur plat* and at the table is half-and-half, and the Ritz is keen to keep it this way. At the Ritz salad will always be tossed in a bowl and individually served at the table. Continental waiters will be initiated into the English ways of serving game (which they may not have learned at college) with bread sauce, breadcrumbs and game chips.

Andrew Jarman, food and beverage manager, stationed on the first-floor gallery of the main staircase.

The waiters take orders by hand and then discreetly enter them on a touch-screen computer using the system known as Micros, which transfers the orders immediately to the chef in the kitchen below. The first course is expected to arrive within ten minutes, unless it is a special dish such as glazed oysters which requires rather longer preparation.

Cooking, says the Ritz's Maître Chef des Cuisines, Giles Thompson, is all about timing. Everything is cooked to order, with the exception of braised dishes such as *osso buco*, *bœuf bourguignon* and *coq au vin*, which will have been prepared earlier. All fish orders and risottos are *à la minute*, cooked at the last moment. The soup bases will have been prepared in advance, but the soup itself is freshly made and the sauces are finished off with juices from the pan.

The task of the chef or sous-chef in charge is to co-ordinate all this activity so that all dishes for each table arrive simultaneously. As an order arrives on the Micros, the chef calls it out over the tannoy and starters begin. One of the tasks of the sous-chefs is to go to the aid of colleagues under particular pressure – if a table of eight have all ordered different

In the chef's basement office, Andrew Jarman (left), Giles Thompson (right) and Ian Scollay (*premier sous-chef*) sit in judgment on a menu prepared by Magalie Leray.

main courses, for example. Intense concentration is needed. 'Any slight distraction can throw the co-ordination', says Thompson. The chef must check the quality of every dish that passes over the hotplate. Major problems arise if one has to be returned and others for the same table are kept waiting, and the whole system is geared to avoiding such a situation.

Orders will have been placed with suppliers the night before and deliveries of fresh fish, meat, game and vegetables will start at 7 a.m., with the bulk arriving by 9 a.m. If meat or game needs to be hung, this will be done by the supplier, though cuts such as a veal Paillard might come a day in advance to allow for preparation. After the morning meeting in the general manager's office ends at about 9.30, the chef will have an hour and a half to talk to suppliers, interview new staff, check everything in preparation for lunch ('with constant interruptions', says Thompson). At 11.30 a.m., the staff have their lunch, and at midday the chef starts 'setting up the hotplate and getting myself *in situ* to start the service'. When there are private functions to be catered for, a sous-chef will be put in charge.

For guests occupying bedrooms or private suites that familiar feature of any hotel of quality today – a well-stocked minibar – is now standard. Often, however, a supply of ice may be required for drinks, and the Ritz has gone one better than American hotels with their ice machines on every floor: in every bedroom or suite an ice-bucket, replenished two or three times a day, is provided.

The housekeeper, Janette Glynn, holds five sets of bedding for each bedroom. Cleaning a room takes anything from 45 minutes to an hour, and suites of course demand even more time. The staff complement includes seven floor housekeepers, two assistant housekeepers, fourteen full-time maids, two evening maids, four housemen and five night cleaners.

Tea at the Ritz is more popular than ever. It may be the most expensive tea in London, but it is still booked out weeks in advance, even in winter. Today there are three sittings, at two o'clock, three thirty and five o'clock. To find a table at short notice, the only way is to forgo lunch and try the two o'clock sitting, when tables in the Palm Court may become free. The delight of tea at the Ritz lies not just in the superb setting or the impeccable service. The real treat is that everything is freshly made in the hotel that day, the scones and the cakes emerging from ovens just beside the chef's office and being decorated under his ever-watchful eye.

FOLLOWING PAGES

Giles Thompson (seated, centre), flanked by his sous-chefs (Ian Scollay, Michael Soder, Thorsten Haane and Jamie Scorer), with members of the brigade of chefs in relaxed mood between lunch and dinner cooking sessions; the brigade has a total strength of forty.

Kitchen preparations and storage shelves for silver tableware.

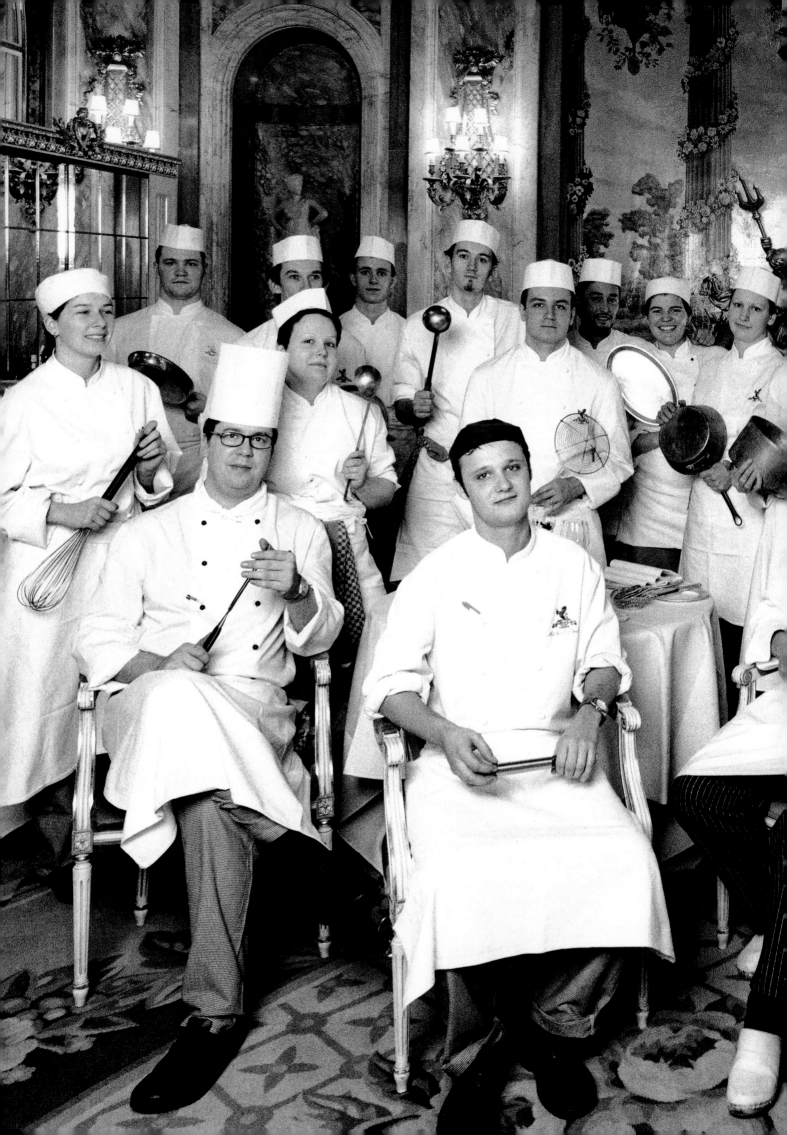

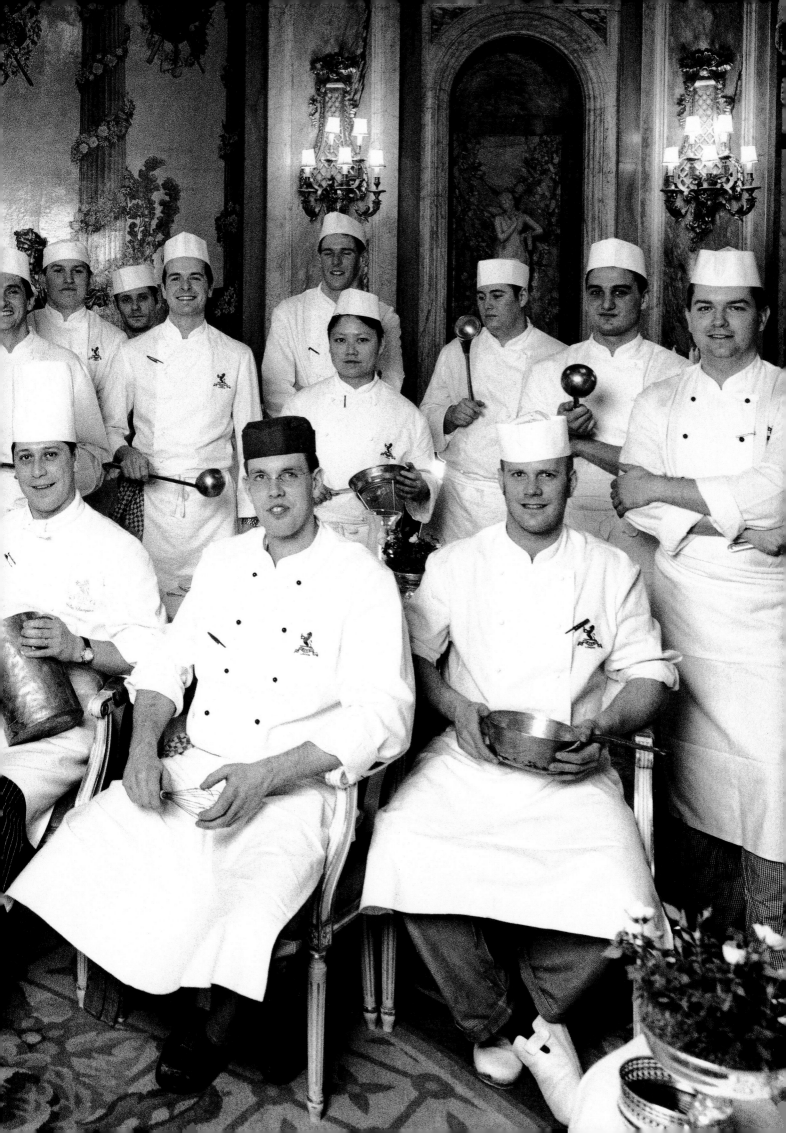

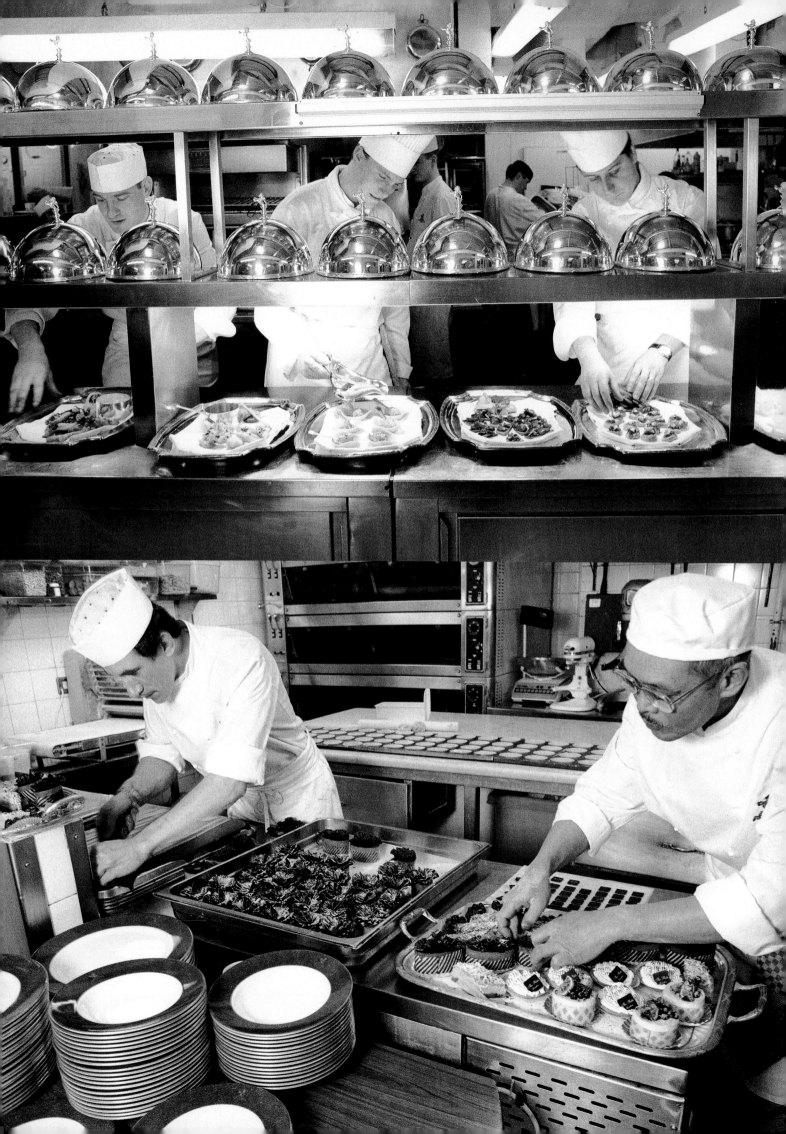

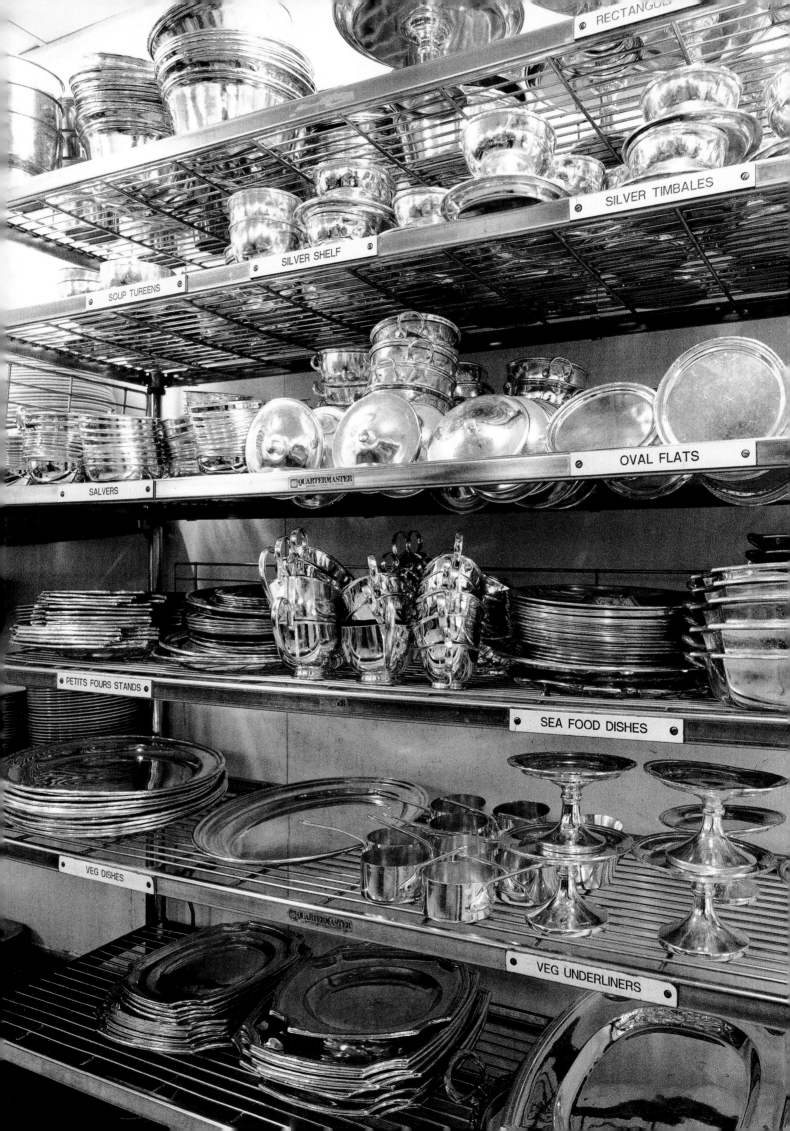

Renovation

Trafalgar House, the previous owners, had been planning to close the hotel for two years for a thorough overhaul. The new owners have chosen to proceed discreetly in stages, closing only one floor at a time, installing triple glazing to deaden the noise of traffic in Piccadilly and providing individually controlled air-conditioning for every bedroom. The Restaurant was closed for just two weeks. 'We don't use a main contractor. They take over the place, shut you out and you lose control. The work is all done under the direct control of our in-house architect, Steele Constantine', says Giles Shepard, the managing director.

In the Restaurant new small glass hurricane lamps shelter each candle; designed by Luc Delafosse, they were introduced in 1998. The lamp bases were copied from the boy-on-a-dolphin silver stands on each table, originally designed for *petits fours* but now used to carry little bowls of miniature red roses – these are replaced each week to ensure that the display is in perfect condition all the year round. Recently cove lighting has been introduced, but while this method often prompts expressions of horror (understandably when it consists of fluorescent strips), it has to be remembered that César Ritz himself was, according to his wife, the first to introduce cove lighting – at the Grand Hotel in Rome. In the Restaurant its use discreetly enlivens the room at night, attracting the eye to the painted ceiling which otherwise would be barely noticed.

One of the great features of French classical interiors is the smooth stucco finish imitating stonework used for halls and staircases to create a dignified effect. Mewès and Davis used this technique extensively at the Ritz, where the *trompe l'œil* effect includes artificial stone joints. This original decorative scheme had earlier been painted over with a cheap butter-coloured imitation, concealing the odd nail-hole and superficial imperfection; the result was very inferior in texture, however, and featured a smaller, less impressive masonry pattern. Happily, the Ritz was able to find a French firm, Nuances, which specializes in the original stucco 'stone blocking' technique. Groups of skilled craftsmen from France have tackled the walls in stretches of about 3 metres at a time, shielded from the guests by temporary screens.

A second major task has been to renew the hotel's carpets (originally Savonnerie), which had been replaced on a number of occasions. The Ritz went to a London company, Xebec Decor Ltd, which prepared designs to be specially woven by Ulster Carpet Mills in Portadown. Philip Arundel of Xebec recalls that 'We worked for about two years preparing designs, first for the dining room, then the corridors, and then the bedrooms.' The weaving is done on Axminster looms. As Anthony Hickman of Ulster Carpet Mills explains, 'We use a system called Uniweave. Axminster can be woven in different widths, from 3 ft to 15 ft, but the Restaurant is so wide that it requires four strips. The beauty of our new computerized system is that it allows us to design a large-scale carpet that looks hand-made for a particular room. We can use a maximum of 12 colours in a carpet, which we have done in the Restaurant and the hotel corridors, to achieve a hand-made feel.' The pile is a standard Axminster mix of 80% wool with 20% nylon to give durability.

The tapering floor-plan of the Restaurant presented a particular problem, for enlarging dimensions from a standard architect's floor-plan could have multiplied any tiny inaccuracy a hundred times. Hickman therefore worked up the design on the computer, always ensuring that the medallion remained centrally placed. A certain tolerance has to be allowed for stretching, and the gap emphasizes the fact that this is a specially made carpet, not a cut and fitted version. The same technique has been used for the bedrooms, each room being given a traditional French design featuring a central medallion and a full border fitted to its exact shape

According to Giles Shepard, the previous owners had cut half an inch off the bottom of every bedroom door in order to make it easy to slide the morning newspapers through. Now that the doors have been replaced in the original size, he has a rather simpler solution – to hang the papers in a carrier bag on the door-knob. As the hotel is refurbished floor by floor, original features such as the Louis Seize fireplaces, panelling and light fittings are retained. In the Green Park suites the original doors, made to follow the curve of the wall, have been retained together with their beautiful bronze hinges, and the built-in cupboards have been restored following the original design. The walls remain a chaste pale cream, very much what Ritz himself chose for his hotels. The main difference is an increased use of gilding to highlight decorative details, while in the Green

139

Park suites, the French decorator M. Philippe Belloir, just a little cheekily, has added the occasional new decorative flourish in the wall panels.

In the eighteenth century, upholstery was usually the most expensive item in any decorative scheme; today the éclat of many a restoration of fine period rooms has been lost because the money has simply not been available to repeat the fine fabrics and rich fringes and tassels that were originally used. For the Ritz, there have been no half-measures, and first the public rooms and now all the bedrooms have been given magnificent curtains in the finest silks and satins. True, they are richer than anything that César Ritz himself would have envisaged, but they add a shot of glorious colour and richness to every room and the fabrics are of ravishing quality.

The work on the furniture and fabrics has been carried out with the help of M. Belloir, whose office is in Paris. Most striking of all are the new curtains in the Restaurant; these have coral-pink inner curtains (*sous-rideaux*) that glow ravishingly whenever the sun begins to stream through the windows in the late morning. The manufacture of the four pairs of curtains required some 300 metres of fabric – they were made by Maison Prelle of Lyon, using silks specially dyed to match the marbles of the walls. The *passementerie* – trimmings, tassels and tiebacks – was supplied by Maison PIE of Paris, all specially coloured to complement the curtains. The oval-backed chairs, echoing those in old photographs, have matching pink seats.

M. Belloir has also supplied the new furniture for the Grand Gallery, consisting of console tables, tables and sofas. The large French armchairs known as *bergères* and *fauteuils*, in both Régence and Louis Seize style, were made in the Vosges and are covered in patterned velvet.

Four principal colour schemes are used for the bedrooms – salmon-pink, rose-pink, yellow and blue. The curtains in every room are handsomely swagged and draped, so that one fabric is seen alternating with another. Both Jacquard and damask silks are used, but the excitement comes from glimpses of dashing red or blue striped silk which catch the eye like a dazzling waistcoat. The pretty lyre-back chairs, covered in velvet or silk, are new arrivals. Much of the bedroom furniture is original, notably the armchairs, the desks and the dressing tables, many of which were repaired and redecorated in the hotel. New bedside tables come from Italy, while the pedestal tables are French. The handsome bedheads, gently rounded like the backs of French sofas, are hand-made and upholstered in silk or satin.

A newly refurbished
bedroom on the third floor
continues the tradition of
elegance and comfort.

The renovation and restoration of the hotel has progressed without a break since 1995. Most of the work has been completed, both in the public areas and behind the scenes – a complex operation supervised by Peter Smoker, who has managed not only a regular workforce but also the activities of specialist subcontractors. The kitchens have been refurbished with the minimum of disruption and laundry rooms, cellars and stores reorganized; a new service lift and a laundry chute have been installed, as has a new fire alarm system. Every room in the hotel now has independent air-conditioning and a new telephone system is in use.

Thus, at the London Ritz the spirit of Charles Mewès and Arthur Davis lives on to an extent inconceivable in most grand hotels approaching their centenary. It does so because they built to last, using the best materials and the best craftsmen. Davis supplied drawings for the fitting out of every bedroom in Louis Seize style and happily guests will still be enjoying the results in two or even three hundred years time.

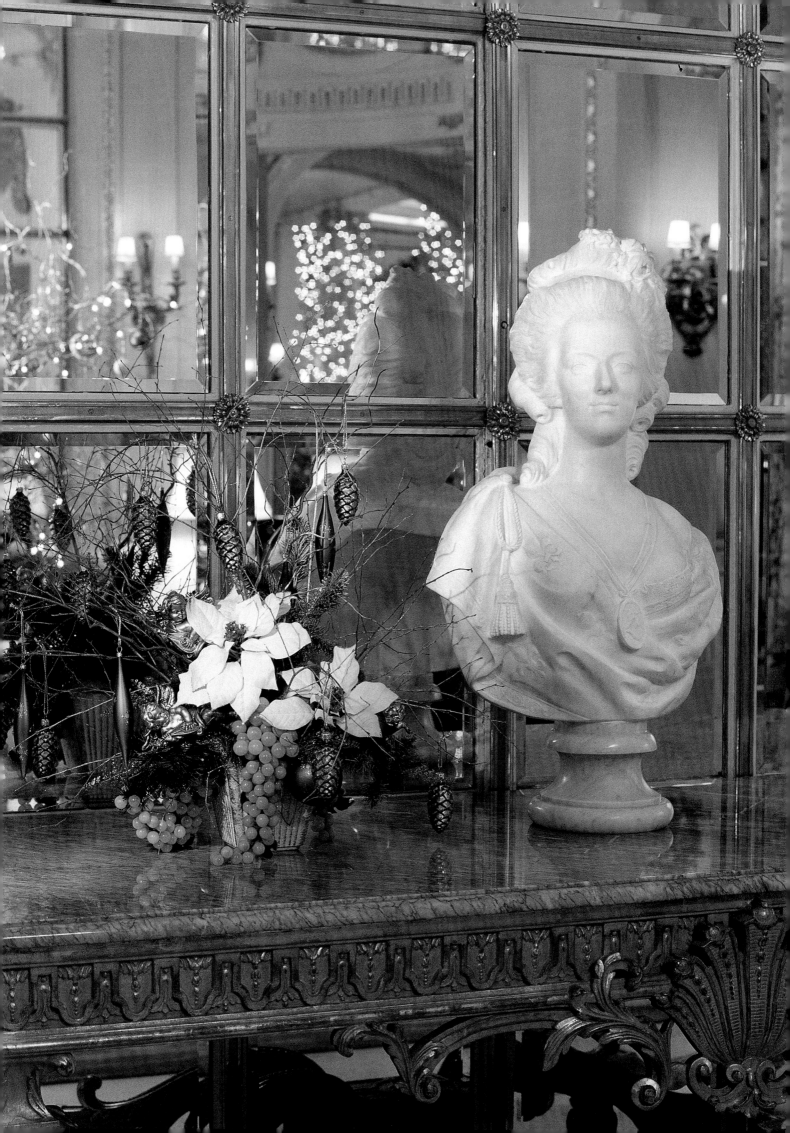

BIBLIOGRAPHY

Andrieu, Pierre, *Histoire anecdotique des Hôtels de France*, Paris, 1956

Boxer, Mark (ed.), *The Paris Ritz*, London and Paris, 1991

Chastonay, Adalbert, *Cäsar Ritz. Leben und Werk*, Visp, 1994

Denby, Elaine, *Grand Hotels – Reality and Illusion. An Architectural and Social History*, London, 1998

Escoffier, Auguste, *Memories of My Life*, New York and London, 1997 (translated from the French *Souvenirs inédits*, 1985);

— (ed.), *Le Carnet d'Epicure*, London, 1911–14;

— *A Guide to Modern Cookery*, London, 1907, and reprints

Gaulis, L. and Creux, R. *Swiss Hotel Pioneers*, Paudex (Switzerland) and Swiss National Tourist Office, 1976

Hamp, Pierre, *Kitchen Preludes (Mes Métiers)*, London, 1932

Herbodeau, Eugène and Thalamas, Paul, *Georges Auguste Escoffier*, London, 1955

Jullian, Philippe, *Edward and the Edwardians*, London, 1967

Kämpfen, Werner, *Cäsar Ritz: ein Leben für den Gast*, Brig, 1991

Lawrence, Jeanne Catherine, 'Steel Frame Architecture versus the London Building Regulations: Selfridges, the Ritz, and American Technology', in *Construction History*, vol. 6 (1990)

Léospo, Louis, *Traité d'Industrie Hôtelière*, Paris, 1918

Levy, Paul, *Out to Lunch*, London, 1986

Macqueen-Pope, W., *Goodbye Piccadilly*, London, 1960

Matthew, Christopher, *A Different World: Stories of Great Hotels*, London, 1976

Montgomery-Massingberd, Hugh, and Watkin, David, *The London Ritz. A Social and Architectural History*, London, 1980

Musée Carnavalet: exhibition catalogue *Du Palais au Palais: des Grands Hôtels à Paris au XIXe Siècle*, Paris, 1998

Newnham-Davis, Nathaniel, *Dinners and Diners*, London, 1899; revised ed. 1901;

— *The Gourmet's Guide to London*, London, 1914

Ritz, Marie-Louise, *César Ritz, Host to the World* (1938, English edition, 1981)

Roulet, Claude, *Ritz: A story that outshines the legend*, Paris, 1998

Savoyard, The (Savoy Hotel publication), London, 1910

Service, Alastair (ed.), *Edwardian Architecture and its Origins*, London, 1975

Shaw, Timothy, *The World of Escoffier*, London, 1994

Waller, Adrian, *The Ritz-Carlton: No Ordinary Hotel* [the Montreal Ritz-Carlton], Montreal, 1993

Watkin, David and others, *Grand Hotel: the Golden Age of Palace Hotels*, London, 1984

Watts, Stephen, *The Ritz* [Paris], London, 1963

Willan, Anne, *Great Cooks and Their Recipes: from Taillevent to Escoffier*, London, 1995

Christmas decorations in the Palm Court.

OVERLEAF: The Ritz coat of arms.

INDEX

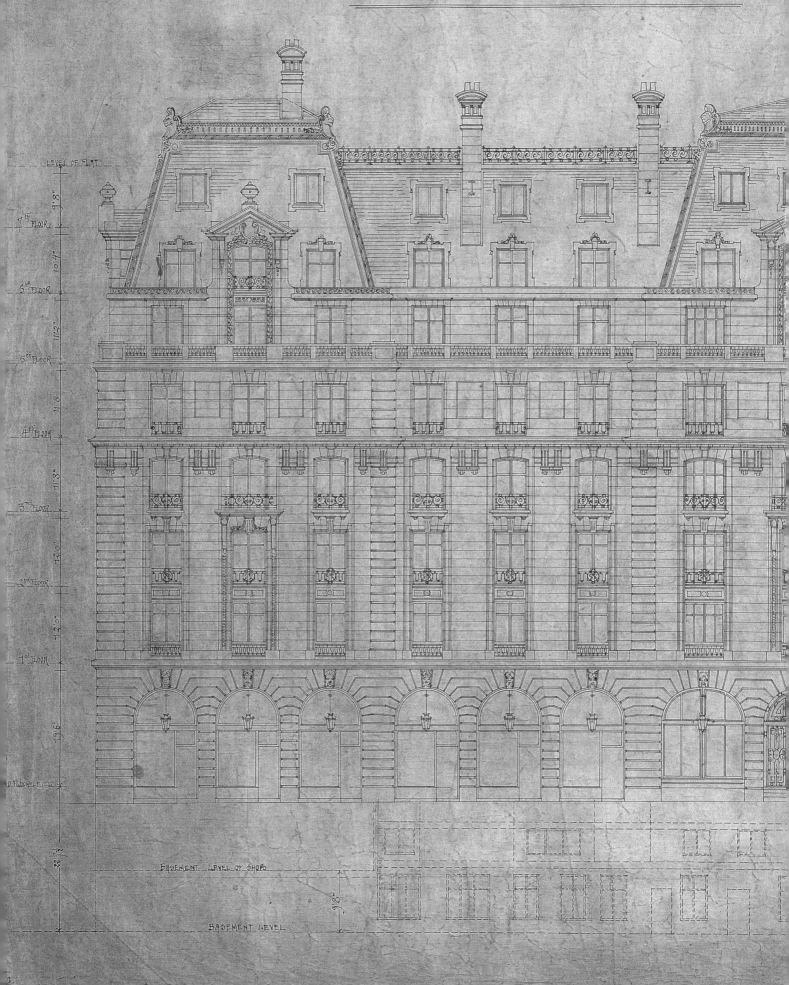

LEVEL OF FLAT

9'8"

7TH FLOOR

10'4"

6TH FLOOR

11'2"

5TH FLOOR

11'8"

4TH FLOOR

11'8"

3RD FLOOR

12'6"

2ND FLOOR

12'0"

1ST FLOOR

19'6"

GD FLOOR LEVEL

32'7"

BASEMENT LEVEL OF SHOPS

9'8"

BASEMENT LEVEL